Grover E. Murray Studies in the American Southwest

Also in the Grover E. Murray Studies in the American Southwest

Texas Quilts and Quilters

Texas Quilts and Quilters

A Lone Star Legacy

Marcia Kaylakie

With Janice Whittington

Photography by Jim Lincoln

Foreword by Marian Ann J. Montgomery

Texas Tech University Press

This book is typeset in Adobe Caslon. The paper
used in this book meets the minimum
requirements of ANSI/NISO Z39.48–1992
(R1997). ∞

Book design by Jennifer E. Holmes

All photographs, unless otherwise noted,
by Jim Lincoln

Library of Congress Cataloging-in-Publication Data
Kaylakie, Marcia.
 Texas quilts and quilters : a lone star legacy /
Marcia Kaylakie with Janice Whittington ; fore-
word by Marian Ann J. Montgomery ; photogra-
phy by Jim Lincoln.
 p. cm.
 Includes bibliographical references and index.
 ISBN-13: 978-0-89672-606-2
 (hardcover : alk. paper)
 ISBN-10: 0-89672-606-1
 (hardcover : alk. paper)
1. Quilts—Texas—History. I. Whittington,
Janice. II. Title.
 NK9112.K39 2007
 746.4609764—dc22
 2006100529

Printed in China at Everbest Printing
07 08 09 10 11 12 13 14 15 / 9 8 7 6 5 4 3 2 1

Texas Tech University Press
Box 41037
Lubbock, Texas 79409–1037 USA
800.832.4042
ttup@ttu.edu
www.ttup.ttu.edu

To the quilt makers of Texas
who left us a legacy of
quilts and stories
filled with warmth, love,
laughter, and tears—
living mementos of their lives.

Contents

Contents

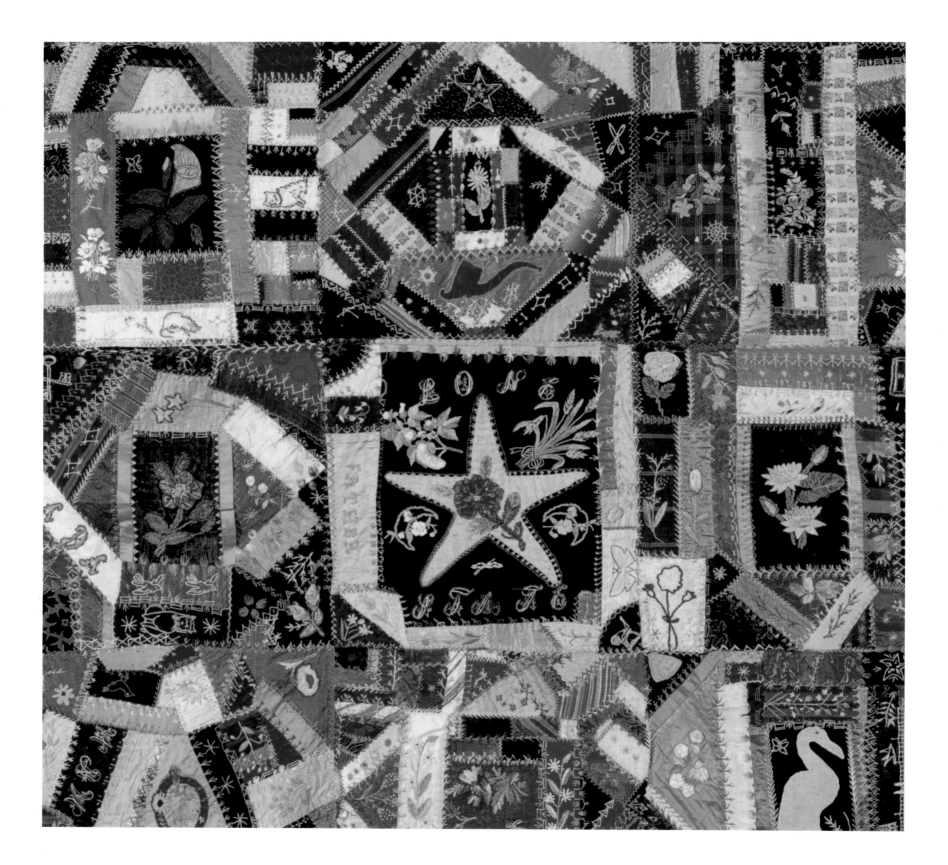

having them now on the quilts that you've inherited.

Gatherings: America's Quilt Heritage documented Washington, D.C., quilter Antoinette Mayer's methodical practice of numbering each of her quilts as it is planned, taking photos of each quilt in progress, and placing this documentation in albums recording each of her quilts. Surely this quilter will have the admiration of future curators and quilt historians, and her method would be easy and inexpensive for any quilter to employ, but this documentation does separate the history from the quilt.

Texas Quilts and Quilters serves an important role in documenting the quilts and the stories of Texas quilters. It incorporates a history of the settlement of

Texas as illustrated through the surviving material culture of the quilts made by the people of the state. Sally Garoutte said, in her foreword to the first issue of AQSG's journal, *Uncoverings,* "We come to our understanding of our history only through small steps . . . and each one is a challenge for someone else to go a little further . . . quilt history is a continuing process . . . there is much to uncover." I hope scholars will be intrigued to delve further into some of the questions posed in this book, and I hope others will be inspired in their own work by these stories. May you enjoy uncovering these small gems of Texas history.

Marian Ann J. Montgomery

Dallas, 2007

quilt. Labeling the quilt ensures that the quilter will get credit for her, or his, creation.

Prior to quilt contests of the twentieth century, quilters seldom labeled their quilts. Occasionally someone would embroider or quilt her initials and a year into the quilting, but those instances are rare. Today quilters are required by contest rules to label their quilts with at least their name and the name of the quilt. This will help quilt historians, and heirs, in the future avoid the difficulties Kaylakie encountered in documenting the stories behind the quilts. The extensive use of reproduction fabrics by quilters in their quilts will pose oth headaches in dating quilts for those same curators and historians, and therefore a proper label will assume even greater importance for historical accuracy.

As a quilt curator and scholar I cannot stress enough the importance of taking that final step to label the quilts you make. Too often I meet with families who discover that a quilt they believed was made by one family member incorporates techniques or fabrics not used during that quilter's lifetime. Quilters, take credit for your creation! Let your labels remove any doubt that you and not your mother-in-law made the quilt! This can easily be done by rolling a piece of fabric into a typewriter or using a pigma pen on solid fabric. You can even write out your label on the computer and ask your local quilt shop to do a photo transfer onto fabric you can sew onto the back of the quilt. As long as the ink is set with heat, like that of a standard household iron, both the typing and pigma pen labels will hold up through cleanings as well as the photo transfer labels do.

One of my favorite Texas quilts has a section in which the quilter wrote with machine quilting stitches something like, "They are discussing cloning on the television while I am quilting this." That quilt encouraged me to incorporate something personal about what was going on in my life into the label on every quilt I make. My husband says that now my quilt labels read more like *War and Peace.* He probably has a point, but I know that Marcia Kaylakie would have been happy to find that sort of information to enhance the stories she shares. Future curators and quilt historians will love those labels as much as your heirs will, and as much as you would love

of this state, but do not benefit from the quilt scholarship of the past twenty years as does this book. Many state documentation books focused on a selection of visually strong quilts among those that had been documented, whereas Kaylakie, over a decade of examining quilts, was able to choose and document visually strong examples whose engaging stories have also survived. Most state quilt documentations focused on quilts prior to 1930 or World War II, as without a cutoff date the wealth of quilts to document in any state would have been overwhelming. In her individual effort, Kaylakie was able also to include quilts made after World War II. Moreover, readers with a passion for Depression-era quilts will be pleased to see the abundance Kaylakie found across Texas. Kaylakie's contribution in this area builds upon the seminal work of Merikay Waldvogel in *Soft Covers for Hard Times: Quiltmaking and the Great Depression.* Also in the tradition of Waldvogel and other scholars, Kaylakie has made sure that documentation of these and other quilts from her personal decade-long study will reside in a public collection (in Kaylakie's case, the Southwest Collection at Texas Tech University), where it will remain accessible to other researchers.

There have been no recent books on Texas quilts, as Charlene Orr and I noted in our article on the quilts of a family in Mesquite, "Quilted Gems by the Jewels of the Lawrence Family," for *Uncoverings 2005.* It is time for fresh insights and more accurate quilt dating informed by the methodology of the quilt documentations and quilt historians since the 1980s, and *Texas Quilts and Quilters* is a welcome addition.

Kaylakie's struggle for information on the quilts and their makers highlights the need for quilters to label their work. Quilts take a lot of work and patience. When they are finished and the final stitch is sewn on the binding, most quilters are ready to use the quilt or give it away and move on to their next project, which has probably been percolating in their minds for a while. But overlooking the comparatively few minutes it would take to label a quilt properly for posterity can lead to confusion within fewer generations than one might think. The time and effort required to take that extra step to label a quilt is relatively small compared to the time and effort of making a

Bets Ramsey and Merikay Waldvogel.

A fine discussion of the work of the state quilt documentations done across the country and the efforts of the volunteers is found in *Gatherings: America's Quilt Heritage,* by Kathlyn F. Sullivan, which accompanied an exhibition curated by Paul D. Pilgrim and Gerald E. Roy in 1995. Outlining the reason quilt documentations took place, Sullivan writes, "Experience showed that quilts get used up and destroyed. Generations pass on and with them the intimate knowledge of their quiltmaking or the stories they'd heard at grandma's knee. Fear of the loss of that knowledge of family, mixed with a regard for the past and a desire for a fraction of immortality, were motivating factors [in moving forward] the quilt

documentation 'movement.'. . . Quilts made in the past would often have remained anonymous, ultimately lost from knowledge, were it not for the state documentation projects."

Texas took on two statewide quilt documentation projects. Karey Bresenhan and Nancy O'Bryant with the nonprofit Texas Sesquicentennial Quilt Association initiated the Texas Quilt Search in 1980, which resulted in *Lone Stars Volume I: A Legacy of Texas Quilts, 1836–1936* and *Lone Stars Volume II: A Legacy of Texas Quilts 1936–1986.* The documentation material generated through this search has become part of the Winedale Collection at the Center for American History at the University of Texas at Austin and should be added

to the Quilt Index by the time this book goes to press. The Texas Heritage Quilts Society also took on a quilt documentation project, which resulted in the book *Texas Quilts: Texas Treasures.*

I got a glimpse of the work and excitement of quilt documentations when I served as the onsite quilt expert for The Grace Museum's documentation of quilts from the Abilene area in 2001. That documentation resulted in a very popular exhibition, "A Stitch in Time." I hope that the records of that documentation, which remain at The Grace Museum, will have been added to the Quilt Index by the time you hold this book in your hands.

The earlier Texas books are a wonderful collection of the quilts and stories

more fully developed while others are fragmented, but together they make a pleasing whole. Each story shines in its own way, much as different fabrics in a scrap quilt vary in texture and hue, complexity and detail, each catching the light in its own way.

Seeking to ensure that quilting command the same respect as other decorative arts scholarship, serious scholars have developed stringent methodologies for quilt study. *Uncoverings,* the journal of the American Quilt Study Group, for example, requires extensive documentation in the articles it accepts. I have been honored to be a part of the work of the AQSG, but also must admit that a strong focus on provenance and documentation has meant fewer opportunities to share

the sort of quilts with limited historical information that have been gathered into this book. Sometimes strong scholarship can result in a read too dry for many quilt enthusiasts across the country, to whom even the most faded quilts speak far more vividly than spare facts. Kaylakie's telling of the stories behind the documentation in a historically accurate but less formal style is an excellent example of how scholarly practices can shape a study that has deep meaning for quilt lovers at all levels.

This book is based on serious documentation that Kaylakie undertook as she examined quilts across the state of Texas. She used the same type of format employed by state documentation volunteers across America who initiated quilt

documentation projects in the late 1970s and early 1980s. These projects involved incredible effort by volunteer corps in the various states. I missed this excitement, as by the time I arrived on the scene as the Curator of Fashion and Textiles at the Tennessee State Museum in 1987, women quilt enthusiasts in Tennessee, ably assisted by some of their husbands, had already documented the quilts of the state prior to 1930. The photographs and quilt documentation forms gathered by this project are on file in the Tennessee State Archives and form part of the online Quilt Index at www.quiltindex.org. Tennessee, like most other state documentations, published a selection of the quilts in the book *The Quilts of Tennessee: Images of Domestic Life Prior to 1930,* by

Foreword

This book is a delightful look at the quilts and quilters of Texas. It follows in the footsteps of *The Quilters,* published in the late 1980s, shortly after the quilt revival of the late twentieth century began. Incorporating methodology developed by scholars interested in looking at quilts and the people who made them, *Texas Quilts and Quilters* is a remarkable conduit between two worlds—that of fascinating stories and accurate historical documentation.

It was *The Quilters* that first opened my eyes to the stories of quilts and quilters, and how interesting and valuable they were to America's heritage and material culture. I have given that book to numerous quilt enthusiasts over the years and am pleased that Texas Tech University Press recently reprinted that volume. Years ago my work in the museum community of Dallas led me to one of the authors, Norma Bradley Allen. It was terrific to talk with someone who had sparked my interest in quilt history. I also enjoyed getting to know Marcia Kaylakie through her quilt research efforts, long before this book was planned. Knowing the considerable time Kaylakie has spent documenting the stories of quilters across Texas, I was delighted to learn her efforts would be preserved in this book. Moreover, I was honored to be asked by Texas Tech University Press to write this foreword. Kaylakie's work over the years has been remarkable, and her passion for quilts and quilt makers resonates throughout this book.

On these pages you will meet unknown quilters, unexpected quilters (a local minister), and relatively famous Texas quilters, like Kathleen McCrady. The stories are surprisingly diverse, and each has something special that the reader will enjoy.

These bits of surviving stories are like a patchwork in themselves. Some are

material past. As people brought me their quilts to examine, the cultural development of this state unfolded in front of me. No, it was not in chronological order, and no, not in true geographical order, for quilts were now in the possession of daughters, sons, grandchildren, or distant relatives of those who had made them. But I saw patterns beyond the quilt patterns; quilting was as much a part of Texas as its people.

In its history Texas has reflected the spirit of westering, of settling a new land; its huge area of diverse geographical features has given people of wide ethnic backgrounds the opportunity to bring with them their diverse cultures as they settled and made their homes. The people brought their talents, their ideas, their struggles, their imagination, and

as these quilts show, their creativity.

What I began to realize as I examined more and more quilts—often with stories or bits of stories attendant to them—is how much of our Texas heritage has been hidden away in closets, attics, and trunks along with these heirloom quilts.

Sadly, I have also encountered many quilts whose histories are lost or, conversely, I've heard fascinating anecdotes that outlived their quilts. Often, as family members begin to tell me about a quilt, they find the details growing fuzzy. More and more, my experiences fanned a sense of urgency. I longed to preserve and share the discoveries in some concrete fashion.

But the decisive event that spurred me, what truly inspired me to begin this book, was an encounter with a 1930s

Log Cabin quilt and the story of its maker. Shown to me by the quilter's grandnephew, this quilt in the Barn Raising pattern was made of silk with 396 blocks pieced onto flannel. Although there was nothing uncommon about its machine and hand piecing, its tying, or even its gold satin backing and knife-edge finish, the edges turned under and stitched shut without a binding, its colors were extraordinary. The quilt gleamed with black and brilliant reds, fuchsias, blues, greens, and purples—no piece wider than one-half inch. Likewise, the story of its maker was extraordinary. This woman, originally from Childress, Texas, worked at the Montgomery Ward in Fort Worth and had pieced the quilt together over ten years from form ends, tiny leftovers of yard goods she had sold at the

Introduction

In the quilting section of any bookstore, or the book section of any quilt store, works range widely in topic from patterns and textiles to how-to books on techniques new and old to scholarly histories and surveys of art quilts. There are even books on quilters themselves and on quilting culture. I am forever grateful to those scholars and writers who have traced the history of the craft, gathered information and patterns, or delineated techniques, for I have learned from them eagerly. Just the number and variety of titles on the shelves reflect the scope of interest in this art called quilt making and how it permeates our culture.

Let me preface this book by saying where it fits in all this literature on quilts and quilters. It is not meant as a scholarly study of quilting. Rather it is a narrative of Texas quilts and quilt makers. Perhaps in these pages readers can discover more about that legacy quilters have left us with their needles and fabric, and with their stories. Through these narratives, perhaps readers may recall their own families' quilts and anecdotes and recognize how we all need to become conservators of our fragile material culture and oral history.

As a quilt appraiser and collector, I have traveled Texas for more than a decade evaluating quilts for individuals and organizations, lecturing on quilt history, and displaying my own antique and vintage quilts. (For the purposes of this work, antique quilts are those older than a century; vintage are more than thirty years old.) Logging at minimum 35,000 miles by plane and car, I have visited museums and quilt shops from the Panhandle to Big Bend country, the Piney Woods to the Gulf, discovering thousands of quilts in towns from Alpine to Austin, Dimmitt to Dallas and countless other Texas communities large and small.

These quilts, I came to realize, were in themselves each a part of Texas history and together an astonishing indicator of the breadth, depth, and diversity of our

Texas Quilts and Quilters

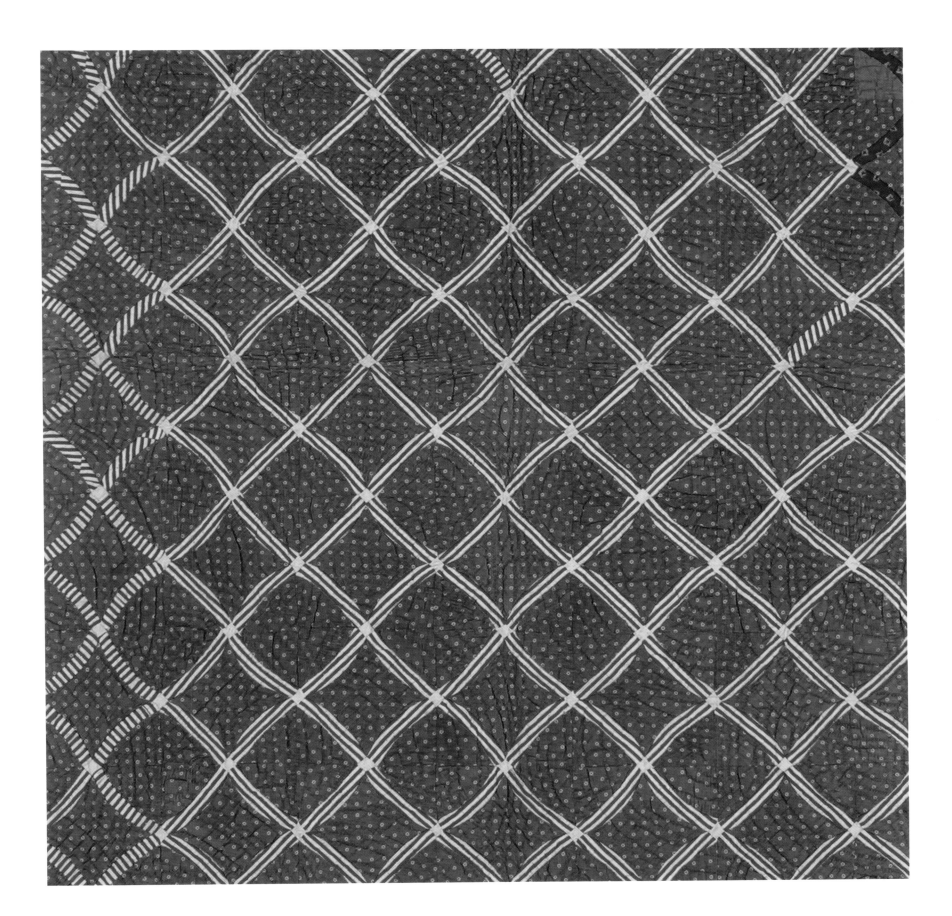

Acknowledgments

No one ever truly writes a book alone, and I am certainly no exception.

I would like to thank, first of all, my husband, Bill, and my sons, Chris and Kevin, for their faith and belief in me and my book even when the light seemed dim. I love you all!

I also want to thank many others:

Judith Keeling, editor extraordinaire, and Barbara Werden, designer extraordinaire, for all of their hard work and patience;

Janice Whittington, my coauthor, for helping to make my thoughts and these stories sing;

Jim Lincoln for his remarkable ability to see what I saw in the quilts and photo-graph them "just so"; and Judy Lincoln, for her hard work and ability to handle the quilts with care and sensitivity;

Jim Bonar, whom I stuffed into small airplanes and put up on tall ladders to get some wonderful quilts in his camera lens;

Michaele Haynes, curator, and the Witte Museum for their generosity in allowing us to photograph the Herrera quilt;

Viola Moore, director, and the Carson County Square House Museum for hosting a search day and for other information regarding Elizabeth Priddy Fields;

Sandy Sandel, owner of A Stitch In Time Quilt Shop in Alpine, Texas, for hosting a search day and for her encouragement;

Sul Ross University, Alpine, Texas, for allowing us to photograph quilts there;

Gage Hotel, Marathon, Texas, for allowing us the use of their historic hotel for photography;

Frank Avent, for generously allowing us to photograph quilts on his ranch;

Texas State Archives and their generous help with historical photo-graphs; and all of the sharp-eyed women and men who knew about quilts and led me to them.

xix

store. This was the only quilt she ever made. Her story and the colors she chose stayed with me, but when I later tried to contact the owner to photograph the quilt, his number had changed; the quilt from Childress had escaped me.

From that point, I began documenting the quilts I came across. As I worked, I continued to look for that Log Cabin quilt—and its owner—without success. I took snapshots of quilts and brief notations, listing names of owners and contact information. I made a survey sheet for willing families to fill out and often interviewed others with a tape recorder. My information files grew, and my mind whirled with the richness of the legacy that was spread before me each time I unfolded a quilt and heard the stories from the families or owners.

Intrigued by a sketchy provenance or quirky detail of the quilter's family history, often I gathered only fragments of stories as if they, too, were pieces of quilts. Sometimes a bit of family lore stayed with me long after I examined a quilt.

And so I began selecting quilts for this book, working with Jim Lincoln to photograph them. All but three of the quilts in this book are held in the quilters' families. Only one is housed in a museum. Two others belong now to collectors. Therefore, most of the quilts may never be in an exhibition or be seen by an appreciative public audience or appear in any permanent or accessible record other than this book.

As I worked on the stories, I realized I needed to remind readers that this book is not intended as a biography of the quilters. Family stories, like quilts, can deteriorate if not preserved properly. And so the stories here are frayed in spots; some pieces are lost or forgotten or, to successive generations, seemed unimportant to the overall picture or pattern. Sometimes details of a quilter's story seemed too private, and I have listened to the wishes of families who've asked me not to print them. And like anyone who might read these stories, I have given myself permission to speculate and imagine the rest of the story. I hope my speculations serve a further purpose by encouraging others to collect and record family stories while those bits and pieces are still vibrant, before the colors and details fade. In this way, fewer stories would be lost, more of the legacy

saved. Although some of the quilts in these pages come with stories that are at times incomplete, in terms of art and artisanship the quilts themselves speak eloquently about those who made them.

This book showcases thirty-four quilts, only thirty-four quilts. They are examples of what Texas quilting was and is as a craft and a cultural narrative. The quilts are all Texas-made, spanning the state geographically and, in date, ranging from the 1870s to the turn of the twenty-first century. Most of the quilts cluster between 1930 and 1950—for good reason. This period saw a resurgence of quilt making. At a national level, seminal events like the Sears National Quilt Contest at the 1933 Chicago World's Fair helped to fuel quilt makers' interest.

In Texas, the quilting resurgence could be attributed in part to the Depression and to a cotton surplus that offered ample cheap supplies for aspiring quilters.

To select so few quilts out of the thousands I have seen was an incredibly difficult process. Each of these quilts in some pattern or fabric, in some element of the quilter, or in some aspect of the place or time span, shines as one facet of Texas culturally, spiritually, symbolically, ethnically, geographically, or historically. But there is something else each of these quilts possesses—its story.

What most influenced the choice of these thirty-four quilts was whether the quilt and its attendant story would enrich our Texas legacy. These quilts preserve in their being, in their narrative history

and their material history, some essence of Texas culture. This is what I saw in these particular quilts and what I wanted to save in photographs and the written word.

The journey I have made while discovering the quilts for this book has, in fact, become part of my own story. Who knows? Perhaps this book will fall into just the right hands and lead me back to the Log Cabin Quilt that inspired it!

Marcia Kaylakie
Austin, 2007

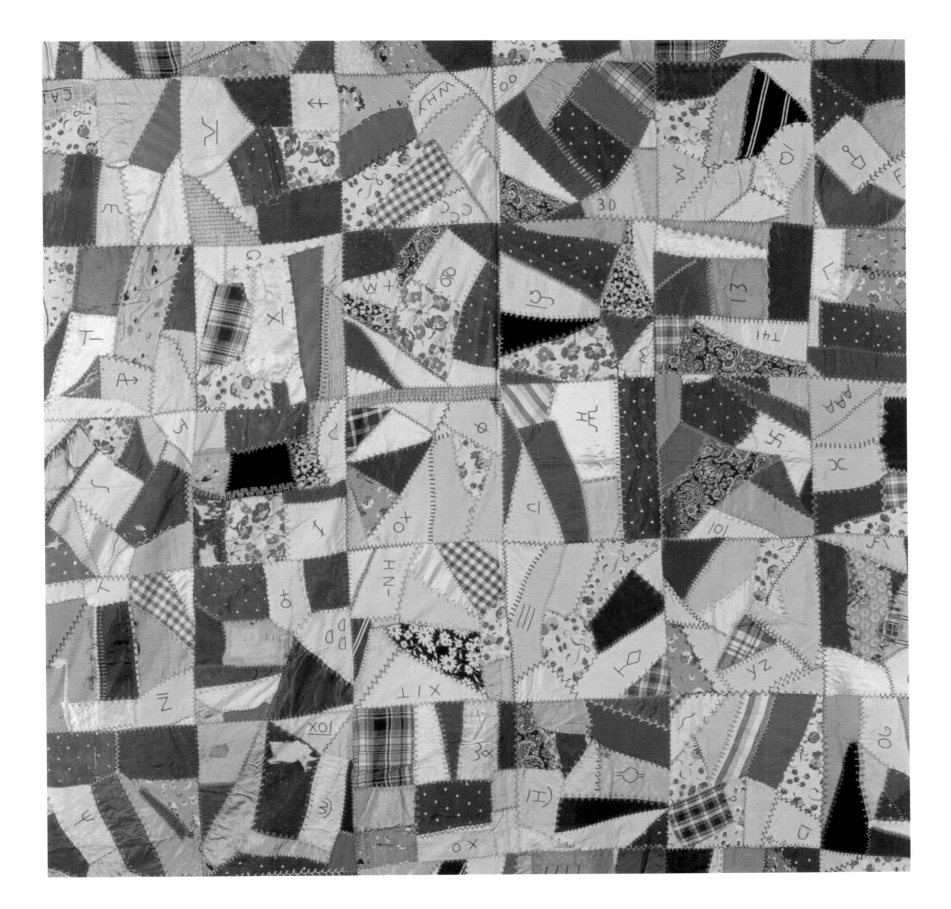

Part One

1860–1920

Long before the Civil War, quilting had been well established in Texas by early colonists. The open territory offered unlimited opportunities, and a wide range of ethnic groups settled here, the largest groups being German, Mexican, and Anglo-Americans. After the Civil War, the influx of new people brought even greater diversity to Texas, and the quilts in Part One reflect the varying influences of arriving settlers.

During these years, perhaps women felt both the influence of their Texas home and also that of an older heritage,

and these influences are reflected in their work, such as the Lone Star Quilt by Acker Lindsey and the Mexican Eagle Appliquéd Quilt by Maria Herrera.

Women made lives for themselves in parts of Texas as varied as their quilts. As the people became neighbors in a new land, they settled on farms, created towns, brought in churches and businesses, and built a community. The quilting bee became a popular way for women to gather, quilt, trade quilt patterns and pieces of fabric, and catch up on local news. While the quilts the women made, whether at the bee or individually, were mostly for bedcovers, they could also be made as commemorative pieces for marriages, births, and deaths, as well as tangible reminders of loved ones. Quilts had already taken on multiple values: they were reasons to gather and socialize; they were the utility items on a family's bed; and they were sentimental items that could be a reminder or a gift.

As the railroad system began to flourish in the 1870s, goods unavailable

during the Civil War at last began to flow into Texas and reached settlers and homesteaders near railhead towns like Abilene, Bellville, Houston, and San Antonio (where two quilters in this section lived in the Veramendi Palace as children—born fifty years apart).

As years passed, other towns sprung up wherever the railroad laid rails, and more quilters had the ability to purchase commercially made fabrics for their clothing and quilts. Emily Mayes, whose husband operated a mercantile, is a perfect example of a woman who had access to such fabric, and her Red and Green Double Irish Chain Quilt appears to have fabric purchased specifically for the quilt. But now all women could come to town to shop for fabrics shipped by rail. However, even though they were given the opportunity to purchase fabric, many women often combined scraps with the fabric they purchased, demonstrating ingenuity, practicality, and artistry to create quilts that kept their families warm and reflected their talents.

Besides the materials for quilting, women were also gaining access to ladies' magazines and often shared them with each other. Many quilt owners whom I interviewed talked about seeing their mothers, aunts, and friends exchanging magazines or tracing patterns from each other's collection of quilt blocks. Magazines like *Godey's Ladies Book, Hearth and Plow, Farm Journal, Ladies Home Journal, Modern Priscilla,* and *McCall's* all featured quilt patterns and articles about quilt making. No longer were quilt patterns shared in just a quilting bee or handed down among friends; now patterns were printed and disseminated. Quilt patterns were becoming standardized and fewer women relied on hand-drawn patterns, but even with these patterns, as this section showcases, women asserted their individuality and creativity in the selection of color, fabric, and quilting designs.

Turkey-red fabric and redwork also rose in popularity during the 1880s. Because of the discovery of a process that

made a vibrant, colorfast red dye, women could have, for the first time, stable red fabric for their quilts. Lillie Neuman's Red and White Irish Chain Quilt is an example. As the same dye process was also colorfast on cotton thread, women could now embroider with the new turkey-red thread on white or muslin fabric, without fear of bleeding. This technique, known as redwork, became quite popular. Sometimes women used redwork to embellish quilts with names, dates, or details, creating what are called friendship or fund-raiser quilts. One example is the Christian Endeavor Group Quilt.

In the late nineteenth century, Victorian style heavily influenced quilters' choices. Quilting changed radically as women created highly embellished pieces of needlework known as crazy quilts. These pieces of ornate needlework served two purposes: (1) showing off a woman's ability to "have a fine hand," and (2) displaying her husband's wealth because his wife had leisure time for needlework. Women created crazy quilts with the same fabrics that were in fashion—heavy silks, satins, and velvets—and heavily encrusted them with elaborate appliquéd and embroidered designs, as well as initials and dates of significance to the maker. Many crazy-quilt tops were completed, but never quilted. Others were backed and used as settee throws or piano covers. Finished or not, most were never meant to be bed coverings and were displayed in parlors instead. The crazy-quilt fad swept the nation in the 1870s, and Fidella McConnell's Lone Star Crazy Quilt is one with a Texas influence.

As the early part of the twentieth century began and the westward settlement of Texas continued with homesteading, women made practical quilts as well as quilts with special meaning. One influence that crept into the quilt motifs and into American reality was World War I. It is the focus of Annie Rushing Martin's quilt and appears in symbolic form in Rubye Hope's Friendship Quilt.

The war is an example of how women stitched whatever touched their lives into their quilts, whether through choice of color, pattern, or motif.

Quilt-making styles would begin to change in the 1920s as women began using lighter, brighter colors, as fabric dyes became more stable, and as goods became more readily available. Even in newly settled West Texas, where the utility quilt would remain the staple, hardworking farmers' wives created quilts of intricate design, color, and imagination.

Lone Star Quilt, c. 1870, 59" x 66", made by Acker Lindsey, owned by Linda Clynch.

Lone Star Quilt

c. 1870

Acker Lindsey

Florence, Williamson County

Shared by Linda Clynch

It is fitting to begin a book about Texas quilts with a Lone Star Quilt, especially a showpiece quilt like this one. And this, the earliest in dating of the quilts in the book, must have been entered in a contest or competition at a county fair because it came to its present owner, Linda Clynch, accompanied by a faded blue ribbon. Unfortunately, the ribbon's letters are no longer visible, and thus the story giving the specifics of what fair or exhibit is lost. But I can imagine the pride Acker Lindsey felt that moment when she

Detail of Acker Lindsey's Lone Star Quilt with diamond quilting and showing dye migration in brown fabrics.

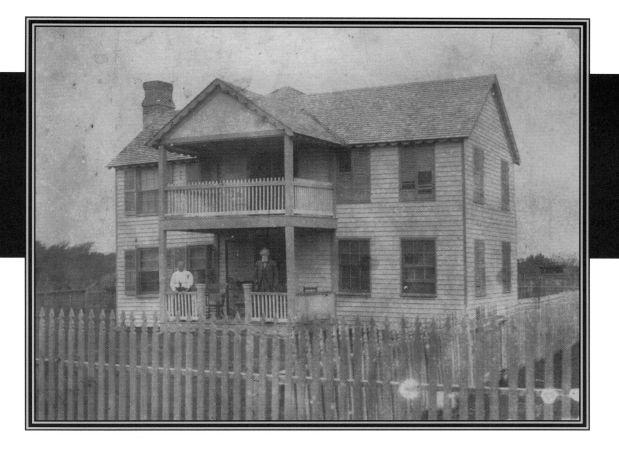

Thomas and Acker Lindsey standing on the porch of their house in Florence, Texas, c. 1900. Courtesy Linda Clynch, with permission.

saw the blue, first-place ribbon pinned to her quilt, a symbol acknowledging her skill as a quilter.

Not only is little known about the competition concerning the quilt, but little early family history exists about Acker Lindsey and her husband, Thomas, as well. What is known is that after the Civil War, they westered to central Texas to settle land near Florence, Texas, a town located in Williamson County, a few miles north of Austin, the state capital.

Originally settled in the early 1850s

and called Brooksville, the town changed its name to Florence in 1857. The town prospered through the turn of the century, and the railroad began service to Florence in 1912. From then until 1935, when rail service was suspended, area farmers and ranchers could find all the goods and services they needed in Florence, and quilters could find supplies.

Thomas and Acker lived in Florence the rest of their lives and worked hard, raising cotton and rearing their ten children. Living well into the Depression,

Acker Lindsey quilted most of her life, and her experiences are reflected in stories about her quilting. Great-granddaughter Linda Clynch recalls the family saying that Acker saved every scrap of material she could find, even threads she unraveled from feed sacks and old clothing, for every bit of fabric was important to her.

As far as the family can recall, sometime in the late 1870s, Acker hand pieced her masterpiece quilt. Made from a classic Lone Star pattern also known as the

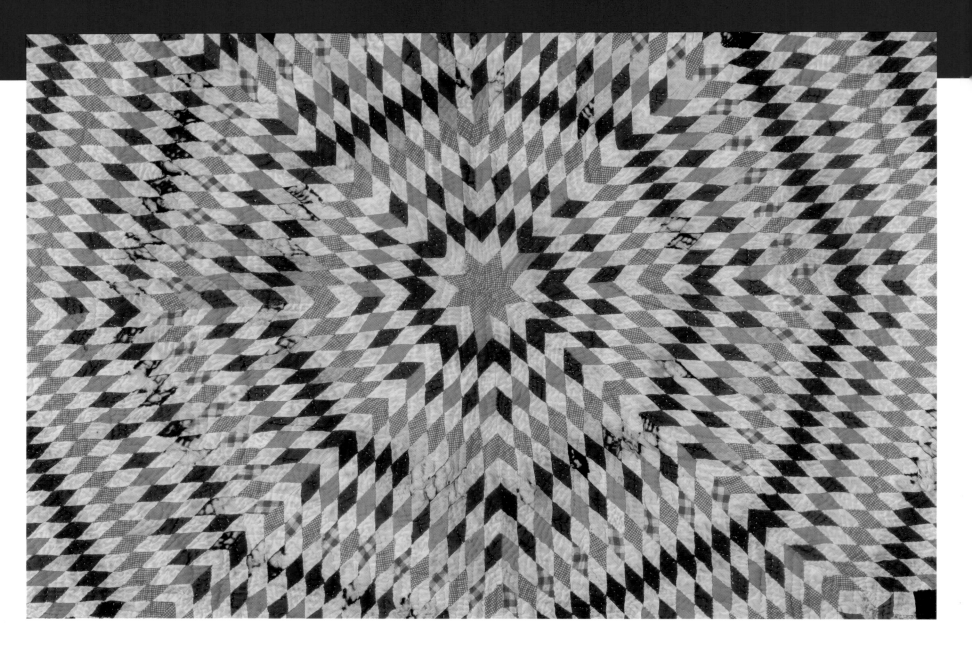

Detail of center of Lindsey's Lone Star Quilt.

Close-up of quilting pattern of Star of LeMoyne block in Acker Lindsey's Lone Star Quilt.

Star of Bethlehem, the quilt measures 59"x 66". Although a very common pattern for the period, this quilt showcases Acker's skill in the fine work required to match the points of the many tiny pieces that form the star at the quilt's center. Each diamond measures just one and a half inches in length and three-quarters of an inch in width. The central star shows a planned piece of work, with Acker's own plotting of color in the con-centric rings of blue, orange, brown, and red checks interspersed with muslin. As an added element of complexity, Acker also incorporated scraps from the main part of the quilt for the small (2 3/4" x 2 3/4") Star of LeMoyne blocks that alternate with the solid blocks in indigo to create the background of the quilt. Acker hand quilted her Lone Star Quilt in a double-rodded overall fan pattern.

Acker Lindsey's Lone Star Quilt is an example of one quilter's artistry in a world filled with children and the hard work that comes with being a cotton farmer's wife. A model of precise design and workmanship, this competition winner's faded blue ribbon, if its letters could still be read, would attest to how fine a standard of Texas quilt making it must have set in Williamson County.

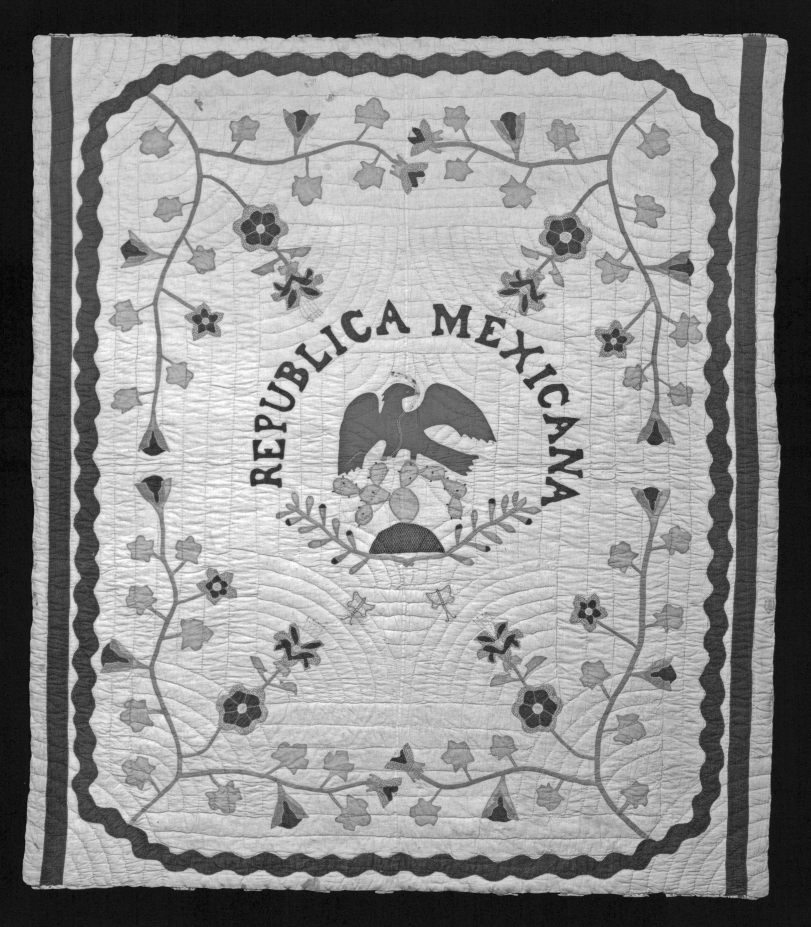

Appliquéd Mexican Eagle Quilt, c. 1870, 69" x 82", made by Maria Antonia Ruiz Herrera. In the collection of the Witte Museum, San Antonio, Texas, with permission.

Appliquéd Mexican Eagle Quilt

c. 1870

Maria Antonia Ruiz Herrera

San Antonio, Bexar County

Shared by the Witte Museum,

Michaele Haynes, curator

Heritage and place blend in Maria Antonia Ruiz Herrera's quilt. It is interesting to discover that although her family was resolute in their support of Texas during its struggle for independence and for the Republic of Texas, in her later years Maria created this quilt depicting symbols not of Texas but of Mexico.

Maria Antonia Ruiz was born in San Antonio in 1809 to General José Francisco Ruiz and Josefa Ruiz, four years before the city would side with the forces fighting for Mexican independence from Spain.

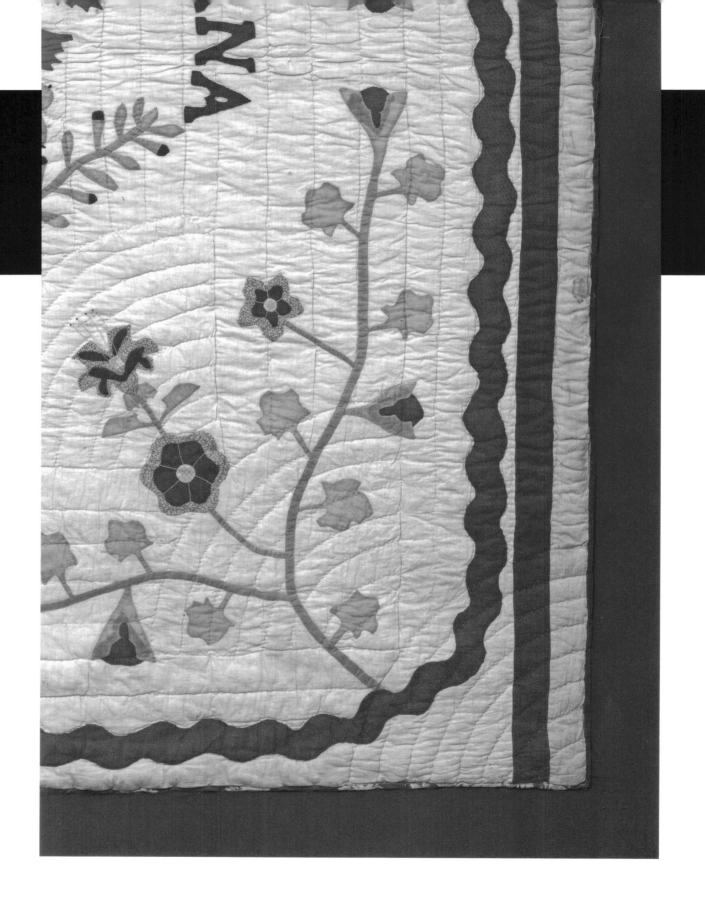

Detail of Appliquéd Mexican Eagle Quilt showing floral appliqué and fading of colors.

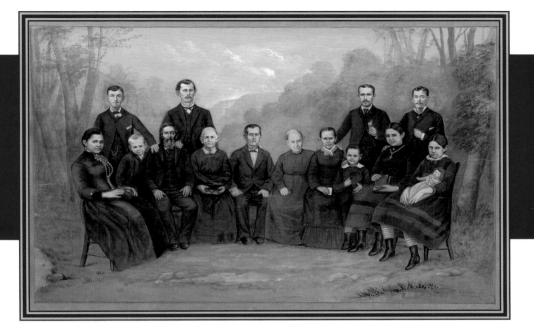

Family photo of Herrera family, c. 1875. Maria is believed to be the oldest woman, seated fourth from the left. Courtesy the Witte Museum, with permission.

Maria was raised in San Antonio, a town that was becoming a hub for settlers moving westward. After the Civil War, the city expanded rapidly with many separate ethnic cultures; Hispanic, German, and Southern Anglo-Americans comprised the largest portion of the population, although many other ethnic groups also settled in the area.

As Maria grew up, she lived in a large house built in the mid-1700s by Fernando Veramendi, a successful merchant in San Antonio, whose son was father-in-law to Jim Bowie, one of the heroes of the Alamo. The residence along Soledad Street was so magnificent that it soon became known as Veramendi Palace. In 1828, nineteen-year-old Maria married her childhood sweetheart, Blas Maria Herrera, who later became a courier and scout in the war. Herrera, often called the Paul Revere of the Texas Revolution, earned that name for his role in warning of General Santa Anna's advance on the city of San Antonio. All of her life, Maria lived in a family involved in the struggle for Texas's independence, for her father played an important role in quelling Indian resistance and was one of sixty-one men to sign the Texas Declaration of Independence in 1836. After their marriage, Blas and Maria settled in an area of southern Bexar County that is today called Somerset and had ten children. Not much more is known about Maria Antonia Ruiz Herrera except that she died in 1887.

The Appliquéd Mexican Eagle Quilt measures 69" x 82" and is hand appliquéd with symbols of the Republic of Mexico. The central motif, an eagle with wings spread wide, is appliquéd in solid brown cotton fabric and sits atop a nopal (cactus) made from solid green cotton. The

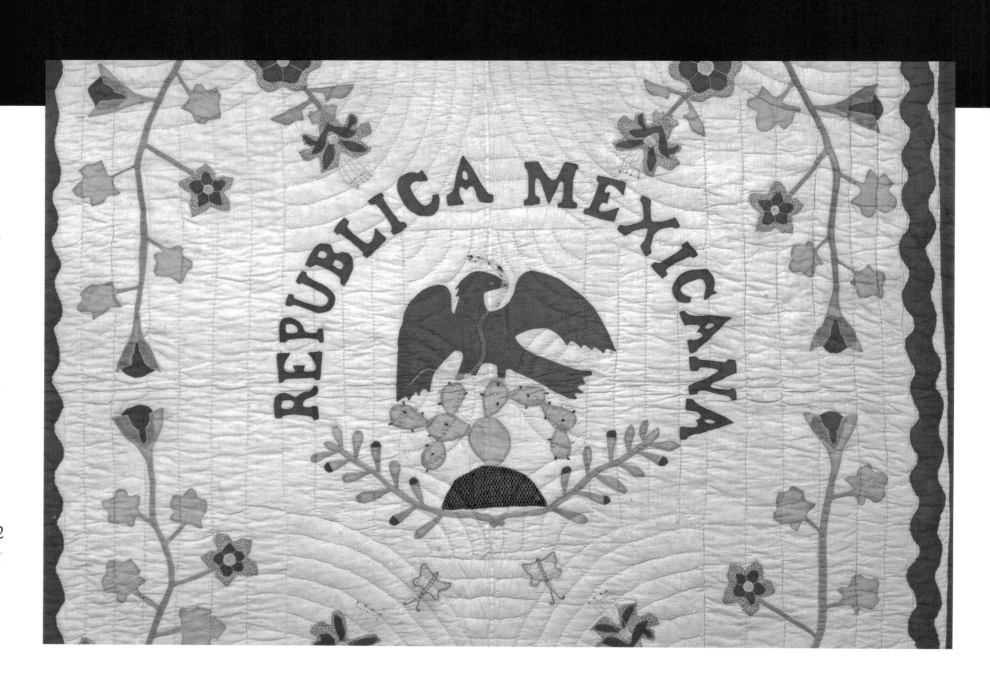

REPUBLICA MEXICANA

Detail of Appliquéd Mexican Eagle Quilt's central motif of an eagle with
a snake in its mouth with whimsical yellow butterflies below.

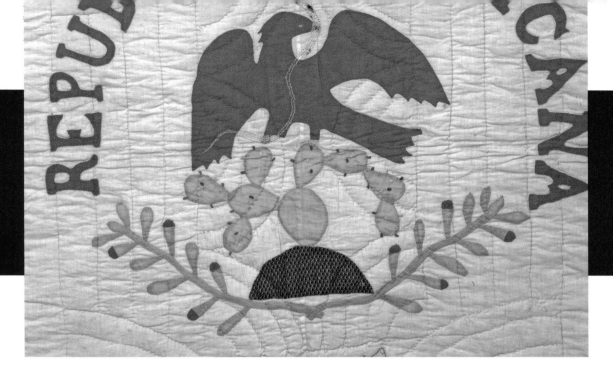

eagle has an appliquéd snake in its mouth, and although most of the snake fabric is missing from the appliqué, the embroidery details of the snake's head and tongue still show clearly. Curving over the appliquéd eagle are the words "Republica Mexicana" in solid red cotton fabric. Both the appliqués and the lettering have outline embroidery with added chain stitching on the letters. Flower and leaf appliqués in red and green surround the central motif even though, through time, the solid green cotton fabric has faded to tan. Adding a whimsical touch to the lower part of the central motif, Maria appliquéd two yellow butterflies hovering over the flowers. The quilt also has two appliquéd outer borders; the inner border is irregularly wavy, and the two side borders are straight. Backed in bright red floral cotton fabric with a repeat, the backing appears to be twentieth-century fabric, matching the quilting, which seems to have been done later than the original quilt top. The straight and curved lines of the quilting design create a frame effect on the quilt, focusing on the central motif of the eagle appliqué.

This quilt is housed at the Witte Museum in San Antonio, a town rich in cultural heritage. This woman who had seen three flags fly over her home in San Antonio and who had seen both her father and her husband support the struggle for Texas independence decided, at age seventy-one, to make this quilt with Mexican images. The cactus grew in her garden, the rich colors surrounded her, and her imagination sparked. Perhaps these images called to her, and she took up her needle to stitch this tribute to her Mexican heritage and that long-ago resistance in her birth-town, San Antonio, as it struggled against Spain for independence.

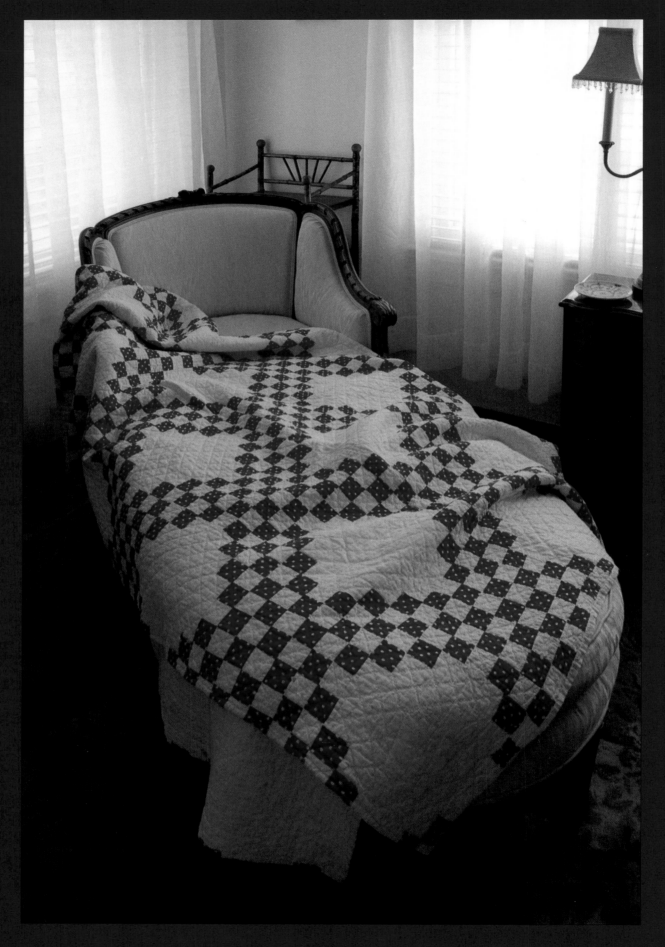

Red and White Irish Chain Quilt on chaise at home of Celia Gibbs, Uvalde, Texas.
Photograph by Jim Bonar; with permission.

Red and White Irish Chain Quilt

1886

Lillie Elizabeth Parsons Neuman

Yancey, Medina County

Shared by Kay Brieden

A girl born in a palace grows up, marries in her teens, survives a terrible flood, and leaves mysterious footprints behind. A story with such details sounds like a fairy tale or romance novel. However, that is the story of Lillie Elizabeth Parsons Neuman and her quilt.

A chance telephone call to the Uvalde Chamber of Commerce while I was driving west to work in Alpine, Texas, brought me to this quilt originally from Yancey, Texas. I planned to stop in Uvalde for lunch and had spoken earlier

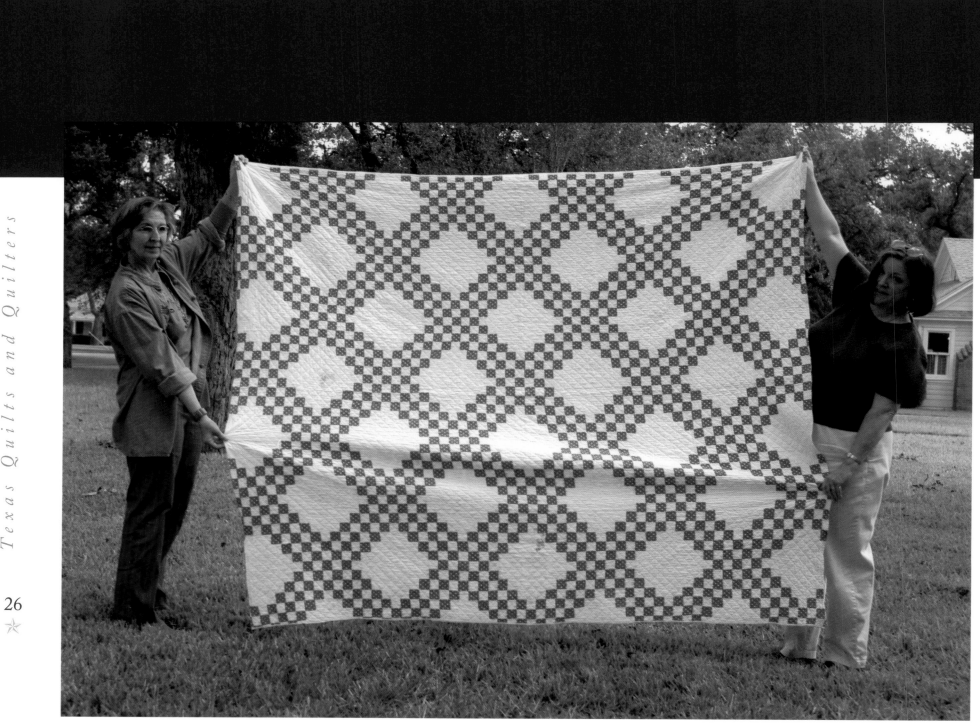

Red and White Irish Chain Quilt, 1886, 72" x 90" made by Lillie Elizabeth Parsons Neuman, owned by Leslie Brieden.
Photograph by Jim Bonar; with permission.

Detail showing date on Red and White Irish Chain Quilt and outline of baby's footprints. Photograph by Jim Bonar; with permission.

to Barbara Woodman of the Piecemakers Quilt Guild of Uvalde, who offered to send out a general e-mail to the guild, inviting members to bring me their quilts and quilt stories. To my delight, Kay Brieden responded with her beautiful Red and White Irish Chain Quilt and shared the story of Lillie Elizabeth Parsons, a story that began in San Antonio.

Lillie was born on March 25, 1863, in the Veramendi Palace on Soledad Street. In her teens, she met and fell in love with Fred Neuman, a German immigrant who worked at the palace as a gunsmith. On her seventeenth birthday, they married, and as a young couple, they moved to a new home on Hondo Creek near present-day Yancey. Located in Medina County, the town was named for the sons of the men who owned the town site land, Yancey Kilgore and Yancey Strait. Most of the inhabitants were of German descent, and most made their living from the land.

When Fred and Lillie Neuman relocated to the area around Yancey, one of the possessions the young couple took with them was a turkey-red and white quilt top that Lillie had pieced while in San Antonio. The borderless quilt top that measured 72" x 90" was made of only two fabrics, a red-and-white polka-dot cotton and a solid white cotton. They kept the quilt top in a trunk that also carried clothing and family items. The same year they moved, the great Hondo River flood came swirling down on them and their neighbors, and people had to climb high into trees to escape the rushing brown waters. In the aftermath of the floodwaters, Lillie discovered that the

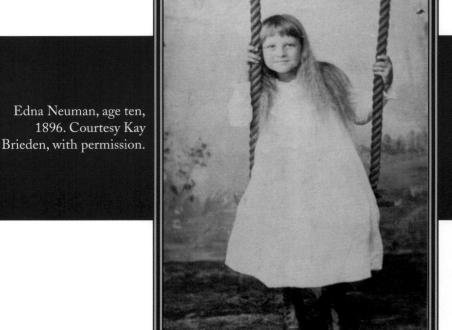

Edna Neuman, age ten, 1896. Courtesy Kay Brieden, with permission.

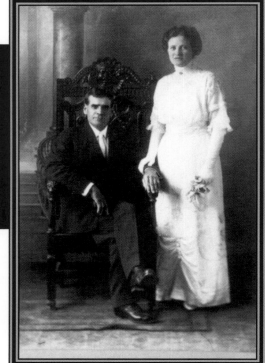

Edna and George Faseler on their wedding day, December 3, 1913. Courtesy Kay Brieden, with permission.

quilt top was badly stained by dyes that had bled from an overcoat, but because turkey red dye is indelible, she was able to boil the quilt top several times to remove the dye stains without diminishing the quilt top's original vibrancy. When their first daughter, Edna Laura Emilia, was born on November 29, 1886, Lillie completed the quilting in a cross-hatch pattern, embroidering on the back in red floss the year 1886 and something special in one corner: a quilted outline of little Edna's footprints.

Generation by generation, the quilt passed down through the family to its current owner, Lillie's great-grandson, Leslie Brieden. But it was Leslie's wife, Kay, who found a tiny treasure among Edna's effects after her death in 1987. "I was cleaning out the bureau in the bedroom and came across an old eyeglasses case in the drawer. When I opened it, I found a pair of Bausch and Lomb wire-rim glasses and two tiny footprint templates of cardboard. When I laid the templates over the footprints on the quilt,

they matched exactly!" With her words Lillie's story seemed to have a perfect end, as if Kay had closed the embossed cover on a leather-bound storybook.

Yet the chapters continued to write themselves. Lillie's daughter Edna, the little girl of the footprints, started her own stories as she grew up and married. Perhaps she understood how important the story would be, for she was the one who preserved the history of the Red and White Irish Chain Quilt.

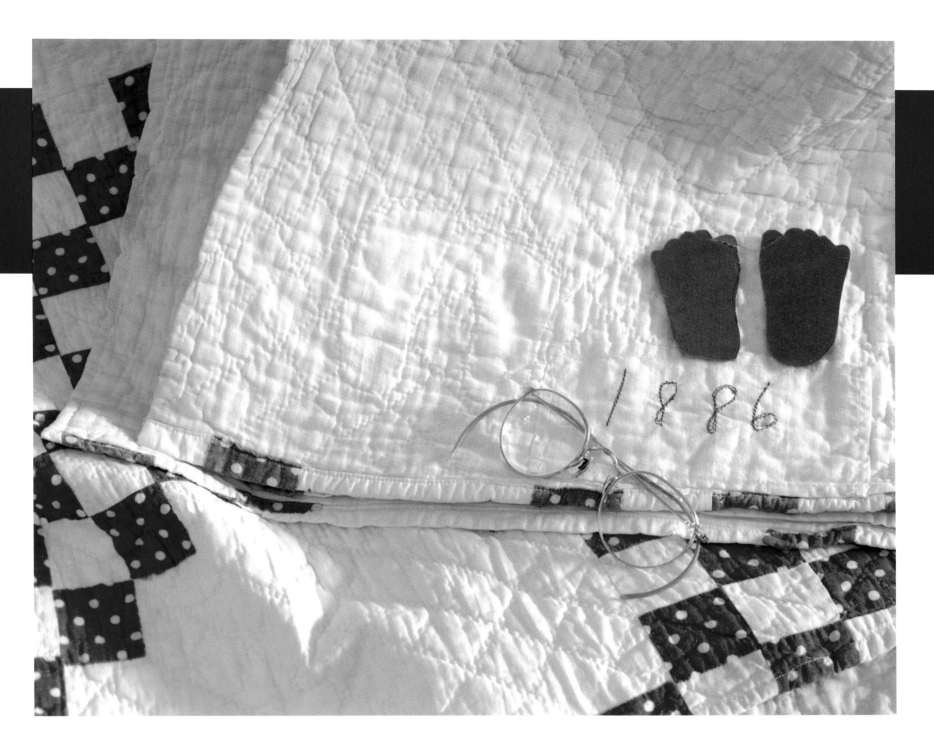

Detail of Red and White Irish Chain Quilt with foot templates and glasses.
Photograph by Jim Bonar; with permission.

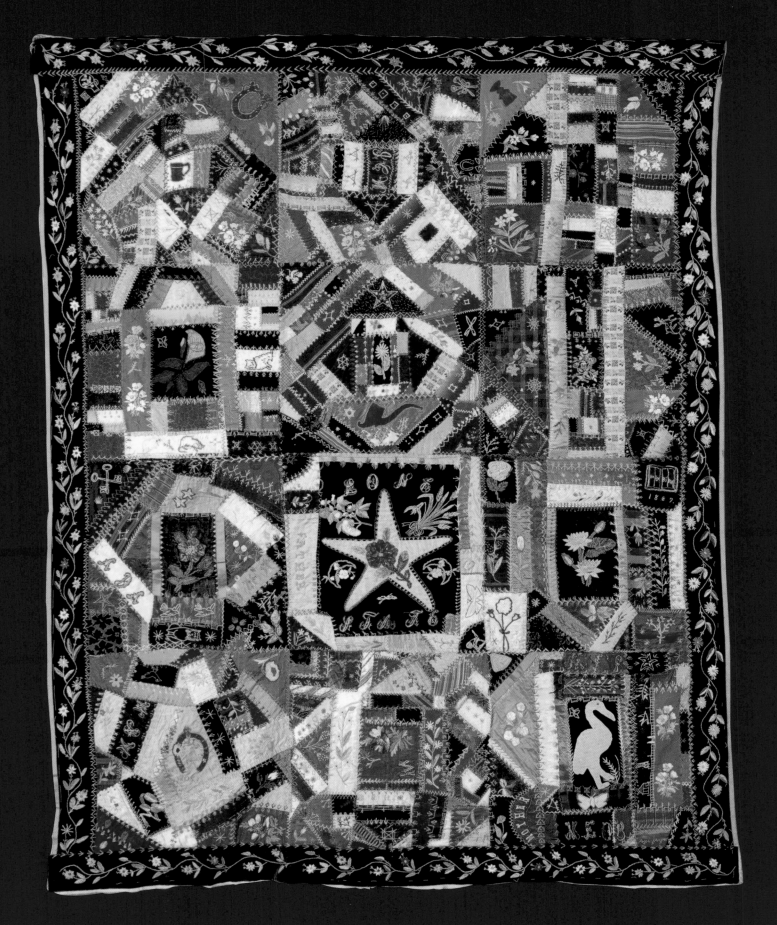

Lone Star State Crazy Quilt Top, 1887, 61 1/2" x 80", attributed to Fidella McConnell, owned by Alice Walton.

Lone Star State Crazy Quilt Top

1887

Fidella McConnell

Raccoon Bend, Austin County

Shared by Alice Walton

Like some long-lost buried treasure, this Texas-inspired crazy-quilt top lay hidden for seventy years until discovered in a trunk in the attic of Alice Walton's father-in-law, William B. Walton. The word *treasure* connotes many things that, indeed, this quilt fulfills: silver, gold, jewels—the colors, the stitchery, the exotic richness. More than these descriptors, the notion of treasure brings to mind the concept of luxury. Here in its flourishes and fancy needlework, this crazy-quilt top suggests the leisure time Fidella

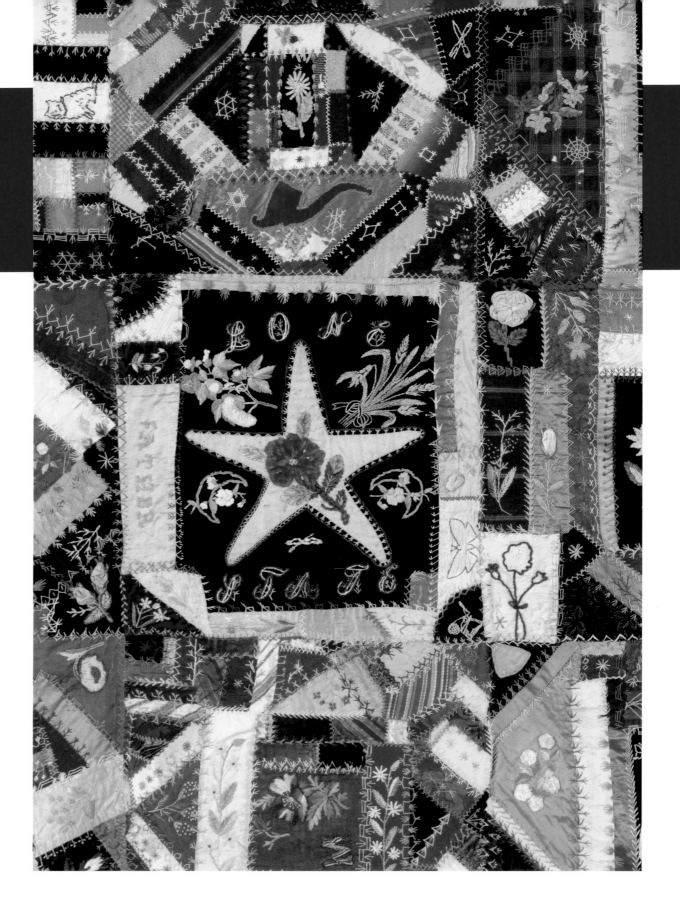

Detail of Lone Star quilt showing "Lone Star State" in center block with chenille-worked rose.

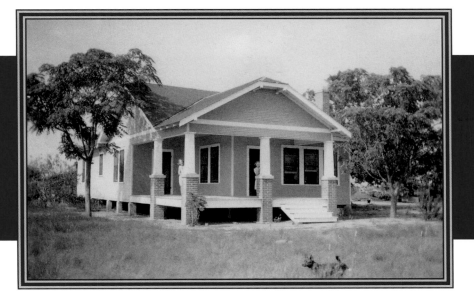

Walton farmhouse where quilt was found,
Raccoon Bend, now Bellville, Texas.
Courtesy Alice Walton, with permission.

McConnell enjoyed because of her family's prosperity.

Beyond Fidella's birth in Raccoon Bend, Texas, July 3, 1856, few details of her life—not even a photograph—survive. But Fidella, known as Della, did leave several letters written to her intended, Edward McGill "Gill" Walton, also from Raccoon Bend. It is clear that Della traveled, because several of her letters are written from Ennis and Mt. Calm. Moreover, in August 1886, longing to return to Gill, she writes from Ennis, "Pa does not want me to return again to the Bend, but I will be compelled to, but he says I must fix up and return to make Northern Texas my home."

When they corresponded, Della and Gill often used their pet names of "Sunshine" and "Shadow," and in one letter to Gill dated August 9, 1886, Fidella describes herself as a "white-haired girl." Both the choice of pet names and Della's description of herself at thirty show her playfulness, but Della expresses herself more than one way in her letters to Gill. In one she upbraids him with a swear word for neglecting her, putting dashes in for part of the word. In just a few brief written phrases, Della shows a high-spiritedness that parallels the embellished crazy quilt she created.

Fidella did return to the Bend by 1887, and she married Gill on January 4, 1888. Less than five miles away was Bellville, a prosperous railhead town for the Gulf, Colorado, and Santa Fe Railroad. With already more than five mercantiles by 1887, Bellville offered ample opportunity to find sewing notions and fabrics, including silks, satins, and velvets.

The top of Della's quilt incorporates the names and initials of several family members as well as popular sentiments of the day. Measuring 61 1/2" x 80", the quilt has twelve blocks and is heavily embellished with a variety of techniques, including embroidery, appliqué, three-dimensional appliqué, and chenille work. The center block of the quilt top bears

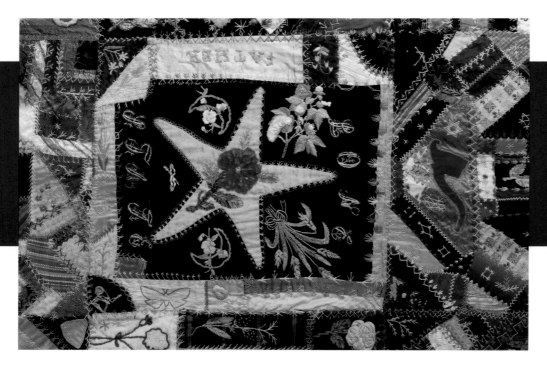

Detail of Lone Star State Crazy Quilt showing wheat and cotton
plants around the star and rose.

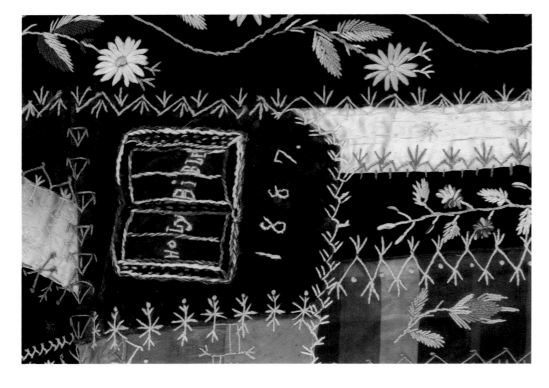

Detail of Lone Star State Crazy Quilt showing Bible and 1887 date.

the words "LONE" and "STATE" sepa-
rated by a three-dimensional red-chenille
rose framed within a five-pointed star
outline. Della also added other images of
nature as she embroidered both cotton
and wheat flowers and other plants in the
center block. As with most quilters of the
time, Della embellished her quilt with
various appliquéd symbolic images: the
large stork figure for fertility, the knife
and fork for prosperity, and the horseshoe
for luck. The quilt is made with velvets,
silks, satins, ribbons, and chenille
embroidery and is foundation pieced to
muslin. The outer borders of black velvet
are decorated with flowers and leaves in
crewel embroidery. The year 1887
appears twice on the quilt, embroidered

once inside the horseshoe and again below the Bible. Family members believe it might be the year Della finished the quilt top.

Like many needleworkers of her day, Fidella created a crazy quilt that became a canvas to show off rich fabrics, exquisite needlework, and elaborate ornamentation so favored by the Victorians. But Fidella showed us more. In her letters, Fidella revealed insight into herself. Similarly, through the symbols, the fabrics, and the stitches she chose for this Victorian quilt, Fidella reveals her artistry and her independent Texas spirit.

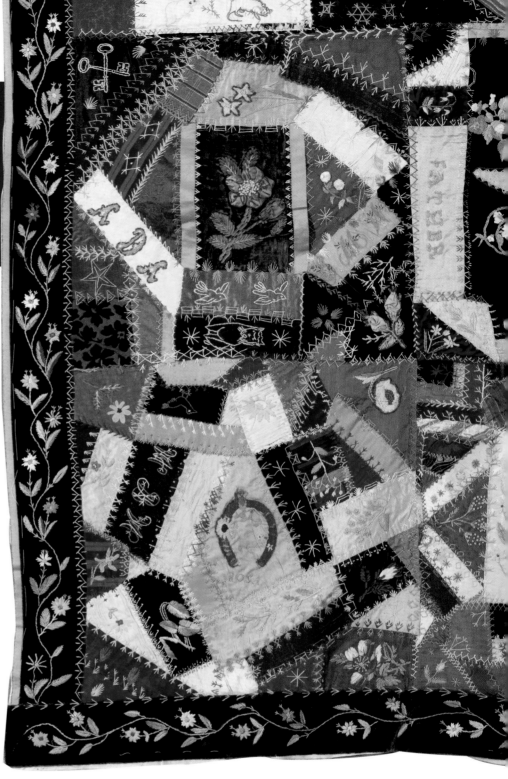

Detail of Lone Star State Crazy Quilt with crewel embroidery in border and horseshoe symbol on quilt.

Lone Star State Crazy Quilt Top, 1887

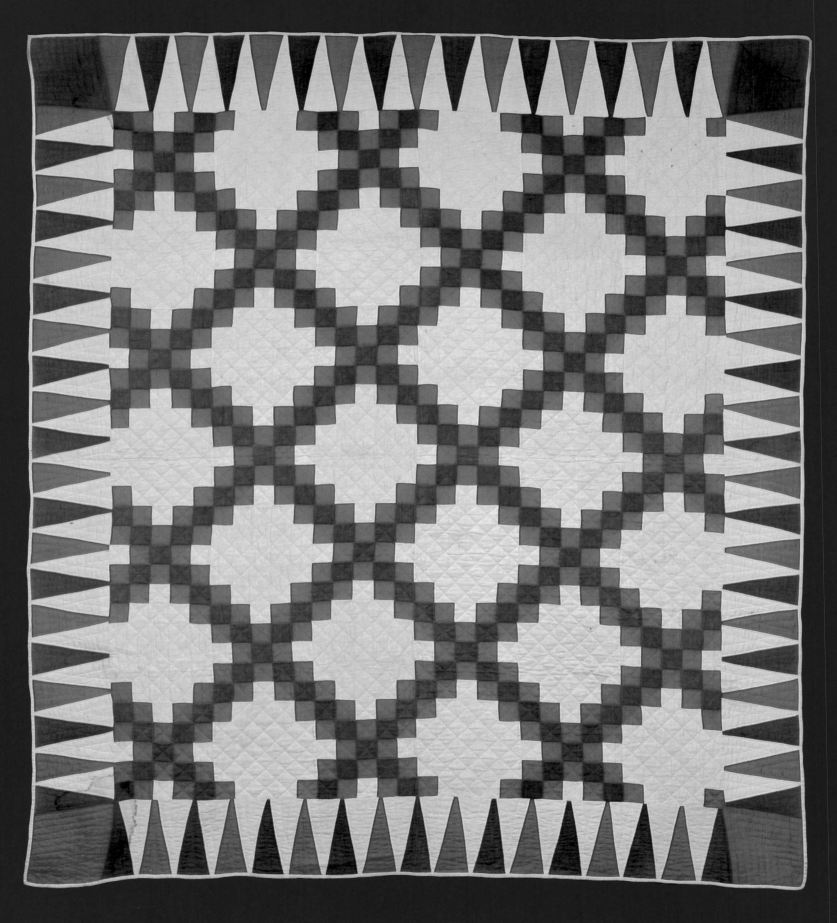

Red and Green Double Irish Chain Quilt, c. 1885, 72" x 85", made by
Emily Holt Mayes, owned by Charlotte Gres.

Red and Green Double Irish Chain Quilt

c. 1885

Emily Holt Mayes

Valley Spring, Llano County

Shared by Charlotte Gres

The years after the Civil War were difficult for most Americans, whether from the North or the South. Many men had fought in the terrible war and had come home with wounds and memories of battle. Women on both sides faced the loss of husbands, fathers, and sons—men who did not return. Southern families often had to pick up the pieces of their lives and start again, physically and economically, and Emily Holt Mayes's Red and Green Double Irish Chain Quilt stands as an example of one family's attempt to do just that.

Detail of Red and Green Double Irish Chain Quilt and dogtooth border.
The changes in fabric caused by fugitive green dye also can be seen.

Emily Holt Mayes, c. 1920.
Courtesy Judith DeBerry, with permission.

Emily Elizabeth Holt was born August 27, 1836, in Georgia. She met and married Louis Monroe Mayes in 1852, and moved to Lawrence County, Alabama. When the Civil War began, Louis went to war as a lieutenant in the Confederate Army, and he was one of the fortunate men who returned safely; however, Louis and Emily soon realized their fortunes no longer lay in Alabama. Seeing so many other families leaving the Deep South for Texas to escape poverty and debt, the Holts decided to join the migration.

They started their new life in Valley Spring, Texas, a small town located in northwestern Llano County. Originally settled by the Phillips family in the mid-1850s, the area was known as Phillips Ranch. Along with other migrating families settling in the area, newcomers Emily and Louis Mayes secured some ranchland. Louis also started thinking of another plan for success. In 1878 he opened a mercantile in Valley Spring, offering various goods and services to the growing community. A savvy businessman, Louis had promotional cards printed on boxes of thread. Those cards showed drawings of little girls on the front and his name and store address on the back. As the wife of a mercantile owner, Emily was more fortunate than many quilters of the time, having first access to store-bought notions, goods, and fabrics for her work.

For her Red and Green Double Irish Chain Quilt, one of the most popular patterns from the 1880s, Emily used only three fabrics, a turkey-red solid cotton fabric, deep-green solid cotton, and cream-colored muslin. Her choices suggest that she selected the fabrics specifically for the purpose of making the quilt. Although the instability of the deep-green dye in the cotton has caused the fabric to fade to a grayish brown over time, the original color can still be seen in certain areas of the quilt. The quilt measures 72" x 85" and has forty-two alternating Irish Chain blocks measuring 9 1/2" x 9 1/2" with an eight-inch-deep dog-tooth border around the outer edge of the quilt.

The quilt itself can stand as a symbol for Emily and Louis's life. They, too, had to put the pieces together and start over as they left their home in Alabama and moved to Texas. Like putting squares end to end, they made a new home in a new town. Louis started a business, and his advertising showed he was creative and enterprising. There are no "bells and whistles" in Emily's quilt. It is straight-forward and simple, just like the plan she and Louis had as they made their way. Step by step, Louis and Emily pieced a prosperous new life for themselves, and this quilt is an appropriate picture of their fresh start in Texas.

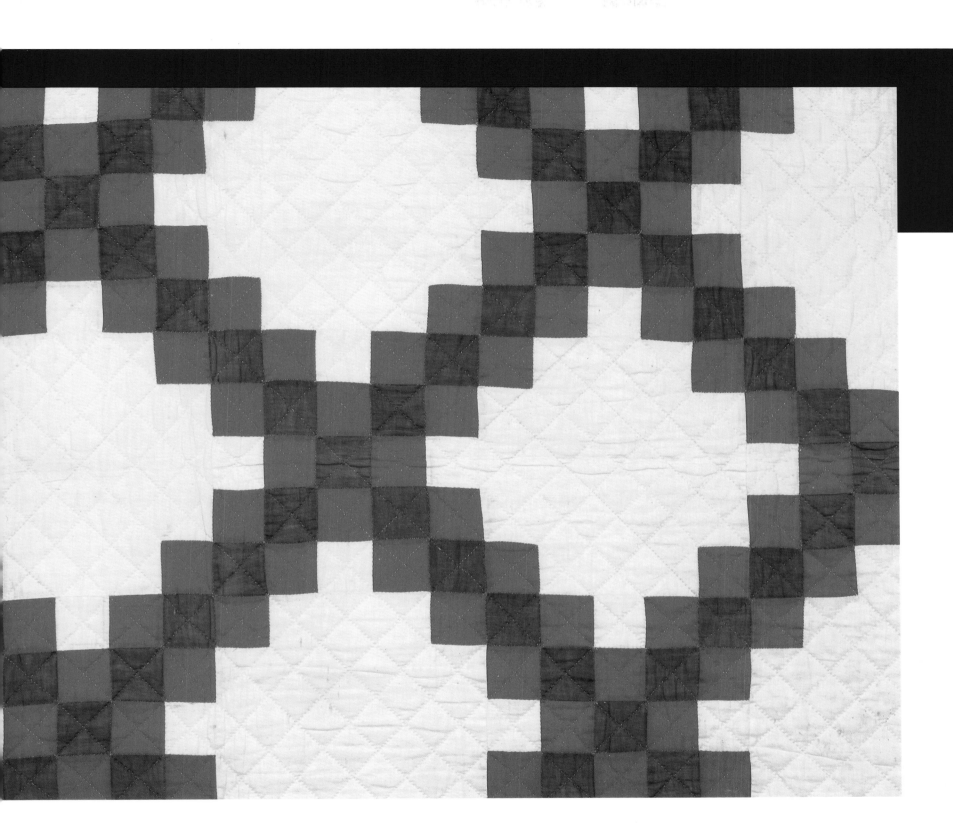

Detail of Red and Green Double Irish Chain Quilt. Note evenness in fugitive-dye color changes.

Red and Green Double Irish Chain Quilt, c. 1885

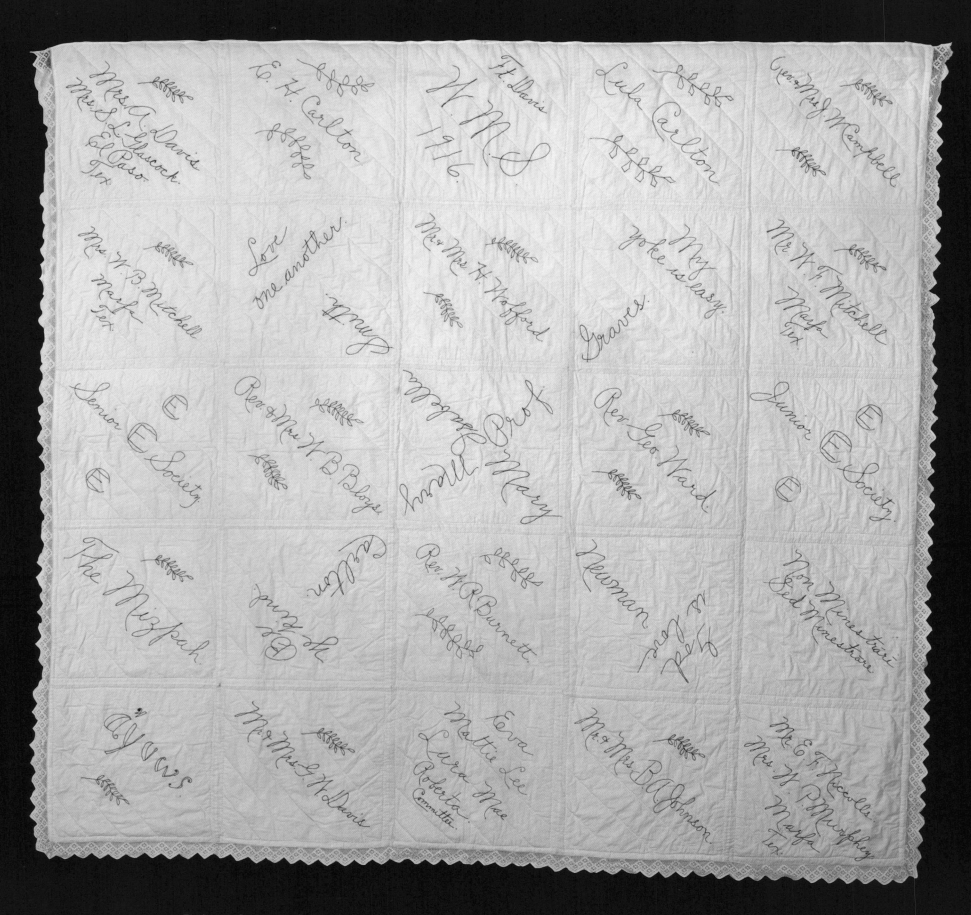

Redwork Signature Quilt, 1916, 60" x 60", made by members of the Christian Endeavor Group of Fort Davis, owned by the First Presbyterian Church of Fort Davis.

Redwork Signature Quilt
1916

Christian Endeavor Group

Fort Davis, Jeff Davis County

Shared by Vivian Grubb

Even today, churches hold potluck suppers, fall festivals, cake walks, and raffles as fund-raisers to support the church or fund a church program. Churches were not so different in the early 1900s. This Redwork Signature Quilt was part of a church fund-raiser of the early 1900s and a testament to how women of the church gathered together and made a quilt, accepting donations for their skill. For a small sum, perhaps ten cents, a person had his or her name embroidered on a square, and the money went to a good cause.

44

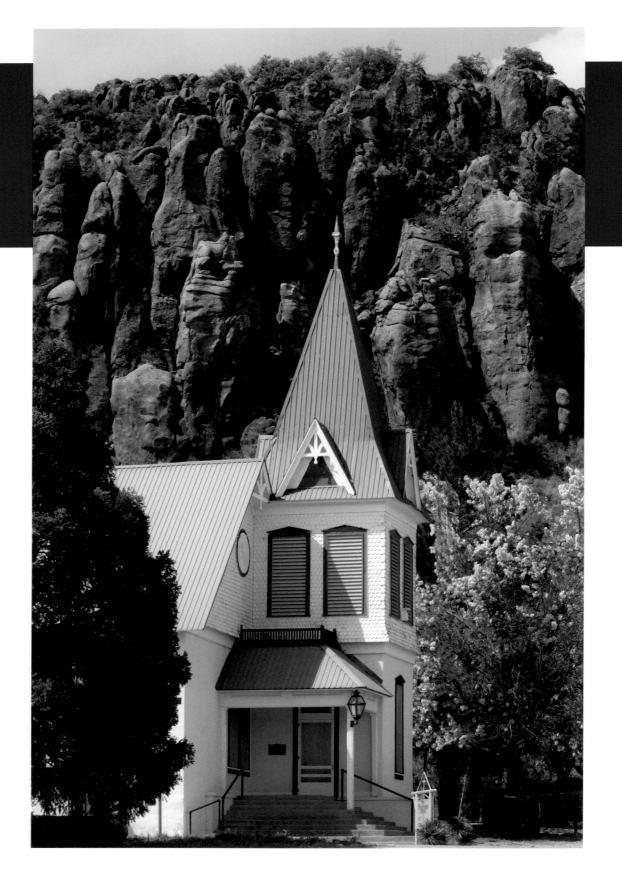

First Presbyterian Church of Fort Davis, Texas, 2005, with Davis Mountains in background.

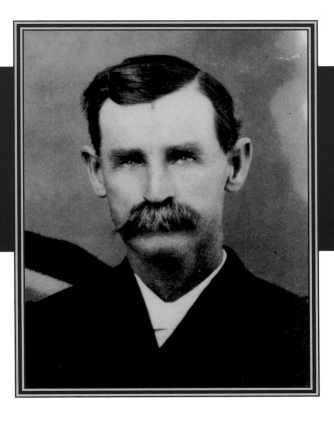

Reverend William B. Bloys, minister of First Presbyterian Church of Fort Davis, Texas, c. 1915. Courtesy Vivian Grubb, with permission.

The quilt was made in 1916 by the ladies of the Christian Endeavor Group in Fort Davis, Texas. Originally a military outpost that was unoccupied during the Civil War, the fort was reoccupied by troops from the Ninth U.S. Cavalry in 1867. The town that had grown up around the post took the name as its own and in 1887 became the county seat of Jeff Davis County. Part of the town's growth included churches, one of which was the First Presbyterian Church of Fort Davis, established in 1888. Reverend William Benjamin Bloys, its pastor, was known as the "cowboy preacher" because he often traveled on horseback to visit ranchers at their homes. By 1890, he was instrumental in holding the first camp meeting in the Davis Mountains, a time when ranch families who lived far apart could come together, regardless of denomination, for Bible study, prayer, and socialization. Reverend Bloys held these meetings every year, and they continue even today at the encampment in the Davis Mountains.

Reverend Bloys's camp meetings were nondenominational, as was the local Christian Endeavor movement, established in 1911 at the First Presbyterian Church of Fort Davis, following a national wave of evangelization for this youth-focused organization. Originally started in Portland, Maine, Christian Endeavor began with the purpose of interesting young people in the church. Within six years the movement spanned the country and became international in scope. One of the projects completed by

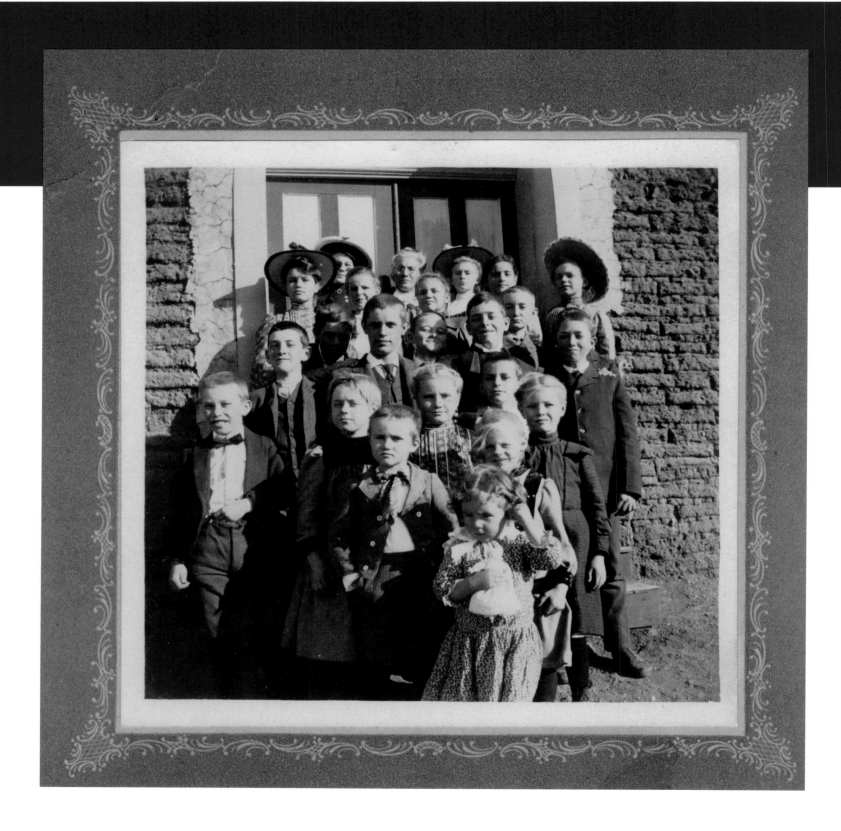

Group photo of Christian Endeavor Association, 1911. Mrs. Bloys is second from left on the back row, not wearing a hat.
Courtesy Vivian Grubb, with permission.

the Fort Davis Christian Endeavor group was the quilt featured here.

This redwork quilt is embroidered with names, some almost a century old, of local group members, church members, and the four circuit-riding ministers from the Fort Davis area: Reverend George Ward, the Methodist minister; Reverend W. R. Burnett, the Disciples of Christ minister; Reverend J. W. Campbell, the Baptist minister; and Reverend W. B. Bloys, the Presbyterian minister. The quilt measures 60" x 60" and is composed of twenty-five squares, each measuring 10" x 10". It has an unusual feature not common to either signature or redwork quilts: four names

of donors cross the center blocks of the quilt, and religious sentiments are placed diagonally at the ends of the outer blocks. The women making the quilt obviously planned this design to emphasize the sense of community in Fort Davis, embroidering the names in this pattern after the quilt top was complete. Additionally, the redwork appears in olive branches on many of the quilt blocks. This element seems appropriate to symbolize the joining of the different denominations, extending olive branches, an acknowledgment of a joint effort in this attempt to bring young people to Christianity. The quilt is hand quilted in an overall pattern of diagonal lines one

and a half inches apart, and it has a one-and-a-half-inch border of handmade lace.

This quilt stands as a symbol itself of the Christian Endeavor Group because it celebrates the ministers of four different Christian faiths who worked to bring services and prayers to the cowboys and townspeople of Fort Davis and the range beyond. These are the men who themselves endeavored to bring the word of God to the people of Fort Davis and the surrounding Davis Mountains. Both the women who made the quilt and the men who preached the gospel used their talents to serve.

Redwork Signature Quilt shown on porch railing
of former church rectory.

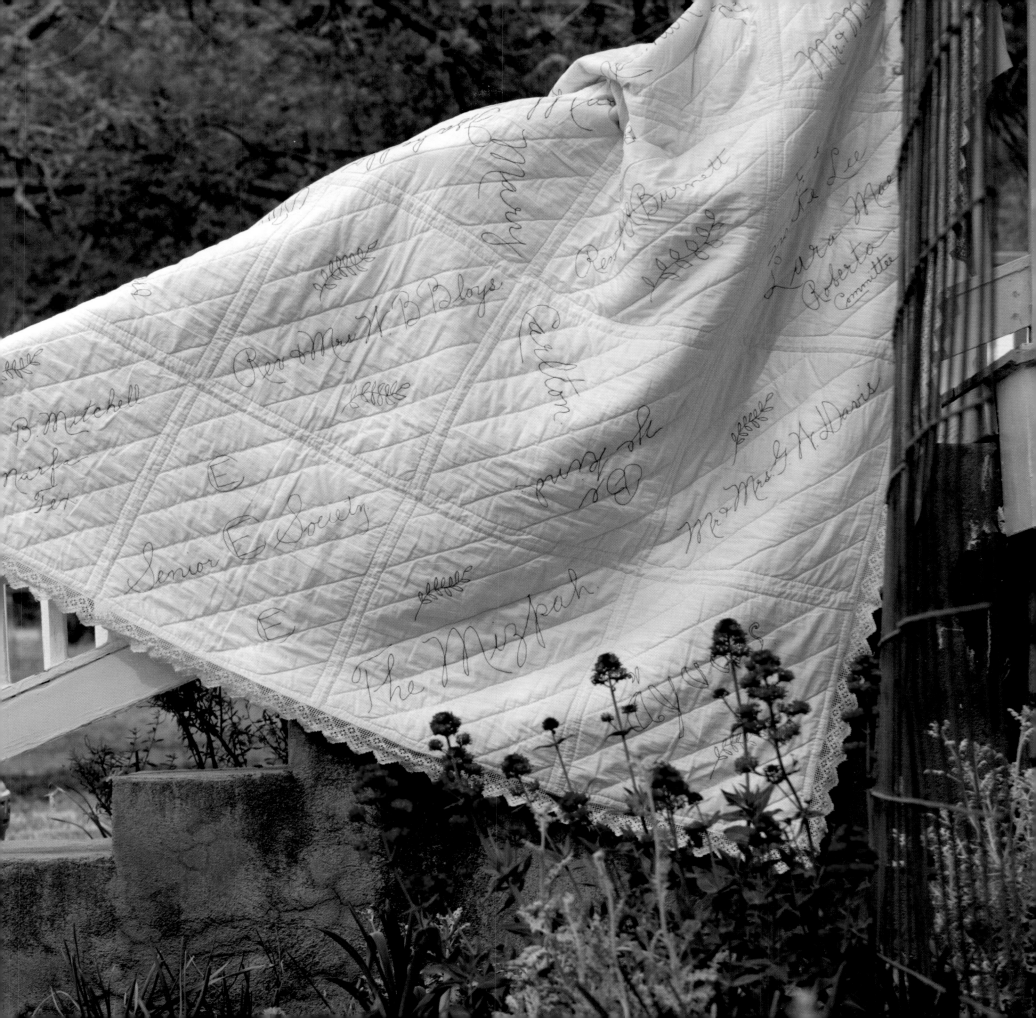

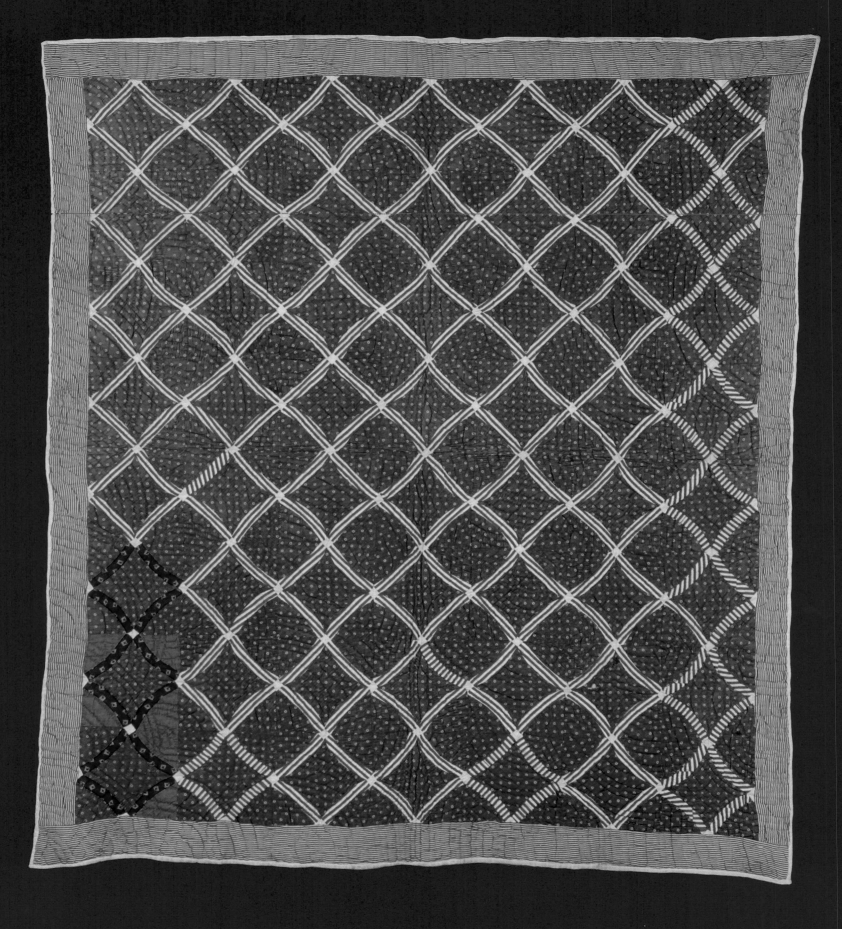

World War I Quilt, 1918, 65"x 72", made by Annie Rushing Martin, owned by Ernestine Munson.

World War I Quilt

1918

Annie Rushing Martin

Ladonia, Fannin County

Shared by Ernestine Munson

When World War I came, men were called to foreign shores, and women were forced to send those they loved into peril. Annie Martin was just such a woman who saw her new husband off to war and sent her love by way of fabric, stitches, and the Red Cross.

Quilt maker Annie Rushing was born on April 19, 1898, in Ladonia, Texas, but moved to Oklahoma with her parents when she was just two years old. Her mother died when Annie was five, and at the age of fourteen, she came back to Ladonia to live with her grandmother.

Annie Martin, 1922.
Courtesy Ernestine Munson, with permission.

Ladonia, a small town located in the southeastern corner of Fannin County, earned its name in a roundabout way. First settled by James MacFarland and Daniel Davis around 1840, the community was originally called McCownville. In 1857, the people of the town changed the name to La Donna in honor of La Donna Millsay, a traveler who entertained locally with her songs. In time, the name eventually transformed into Ladonia. As with many towns in Texas, the arrival of the railroad created a boom for Ladonia as a marketing town for cotton, corn, oats, and wheat.

While growing up in Ladonia, Annie met Arthur Martin, a farmer, carpenter, barber, and musician who played both the guitar and the mandolin. They married in 1917, and shortly thereafter, Arthur enlisted in the army, ready to fight in World War I. When he was sent to France, Annie wanted to send a bit of home to her new husband, so she made a quilt and shipped it overseas with the Red Cross. For whatever reason, the quilt never reached Arthur, and when the Red Cross reported the quilt lost, Annie wasted no time, quickly making an identical quilt to send to her soldier.

Lacking enough of the original material, she substituted the claret fabric seen in the lower left-hand corner of the new quilt. Annie also turned the red-and-white-striped fabric perpendicular to the original direction of the stripes in order to stretch its use. The quilt, measuring 65" x 72", is an interesting pattern that seems to be of Annie's own design. It is made of three fabrics: a cotton print in cadet blue, a red-and-white-striped cotton, and a claret print cotton fabric. The quilt has an outer border in very small red and white stripes, and the binding is from the muslin backing turned to the front

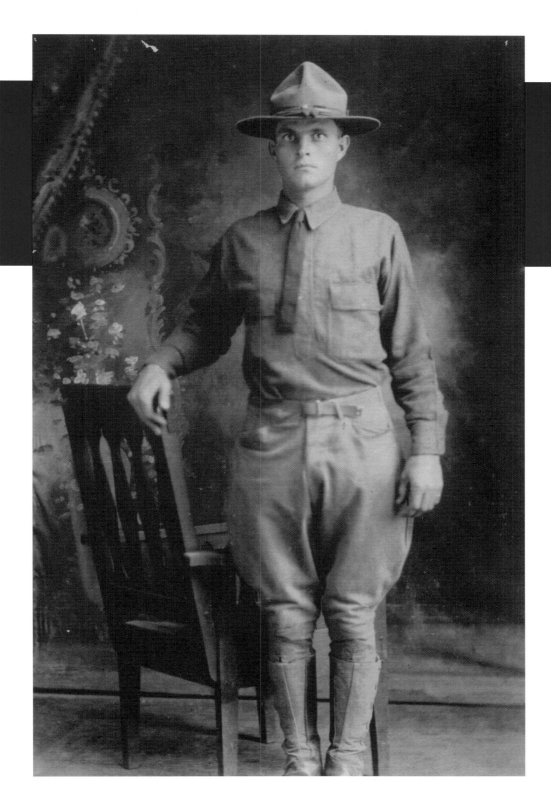

Arthur Martin in World War I uniform, 1917.
Courtesy Ernestine Munson, with permission.

and stitched down. It is machine pieced and hand quilted, and many of the blocks are made from smaller fabric scraps pieced together as she attempted to get the most out of her limited supply of fabric. Although the sashing is generally cut on the straight of the fabric, it has been turned sideways in several sections to utilize the fabric fully, and she has also set plain muslin cornerstones to extend the sashing fabric. Stripes in the sashing create the effect of movement in the quilt, imitating the ripple of a waving flag, an effect appropriate because of the patriotic times in the United States and perhaps her own feelings of support for

her soldier-husband. Indeed, the colors she chose—red, white, and blue—reflect the very same patriotism.

After Arthur and the quilt returned safely from France, he and Annie moved to Naples, Texas, and then to Omaha, Texas, where they settled permanently. Annie became a farmer's wife, sewing for the public before having children. While sewing or working in the kitchen, Annie enjoyed listening to the Grand Ole Opry on the radio, for music was an everyday part of the Martin household.

Quilting was a seasonal task in Annie's home, and in the spring other chores such as keeping a garden took

precedence over quilting. But, when the weather turned cool and her chores were finished, Annie went to her quilt frame. According to Annie's daughter, Ernestine Martin Munson, "Mother quilted during the winter months, from November to about March. The quilting frame was lowered on ropes from the living room ceiling, and Mother quilted in front of the fireplace to keep warm." That image of her mother quilting is the one that Ernestine remembers when she unfolds the quilt that went to war.

Detail of World War I Quilt showing striped fabric.

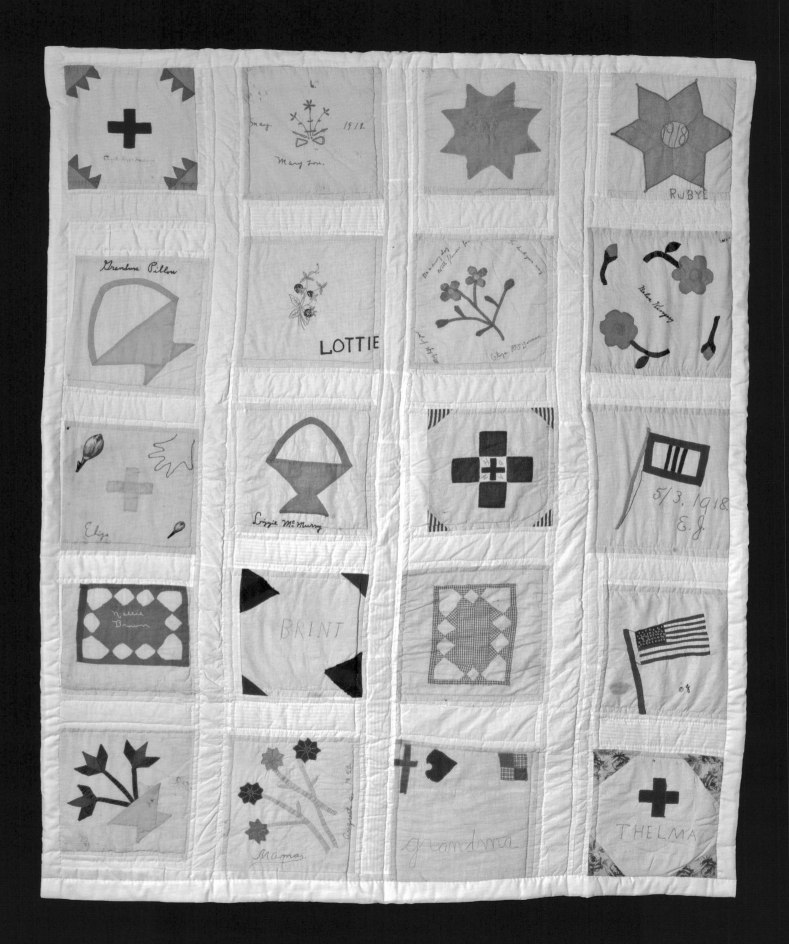

Friendship Quilt, 1918–1983, 61" x 74", made for Rubye Pillow Hope, owned by Rose Lemons.

Friendship Quilt

1918–1983

Rubye Pillow Hope

Dickens County

Shared by Rose Lemons

Today we hear how autographs of famous people sell for extraordinary sums. But a signature needn't be of a famous person to have value. In all eras of quilt making, signature quilts commemorate events and friendships, both more valuable than money. This quilt, covered with signatures, is a good example of how friends and relatives joined together to make a quilt for Rubye Pillow Hope.

Rubye Pillow was born in May 1899 in Erath County, Texas, but she lived her early life in a half-dugout home in

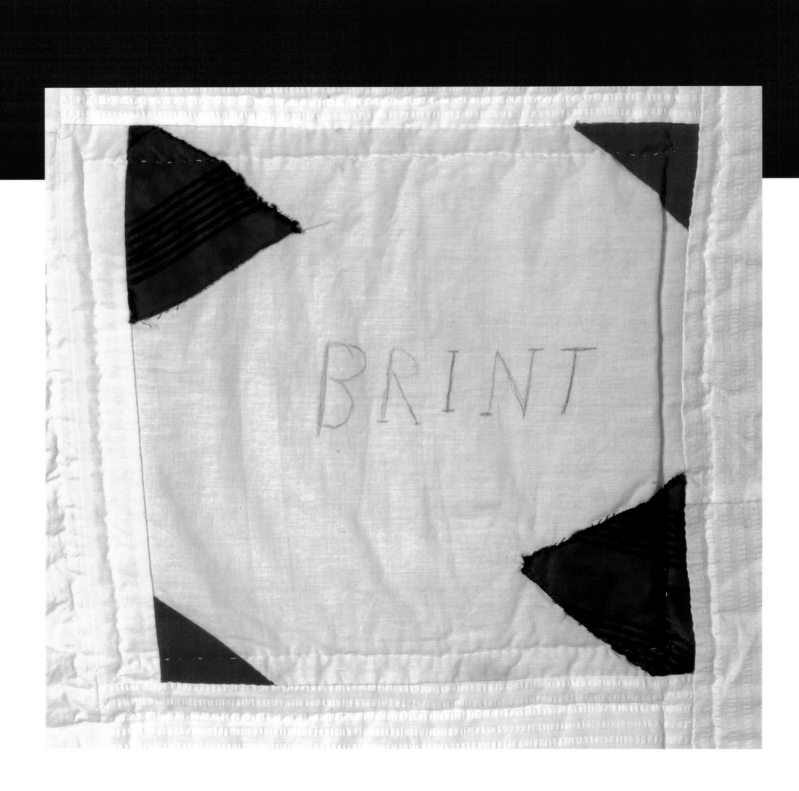

Detail of Friendship Quilt showing Brint's block with tie pieces.

Dickens County while her father dryland farmed cotton. After her father's death, her mother remarried, and Rubye became a stepdaughter surrounded by many new brothers and sisters. Before her marriage Rubye taught school in Salt Flat, Texas. When she married Archie Hope, an engineer for the Santa Fe Railroad, she surprised everyone since it was rumored that she was engaged to another man. She and Archie had a "buggy wedding," driving over to the preacher's house to be married outside, sitting in the wagon. According to Rubye's daughter, Rose Hope Lemons, when Rubye's mother learned of the marriage, she threw her apron over her head, sat down at the table, and cried over her daughter's choice of a husband.

The quilt blocks for Rubye's friendship quilt were not put together until later, but many were made at a variety of local quilting bees that took place between 1918 and 1920, around the time of her marriage to Archie. Ruby's aunts, grandmothers, and other female relatives made many of the blocks for Rubye's quilt. For this rural community, a quilting bee remained a social event, and it was also an occasion where young men could meet marriageable young women. Therefore, on this quilt, as with many signature quilts, blocks were signed by people who wished to be remembered, not just the makers of the quilt, and both men's and women's names appear on the blocks.

The quilt measures 61" x 74" and has twenty friendship blocks, each measuring 11" x 11", with various original designs, sentiments, names, dates, and symbols. The flags and the Red Cross symbol suggest that World War I was very much in the minds of the quilters. Although no evidence proves that any of the women had loved ones in the war, the symbols seem incorporated as a patriotic gesture appropriate to the times. Rose Lemons

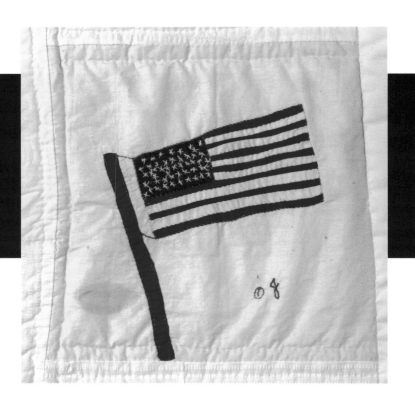

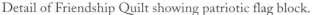

Detail of Friendship Quilt showing patriotic flag block.

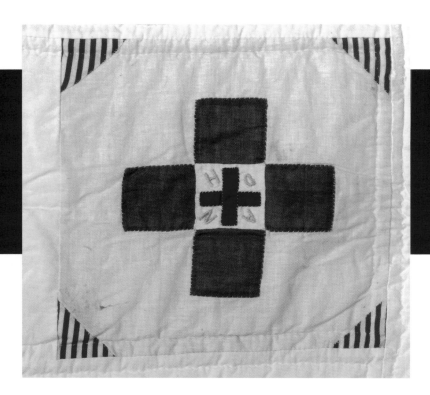

Detail of Friendship Quilt showing the letters H-A-N-D
surrounding the Red Cross.

commented to me when we spoke, "Oh that was just after World War I. Everything was very 'flaggy' back then." The blocks are made of muslin or sacking materials, and the sashing and backing are a polyester-cotton blend. Two of the blocks, one signed by Lottie, are not pieced but embroidered with flowers. Other blocks bloom with bright red and yellow floral prints or rectangles of purple, perhaps reflecting the personalities of those who made them. One quilter, Eliza, placed the Red Cross symbol in the center of her block, then embroidered her handprint to the right and added two rose buds in alternate corners. Two other special blocks appear because of Rubye's cousin Brint and her half-brother E.J. The young men enjoyed coming to the bees to meet young ladies. When told at one bee they had to quilt if they were to remain, Brint cut up his tie and made a block and then wrote his name. E.J. has his name on another block, but it is doubtful he embroidered the initials himself. Rubye's daughter found all of the blocks after her mother's death in 1969 and eventually had them pieced and quilted in 1983 by Mrs. Knight of Belton, Texas.

The names on a signature quilt may not be worth money, but they have value beyond the dollar sign. These quilts acted like autograph albums or the yearbooks everyone signs at high school graduation. They became tangible memory books for those to whom they were given.

Rubye's block in the Friendship Quilt, made and dated 1918.

Part Two

1920–1950

This section covers only thirty years but nearly half the quilts in this book, reflecting the rising interest in quilt making, especially in Texas. These three decades saw more quilt competitions both locally and nationally, but the most significant factor influencing Texas quilt makers was the cotton surplus during the 1930s.

Although Texas quilters had learned frugality as settlers in a new land, with the onset of the Depression years, difficult economic situations stretched family budgets even further. Thus, during this

period quilters had to use smaller amounts of material in a more imaginative way. Patterns like Mattie Adams's Postage Stamp Quilt, where her tiny square pieces show how she wasted nothing, became popular fads of the day.

Without much money, quilters also discovered fabric in items not specifically intended for quilting, and their ingenuity and inventiveness brought the idea of "found goods" into the quilt-making repertoire. Two examples appear in the Tobacco Sack Quilt by Thelma Curry and Effie Roe's Tobacco Sack Puff Quilt, for which the quilt makers recycled tobacco sacks in different ways to create quilts. Another woman with "found goods" pieced into her quilt was Katherine Hervey, who bleached and cut up her husband's old cloth oil field maps to use in her Oil Field Map Quilt. In difficult years when store-bought fabric was a luxury, these inventive quilters still found ways to stitch their colorful bedding.

This era also saw an increase in quilt makers' use of feed, flour, and sugar sacks, whether for piecing into their quilt tops or for backing. When feed-sacking manufacturers realized this new marketing potential, they quickly discovered ways to increase demand. They hired fabric designers to create colorful designs to be printed on feed sacks, and they included small brochures with patterns for clothing and quilts to encourage sales of their products. As a result, women purchased a certain brand, insisting on sacks with the same design. Ollie Wilson's String Pieced Star Quilt and the Blue Lone Star Quilt by Allie Mae Close Burkett show feed-sack piecework. In the Four Tulips Quilt by Eva Doherty, many of the feed-sack pieces come from the Burrus Flour Mills, made famous because of its connection to Texas history and Governor Pappy O'Daniel and his ties to politics and Texas music. All of these quilters incorporated their flour and feed sacks into their work so artfully

that only a skilled eye can believe the pieces were once parts of sacks filled with grain.

In the 1930s and 1940s, cotton surpluses in Texas meant cheap or often free access to another source of fabric and batting for quilters. As part of a federal program, counties sent agents to help farmers rebuild and begin farmers' co-ops. Government agencies also distributed surplus cotton to qualifying families. Encouraging women to use cotton in various ways, they gave each family free fabric and several pounds of cotton.

Additionally, at farmers' requests, local cotton gins could pull batting before the ginned cotton was baled. Even today, Jimmy Sybert, owner of Williamson County Cotton Gin, pulls several batts yearly for local cotton farmers but remembers once pulling as many as one hundred a year. Although not free, these pulled batts were more affordable for farm families than store-bought batts.

The government also sent county

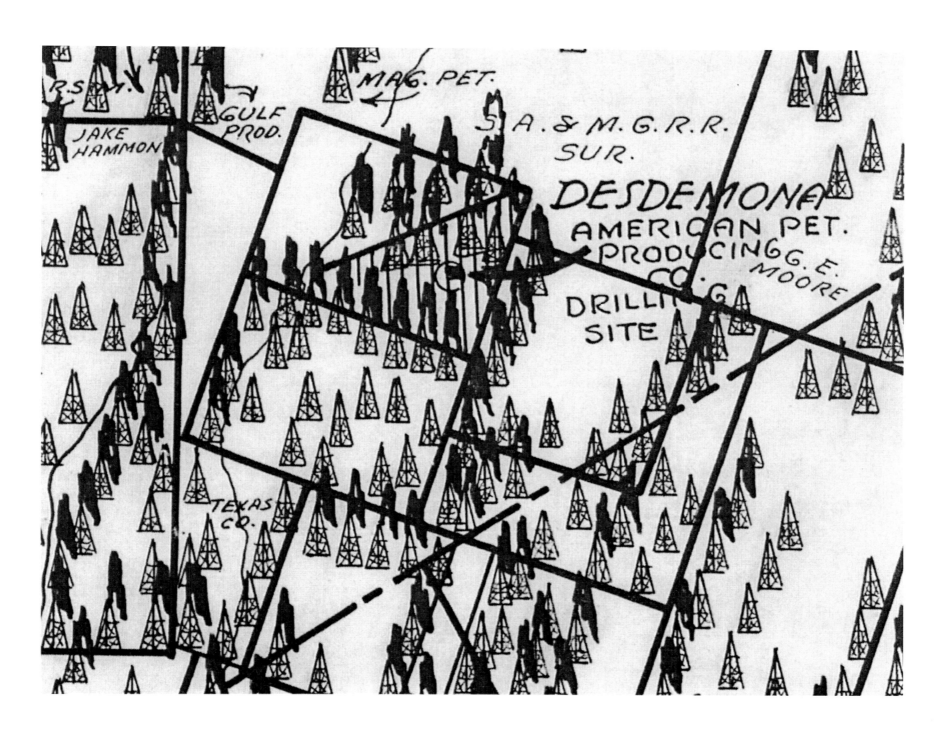

Detail of cloth oil field map. Producing wells depicted with "gushers" and dry wells without.
Courtesy Texas State Library & Archives Commission, with permission.

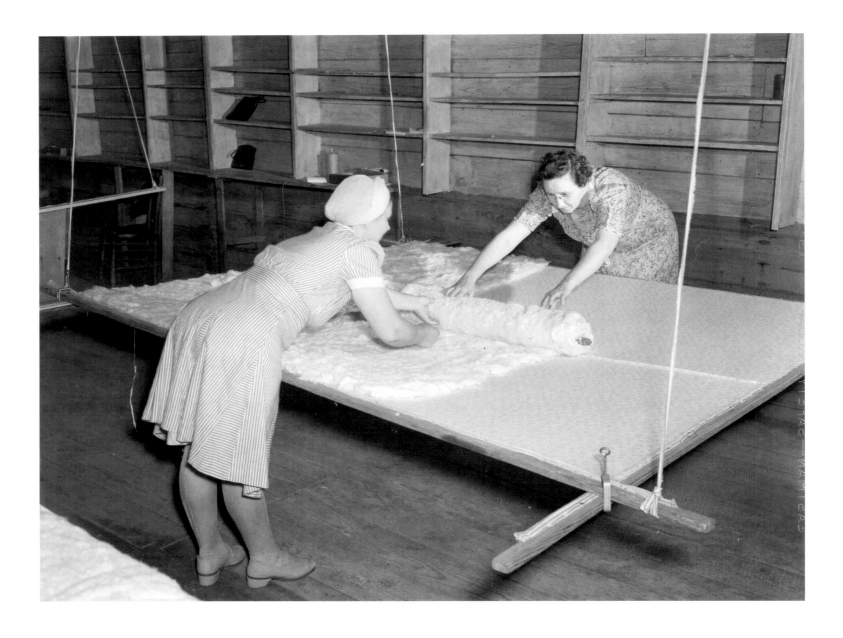

Women rolling batting onto quilt backing in preparation for laying top of quilt on batting.
Courtesy Cushing Memorial Library and archives, Texas A&M University, with permission.

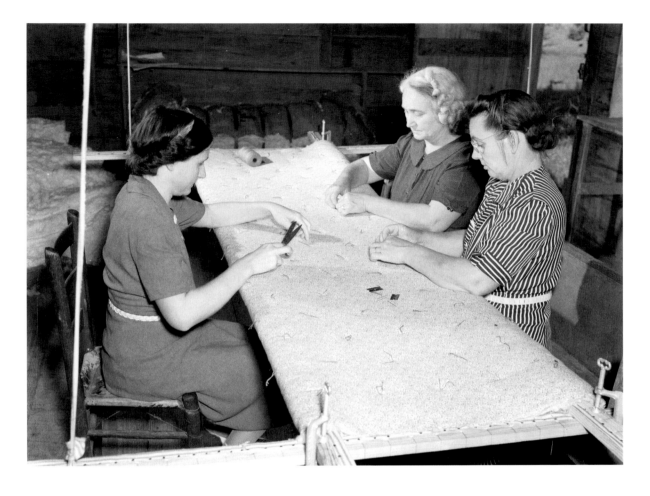

Women tying a quilt in the traditional method. Courtesy Cushing Memorial Library and archives, Texas A&M University, with permission.

demonstration agents like Frances McCulloch as instructors who showed the women how to make mattresses and tie quilts. While working as an agent, Frances made her Texas A&M Quilt for her friend John Shows, the county agent who worked with her.

During these years, quilting was growing in popularity and seemed to be undergoing a renaissance. National con-tests were taking place, including the Sears National Quilting Contest, with regional contests as preliminaries and the winning quilt for each region being sent to Chicago and displayed at the 1933 World's Fair. Big manufacturers started creating patterns, and these commercial patterns were rapidly becoming available in brochures, pamphlets, and newspaper columns devoted to quilting. Several of the quilts in this section reflect that trend, including the Improved Nine-Patch by Elizabeth Fields and the Yo-Yo Quilt by Etta Mae Back. Although stan-dardized, these patterns continued to allow women the opportunity to be cre-ative in the choice of colors and fabrics.

With the advent of commercial pat-terns, newspapers and ladies' magazines also began to offer kit quilts in which

companies included fabrics along with the patterns. For quilters who did not want to select their own fabrics, this was an easy way to create a quilt; the kit provided everything except notions. Often kits came in installments where quilt makers paid a fee for individual parts of the kit; however, more often the entire kit came in one package. This gave women one more opportunity to take advantage of printed patterns.

But Texas women were not content simply to follow the patterns. For the Texas Centennial in 1936, quilters made quilts to celebrate, and Frances McCulloch created her own design of the Cattle Brand Quilt to commemorate the state centennial. The motif of cattle brands appears two other times in this section, but each in an entirely different design. In Willie Ann Young's Crazy Quilt with Cattle Brands, she takes the Victorian crazy quilt and simplifies it, adding brands and turning it pure Texan. In Jack's Brand Quilt, Gertrude Roberts

personalizes the cattle brands by making her own templates and designs. Gertrude also makes the Rainbow Quilt, her second example of a personal design, not a commercial pattern. Although quilters at this point have more access to a wider selection of printed patterns and make use of them, there are always those who still choose their own designs and patterns as well as their own colors and quilting motifs.

Also in this section quilters continue the tradition of commemorating special moments with quilts. One example is the Ralls Friendship Quilt. Although the quilt maker's identity never came to light, the search itself was a journey of discovery for the entire town. Another commemorative quilt is the High School Graduation Friendship Quilt by Bertha York, a gift for a special occasion and a quilt made from friends' clothing as items of remembrance.

With the fabric shortage of World War II, many women continued with or

returned to their frugal habits, and to help financially some began to quilt for pay, which was minimal. Charles Gearheart in Lamesa, Texas, remembers how angered he was when in 1945 a woman complained that three dollars was too much to pay for the quilting his mother had done for her. However, after the war ended, the hard times of scrimping and saving were almost over. Even then with the increased availability of goods, some women simply continued to save what they could. By the 1950s, although many quilt makers continued their art in rural areas, the popularity of quilting had begun to wane in the cities and larger towns as interests turned toward a modern lifestyle.

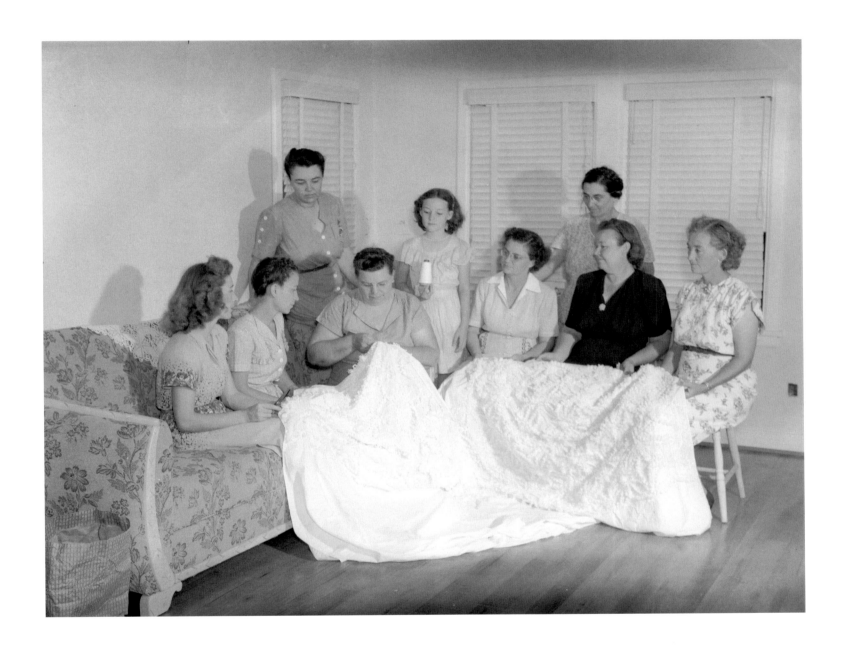

Group photo of home demonstration club, Tarrant County, 1947. Frances McCulloch is at left, in back row.
Courtesy Cushing Memorial Library and archives, Texas A&M University, with permission.

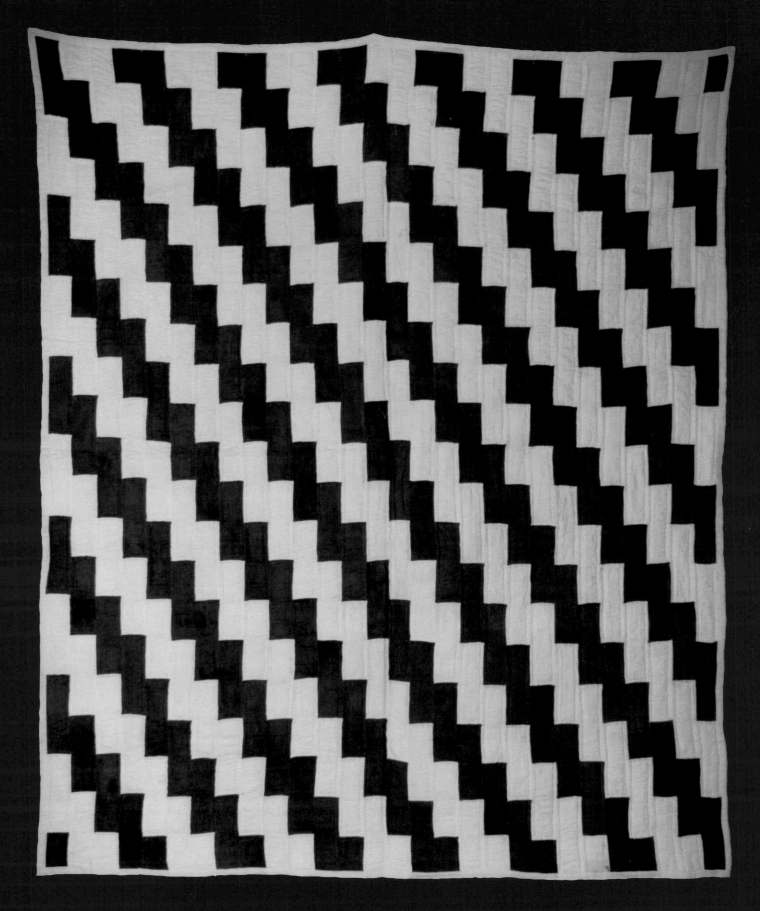

Tobacco Sack Streak of Lightning Quilt, 1927, 70" x 85", made by Thelma Martin Curry, in the collection of the quilter.
Photograph by Jennifer Beecher; with permission.

Tobacco Sack Streak of Lightning Quilt

1927

Thelma Curry

Canadian, Hemphill County

Shared by Thelma Curry

Determination. Perseverance. Tenacity. These are very impressive words, words not often mentioned in the same breath when describing a little girl. But these words are part of the story of Thelma Curry and her Tobacco Sack Quilt. Somewhere, for whatever reasons, these qualities grew inside this little girl who was only eight years old when she decided she wanted to make a quilt. Perhaps those qualities had something to do with the fact that she was born in a small town called Canadian in the far northern Panhandle of Texas.

Thelma Curry in front of her Tobacco Sack Streak of Lightning Quilt, 2005.
Photograph by Jennifer Beecher; with permission.

Canadian, Texas, had first been established in 1887 when two men, E. P. Purcell and O. H. Nelson, sectioned out a 240-acre town site on the south bank of the Canadian River in the northern Panhandle in preparation for the arrival of the Southern Kansas Railway. Right away, Canadian had a post office, and by 1890 the town was booming because it had become a division point for the railroad.

However, after years of growth, like many small Texas towns, Canadian saw its population start to decline with the loss of the railroad and later in the 1950s and 1960s with the slacking off of the oil boom. But Canadian, just like little Thelma Curry, showed determination, perseverance, and tenacity and found a way to turn its decline around, becoming a new center for tourism with the Texas Prairie Rivers Initiative, a wildlife cooperative.

So perhaps something in the waters of the Canadian River that flowed through the town gave little Thelma her determination to begin that first quilt. Born on December 17, 1916, as the fifth child of six in a home with few economic advantages, Thelma proved to be a resourceful young quilter. This eight-year-old found the fabric for her quilt top right in front of her—or at least in her father's hands. She saved the Bull Durham tobacco sacks from her father and his friends, pulling out the gold drawstrings and carefully undoing the stitches from the seams until she had a muslin rectangle to wash and press. During the next three years, Thelma showed how patient she was, saving 294 tobacco sacks.

Thelma had plans for a pattern and wanted to dye part of her sacks, so she took babysitting jobs thirteen hours a day, gradually saving the fifteen cents she needed to buy a packet of brown Rit dye. She chose brown for that alternate color,

and, although brown was one of the traditional colors for this pattern, perhaps her choice was influenced by the bits of dark tobacco she shook out of those Bull Durham sacks, the smell still lingering in the air and on her fingers. Or perhaps she took a walk one day and admired the rich brown banks of the Canadian River.

In any case, Thelma dyed half of the sacks brown and left the others a natural white to create the Streak of Lightning pattern in the quilt. Measuring 70" x 85", the quilt is pieced and quilted by hand and has no borders. The backing is made from coarse feed sacks, another indica-

tion of how few material advantages were around Thelma and of how inventive she was in achieving her goal—a finished quilt. Thelma completed this quilt, the first of many, when she was eleven years old.

As the years passed, Thelma grew up in Canadian and eventually married Olliver W. Curry, a cattle hauler and home builder originally from Weatherford, Oklahoma. Together they had four daughters. When World War II came along, Thelma, like many other women of the time, took a job outside her home and worked both as a presser

in a dry cleaner's shop and as a silk finisher while continuing to raise her daughters. Even though she considers no quilt more special than that first quilt made from tobacco sacking, Thelma continues to make heirloom quilts for her family, showing that just like Canadian, she is filled with perseverance and determination.

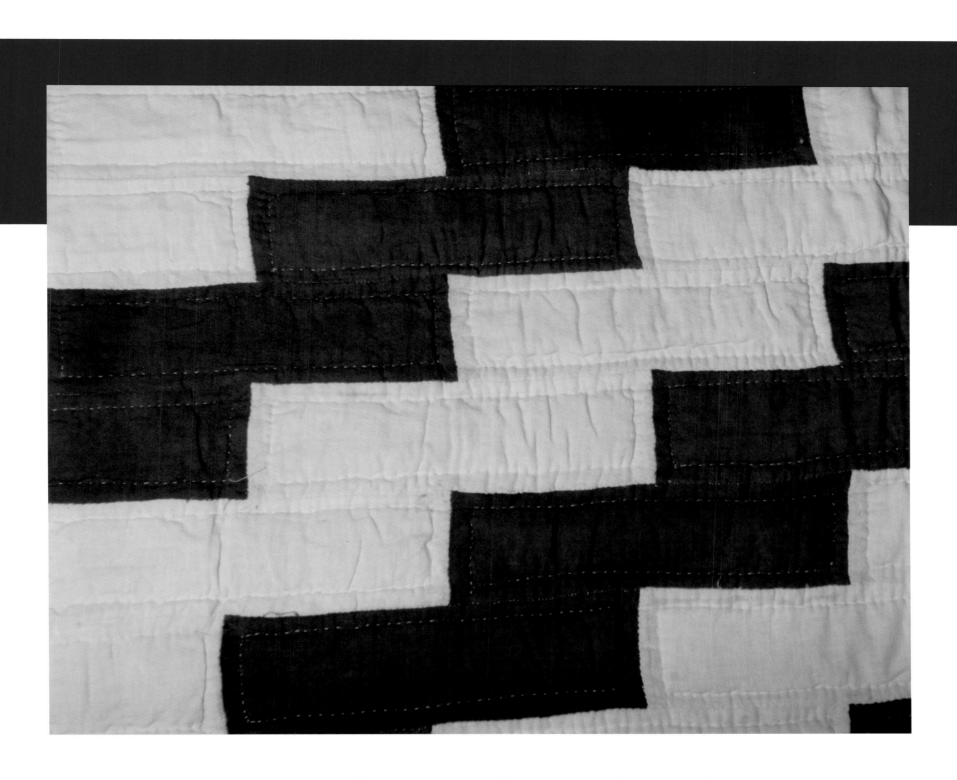

Detail of Tobacco Sack Quilt. The sacks are hand dyed. Photograph by Jennifer Beecher; with permission.

Tobacco Sack Streak of Lightning Quilt, 1927

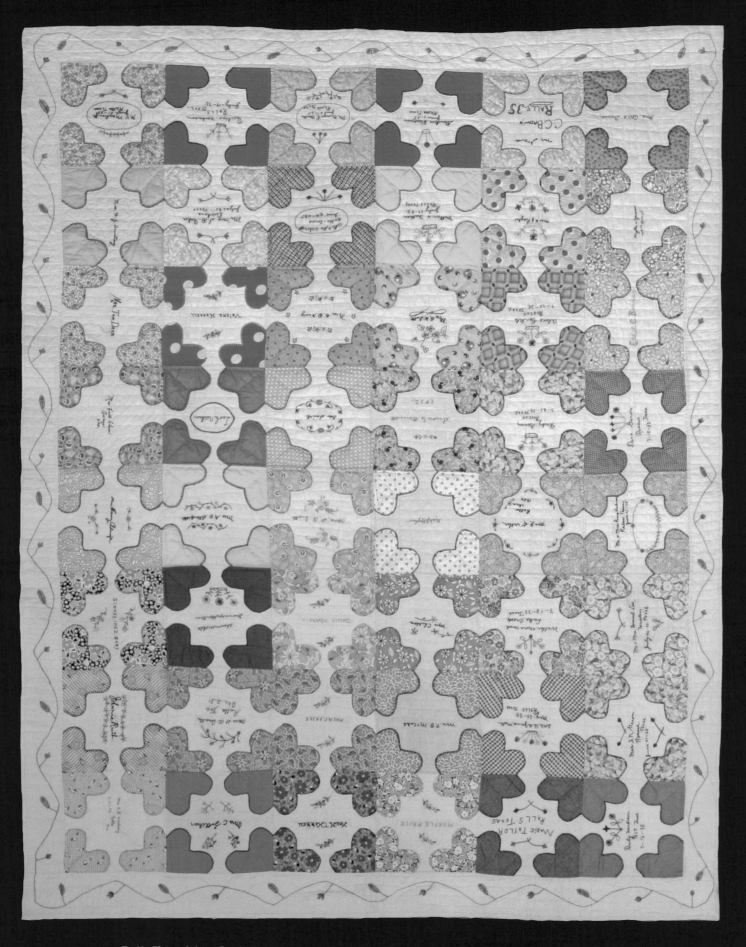

Ralls Friendship Quilt, 1931–1934, 73 1/2" x 99", maker unknown, in private collection.

Ralls Friendship Quilt

1931–1934

Quilter Unknown

Ralls, Crosby County

Shared by the townsfolk of Ralls, Texas

Human beings cannot seem to resist a mystery. Our curiosity stirs, and we want to know more. A quilt, especially one whose maker is unknown, has that same sense of mystery about it. Sometimes we discover the answers; sometimes they elude us.

Just as any investigation starts with a lead, mine started with a tip from a quilting friend, Penny Yost, who told me about an interesting quilt hanging on a wall in a doctor's office in Houston. The quilt bore dates and names of small towns

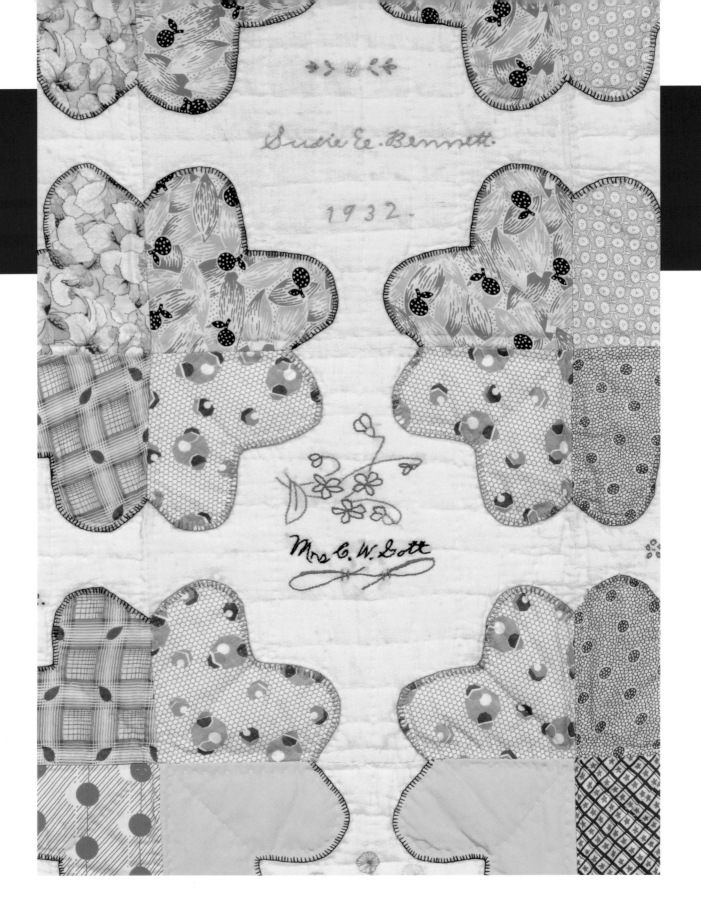

Detail of Ralls Friendship Quilt showing names embroidered in blocks and buttonhole outline stitching.

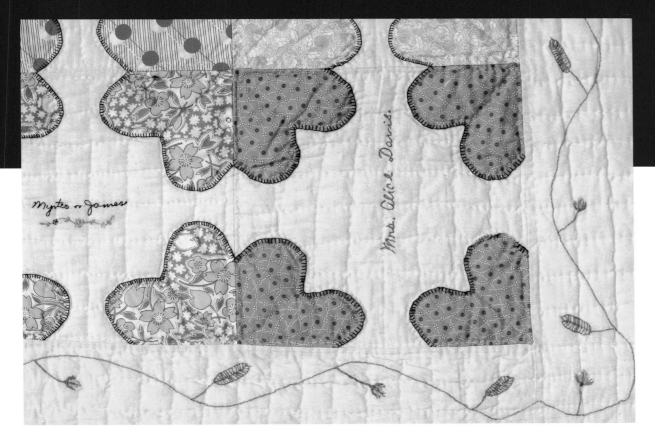

Myrtes – James

Mrs. Alice Davis

Detail of Ralls Friendship Quilt showing blocks and embroidered border of vines and flowers. Embroidered borders are quite unusual.

and individuals in West Texas but offered no clues about who made the quilt or why it was so far from home. When I began some genealogical research to find answers to these mysteries, the town of Ralls, Texas, kept appearing as the place where most of the names on the quilt originated. After searching cemetery records, newspapers, and Internet websites on genealogy, I decided (with permission of the owner) to take it to Ralls for the weekend. There I hoped to meet some of the descendants of those who had signed the quilt and listen to their stories. I contacted the Ralls Historical Museum and spoke to the curator, Donna Harris, who eagerly agreed to let me exhibit the quilt and invite the townspeople to see it.

Ralls is a small West Texas town founded in 1911 by John Robinson Ralls, who owned land in Crosby County two years before the Lubbock extension of the railroad was finalized. When I reached the Ralls Historical Museum on Friday, August 27, 2004, several men and women, whose surnames were the same as those on the quilt, met me, eager to see the Friendship Quilt. As I began hanging it in the largest of the museum's rooms,

they started pointing out the names of their mothers, aunts, and grandmothers.

This quilt measures 73 1/2" x 99" with each block measuring 11" x 11" in the Album Block pattern. The hearts in each corner are appliquéd with matching and coordinating embroidery floss in blanket stitching, and the heart appliqués in the four corners of each block meet with others to form an eight-petaled flower. The borders measure four inches on each side and four and a half inches on the top and bottom of the quilt. The embroidered flowers and leaves in the borders are very unusual for this style of quilt. Although I originally thought the

quilt was a wedding quilt because of the number of hearts and embroidered flowers in the blocks, the dates on the blocks span a four-year period, a very long engagement time.

While the quilt was on display, entire families, including sons, daughters, grandchildren, and great-grandchildren, came to see their relatives' names, standing in front of the quilt to be photographed. As they answered questions about the people they knew, a portrait of life in a small town began to emerge in bits and pieces. "Mr. Ashcraft, he was a master carpenter." "Susie Bennett was a seamstress." "Mrs. Childres ran a café."

"Mrs. Davis's husband was a cotton buyer and a jack-of-all-trades." "Mr. and Mrs. Brown were fruit truckers and house movers." Men, seeing their mother's name on the quilt, stood quietly, red-eyed, sniffling into white handkerchiefs. Their wives and daughters came with files of old photos, pages from family history books, even complete genealogies.

The next day people arrived with other quilts and quilt tops made by the women who had made this quilt! At one time more than forty-five quilts filled the room. As families visited, this gathering became a giant social for the town.

Descendants of Susie Bennett, one who signed Ralls Friendship Quilt. Four generations of the Ashcraft family:
Front row, left to right: Slayde, Kaleb, Steel, Seth, and Kouren Appleton, Norma Ashcraft.
Back row, left to right: Carolyn Appleton, Deborah Holt, Lois Landsdown, Sarah Roden, Bill Ashcraft. Debbie,
Bill, and Lois are descendants of Mrs. Emory Ashcraft. Carolyn is Lois's daughter and all five boys are hers.
Bill Ashcraft and Sarah Roden are brother and sister. Photograph by William G. Kaylakie; with permission.

Examining the other quilts, I saw patterns from the 1930s and '40s, many hand pieced and hand quilted. Bill Ashcraft brought several quilts and quilt tops his mother had made. While we were examining one, a woman nearby exclaimed about the hand piecing, "Oh, Bill, look! She did it all on the fingers!"

Then Donna Harris brought out another quilt from the museum's collection that had the identical pattern, was from a similar time period, and had some of the same signatures as the first quilt. When a family member of one of the signers of the quilt showed up with a third quilt in the same pattern and style, I knew we had a different mystery; these quilts were part of one group, but who had made them? Instead of finding answers, I was developing more questions, and the museum's archives provided some help. An article in the *Ralls Banner,* dated October 30, 1984, reported that during the 1930s and '40s, members of the Ralls Quilting Club stitched a friendship quilt monthly in a member's home and presented it to the hostess. This quilt probably was one of the friendship signature quilts made by the quilting club.

But who was the hostess? Who owned this quilt? That part of the mystery remains to be solved, and although all of my questions were not answered, the people of Ralls came together and put many of the pieces together, as if the mystery itself were a quilt in progress.

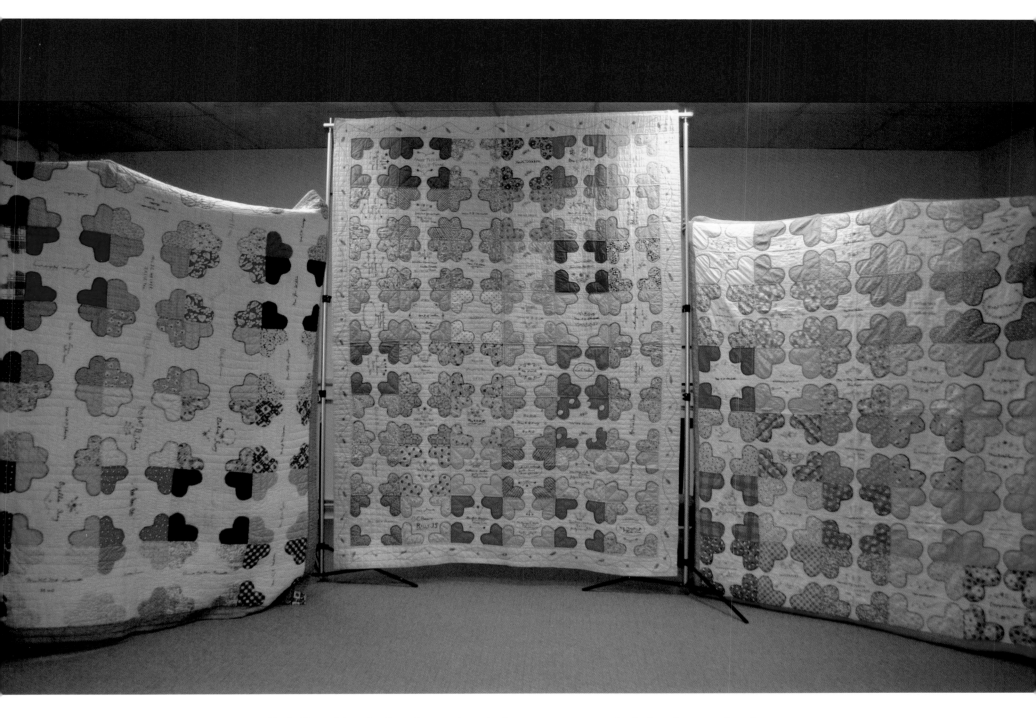

Ralls Friendship Quilt and two others in the same pattern made during the same decade.
Photograph by William G. Kaylakie; with permission.

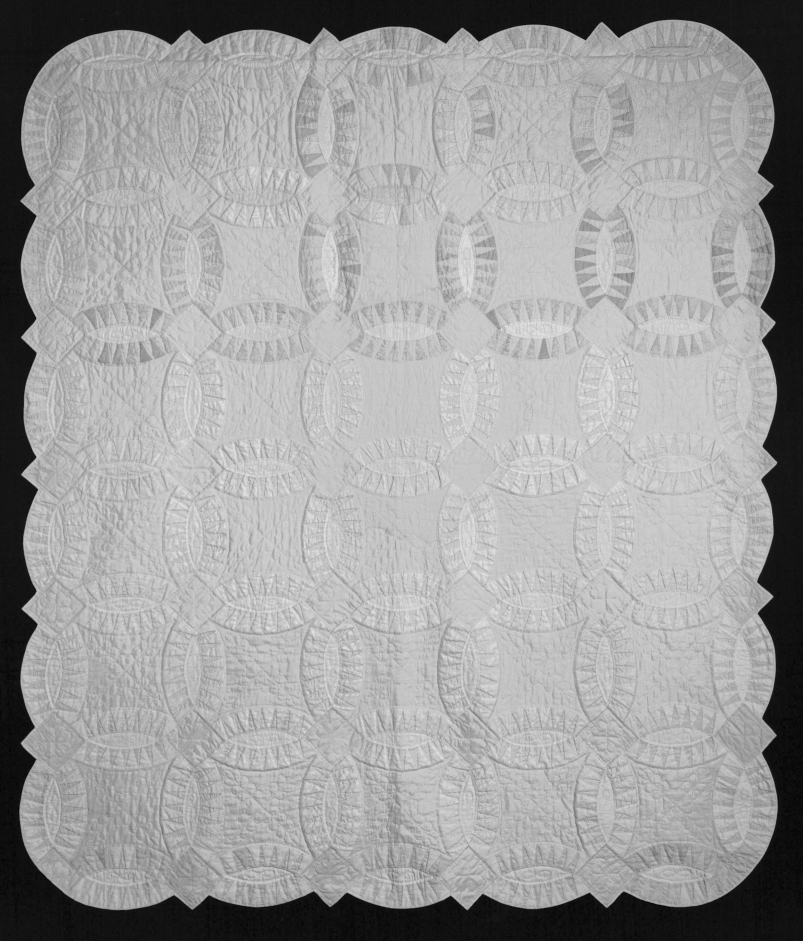

Oil Field Map Quilt, c. 1930, 78" x 92", made by Katherine Julian Delano Hervey, owned by Larry and Sue Laurent.

Oil Field Map Quilt

c. 1930

Katherine Julian Delano Hervey

Fort Worth, Tarrant County

Shared by Larry and Sue Laurent

Not all of us can find an oil well in our own backyard, but I found an oil well quilt in mine, or at least this Oil Field Map Quilt in my own quilting bee. In my weekly bee, Sue Laurent was quilting the top given to her husband, Larry, by his grandmother Corrine H. Simms, daughter of the quilt top's maker, Katherine Delano Hervey.

Katherine Julian Delano, the daughter of a sugar plantation operator and a distant relation of President Franklin Delano Roosevelt, was born in Tuxpan,

Katherine Julian Delano Hervey, 1925.
Courtesy Larry Laurent, with permission.

Mexico, on September 15, 1868. In 1879, when Katherine was eleven, the family returned to the United States. The Delanos were good friends with the Archibald P. Gautier family of Galveston, Texas, and Katherine had even been named after Mrs. Gautier.

Beverly Percival (B. P.) Hervey, Katherine's future husband, apprenticed with a printing firm owned by one of his relatives and a relative of Mrs. Gautier;

when he was twenty-one, B. P. met and fell in love with Katherine.

In his own unpublished journals, B. P. recalls, "As I was a top class job printer and could get work any time, my hobby was running around the world, no marriage and free of all restraint, but I guessed wrong. Without warning, I was hooked by the first and only love of a woman I ever had and became engaged to—Katie Delano." However, all sides

thought that the young man needed to work a while before they married, so B. P. went to Purcell, Indian Territory, later to become Oklahoma. After co-owning the *Purcell Register,* he sold his share to his partner, Ed Engles. B. P. wrote that he "shook the snow off my shoes and took the train to Fort Worth," there to marry Katie on March 22, 1888.

During their marriage, Katherine was a homemaker, and the couple had five

B. P. Hervey, c. 1930. Courtesy Larry Laurent, with permission.

children. B. P. continued to work as a printer, but for some unexplained reason, he returned to Monterrey, Mexico, in 1900, and lost his money on bad business deals. He returned to Dallas and worked in real estate, going broke again during the 1933 bust in oil well drilling. During this time B. P. used cloth maps of the oil and gas fields in eastern Texas to locate areas where he might buy mineral rights. According to his family, after B. P. finished with the maps, Katherine washed and bleached them, then cut them up for pieces in her quilts and doilies. This was, after all, the Depression, and women were careful with every penny.

However, in this particular quilt top, the maps did not bleach out entirely, and perhaps that is why this quilt was never finished. The quilt measures 78" x 92" and is made in the Pickle Dish pattern. The map markings are clearly visible in the pattern pieces and give some idea of the layout of the geological markings of the oil fields in the area. Although Katherine would have preferred that the maps had faded completely, we benefit from her disappointment. Once again, we have a quilter who has used what she had available to make a quilt. At the same time, we are able to glimpse a historical document of the oil fields' geological

charts of the era, and this history has been preserved in quilt form. Although Katherine never finished the quilt herself, her great-grandson's wife, Sue Laurent, did finish the quilt, backing it in white cotton fabric and quilting it by hand.

More than ever, I learned to look around and appreciate what I find in my own backyard, in my own quilting bee. This quilt was right there, like an undiscovered oil well, waiting for me.

Detail of Oil Field Map Quilt. Names of oil field properties can be read clearly.

Detail of Oil Field Map Quilt showing oil field properties and roads.

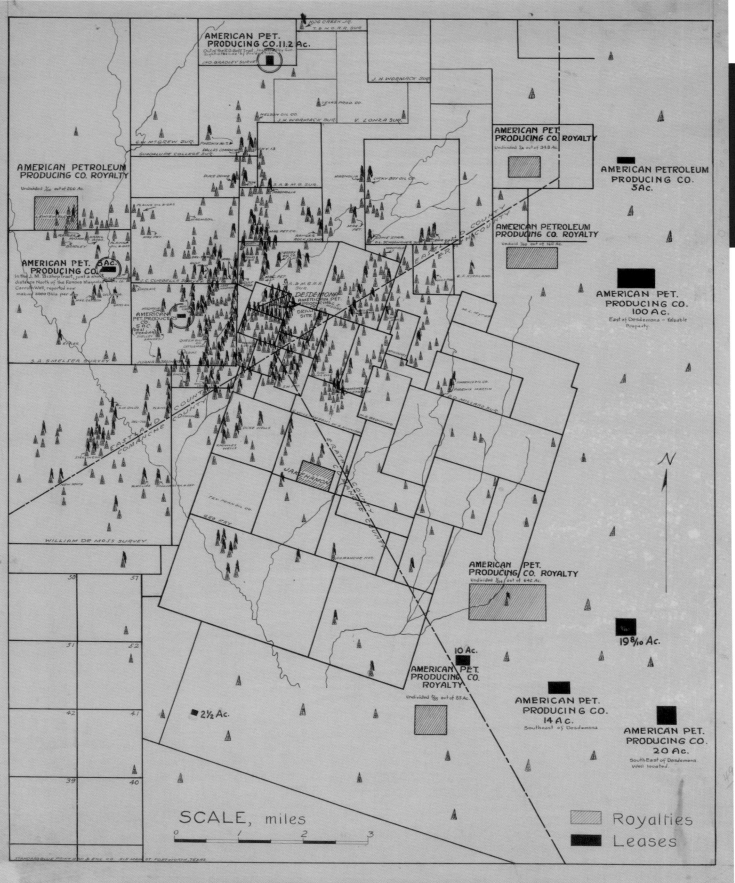

MAP OF HOLDINGS, DESDEMONA DISTRICT
American Petroleum Producing Company

Cloth oil field map showing producing and dry wells for the American Petroleum Producing Company as well as individually owned wells, c. 1920. Courtesy Texas State Library & Archives Commission, with permission.

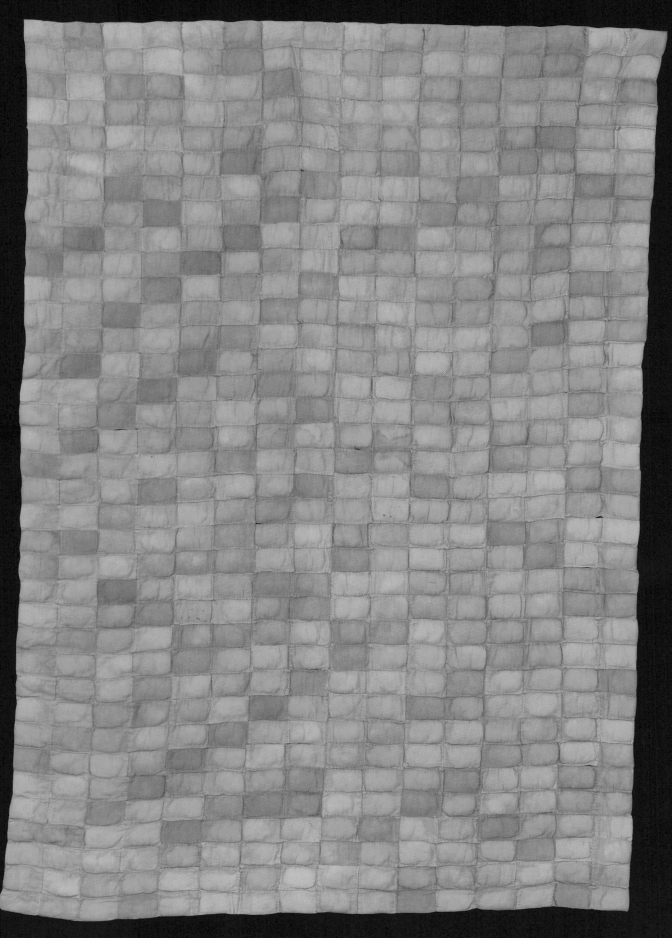

Tobacco Sack Puff Quilt, c. 1935, 59" x 80", made by Effie Roe, owned by Kathleen McCrady.

Tobacco Sack Puff Quilt

c. 1935

Effie Roe

Kerr County

Shared by Kathleen McCrady

In Effie Roe's quilt one finds the straight rows of someone who knew farming life, and the story of a resourceful woman who "made do" with what she had in order to create this practical bedcover for her family.

Effie Roe was born in Williamson County, Texas, in 1887 on a farm near Leander, a town that established itself near the new railroad. Cotton farming and ranching were the main employment of the townspeople of the area, and Effie's father, although mainly a cotton

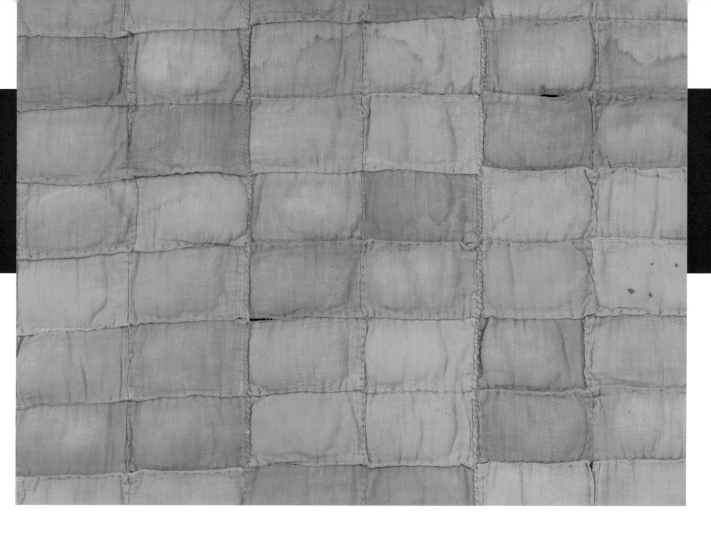

Detail of Tobacco Sack Puff Quilt showing home-dyed sacks with hand-sewn whipstitching.

farmer, also earned extra money chopping cedar. A cedar chopper was someone who cut cedar from groves called stands and sold the logs to pole yards who, in turn, sold them for fencing or building supplies. Because cedar was plentiful and money was scarce at this time, cedar chopping provided a livelihood for many families, and often the cedar functioned as currency that could be traded for groceries.

Effie never married and instead kept house for her father, tending to the household chores. Just as Effie's father chopped local cedar as a way of taking care of his family in difficult times, Effie's Tobacco Sack Puff Quilt is an example of how she incorporated "found goods," in this case tobacco sacks, in order to get the most out of everything for her family. Effie simply recycled. Used to a life of making do and using

every item twice, Effie saved tobacco sacks and turned them into this puff quilt. The quilt measures 59" x 80" and has 576 tobacco sacks, each measuring approximately 2 1/2" x 3 1/2". Effie did not even unstitch the sacks. She left them in pouch form and then home dyed them in shades of brown, blue, gold, and green. Then Effie stuffed the sacks, still intact, with cotton, sewed each one shut, and whipstitched them together. It is

Bull Durham tobacco sacks with Tobacco Sack Puff Quilt. (The labels are soaked off before dyeing begins.)

probable that the cotton Effie used to stuff the tobacco sacks was grown on the family farm.

This quilt was bequeathed to Effie's niece, Gerry Winningham, who later gave it to Mary Bible, a friend who also lived in Leander. Mary, too, remembers going out with her own father on Saturdays while he chopped cedar wood to buy food they couldn't raise on their farm. At present the quilt resides in the permanent collection of Kathleen McCrady.

Effie's quilt reflects life in the 1930s, where farmers met the challenge of hard work and women's scrap quilts stretched what goods were available to them. But even in those hardworking days, Effie's quilt echoed the straight lines of a farmer's well-plowed field. Her color choices celebrated what was around her: the browns and golds of variegated cedar trunks and rich earth, the greens of the cedars themselves, and the blues of Texas skies. Even though Effie and her family may have had few monetary riches, her "found" riches show in her quilt.

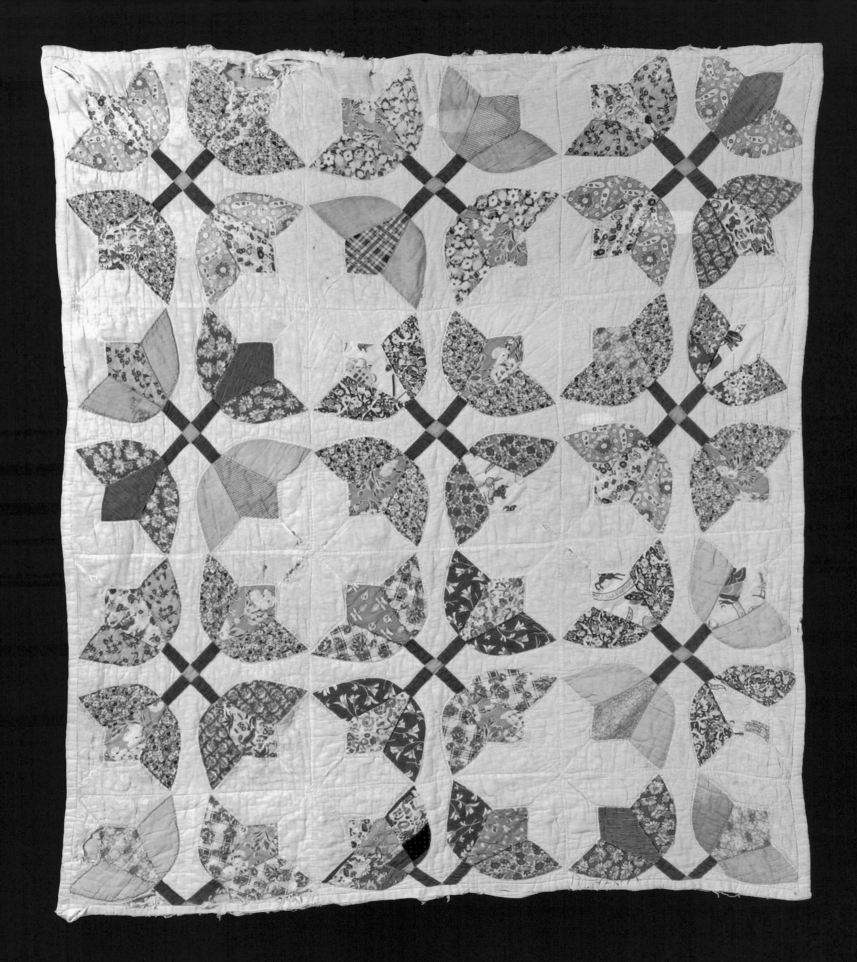

Four Tulips Quilt, 1935–1938, 68" x 76", made by Eva Sue Doherty, now in the collection of the Doherty family.

Four Tulips Quilt

1935–1938

Eva Sue Doherty

Mount Calm, Hill County

Shared by Shirley Doherty

How do flour sacks, politics, music, and quilting intertwine? As the saying goes, only in Texas. Eva Doherty's Four Tulips Quilt stands as an example of how those four things, like her Four Tulips, came together in the 1930s.

Born in 1883, Eva Sue Jones, known as Sudie, grew up in a farming family. When she was sixteen, she married Ed Doherty and they had twelve children. Together they worked their farm just outside of Mount Calm, Texas, in the southernmost part of Hill County.

Eva Sue "Sudie" Doherty, c. 1945. Courtesy Shirley Doherty, with permission.

Through the years, Mount Calm had always been attractive to early settlers because of its rich soil, and in the 1880s, the railroad made access easier with an extension nearby. By the turn of the century, the town was experiencing a boom, but drought, the Great Depression, and overworking of the soil caused many to move away from the area.

Living in Mount Calm even before the Depression, because Sudie was a farm wife, frugality was a way of life in a household with so many children. Recycling was the norm long before the word was fashionable or even in use, so it is not surprising to find that her quilt was made from fabric scraps, feed sacks, and muslin.

Feed sacks were a staple in rural communities. In the late 1920s, milling companies realized that housewives were using their brightly printed sacks to make clothing and household items such as towels and quilts. To encourage brand loyalty, the companies began to produce distinctive decorative prints, realizing that women who wanted to make an entire outfit or a quilt would have to buy numerous sacks of the same brand. Often, women who sent their husbands

Governor O'Daniel and the Hillbillies play hymns, c. 1941. Courtesy Texas State Library & Archives Commission, with permission.

Detail of a feed sack featuring the Hillbilly Boys and "Beautiful Texas," produced by the Hillbilly Flour Mills between 1935 and 1938; in the collection of the author.

100

or children to the store to buy flour, sugar, and other items sold in sacks gave specific instructions: "Now you make sure you get four of the same pattern!" Quilters commonly used feed sacks, both for the pieced quilt top and for backing.

This particular quilt made by Sudie combines music, politics, and flour sacks with Texas twist. Some of the blocks have pieces of feed sacks that came from

the Hillbilly Flour Mills, once owned by the forty-third governor of Texas, Wilbert Lee "Pappy" O'Daniel. Wilbert O'Daniel was born in Malta, Ohio, and grew up on a farm in Kansas. After completing business college, he started working in various flour-milling companies, eventually going into the milling business himself. In 1925, O'Daniel and his family moved to Fort Worth, Texas,

where he became manager of Burrus Flour Mills. To promote Burrus Flour, Pappy used the radio airwaves, writing songs and hiring a group of musicians to sing them. In 1931 he formed the Light Crust Doughboys at the suggestion of Bob Wills, who worked in the mill by day and played fiddle by night. Pappy O'Daniel wrote many songs and was closely associated with the musical style

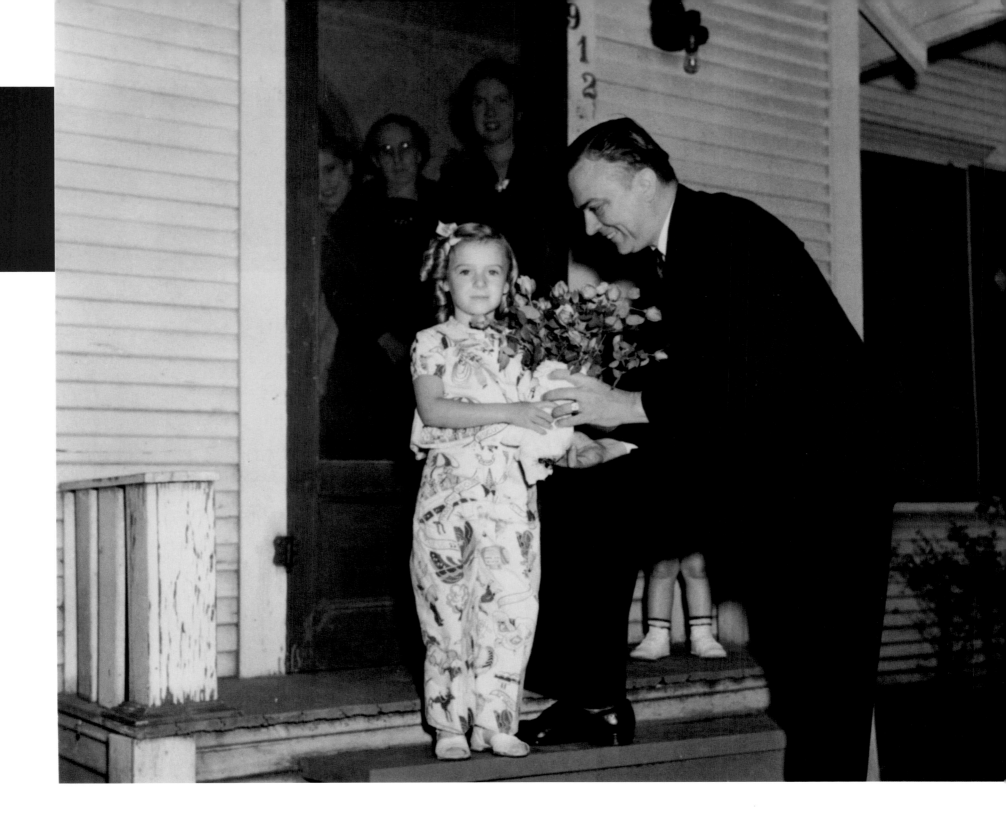

Little girl giving flowers to Governor O'Daniel, Terrell, Texas, 1941. Note feed-sack material in the child's outfit is the same as the feed sack in Eva Sue Doherty's Four Tulips Quilt. Courtesy Texas State Library & Archives Commission, with permission.

called Texas swing, a style immensely popular with listeners throughout the South. O'Daniel left Burrus Mills in 1935 and began his own milling company, Hillbilly Flour. A new Texas swing band, the Hillbilly Boys, with vocalist Leon Huff was created and played daily on the radio. O'Daniel capitalized on the success of the Hillbilly Boys by printing feed sacks with Texas symbols, portraits of the band members, and names of various popular songs. Pappy ran for governor of Texas in 1938 and won, due in part to the immensely popular radio show, "The Hillbilly Flour Boys," and in part to a Democratic platform that appealed to his largely rural audience.

Sudie's quilt is a good example of the type of quilts that were made with matching feed sacks, and pieces with the prints appear as well as pieces with the musical motifs, including one with WBAP, the radio station that broadcast the Light Crust Doughboys. The quilt, made in a Four Tulips pattern, measures 68" x 76" and has nine large blocks, each measuring 22" x 22". The quilt also has three half blocks composed of feed sacks, fabrics, and muslin. It is heavily batted with cotton and has a one-inch-wide self-binding turned from back to front. Because the quilt has been constantly used by family members, it is well worn. Sudie made quilts throughout her life-

time, but most have not survived because of everyday wear.

Although Eva Sue Doherty was being frugal as she made her quilt, she saved a bit of Texas history for the rest of us. Her Four Tulips Quilt has preserved a printed story in the flour and feed sacks she cut and stitched into quilts to keep her family warm. As colorful and creative as they were, these were not show quilts—Eva Sue was far too busy. She had twelve children to feed, clothe, and rear; maybe, as she quilted, she also listened to Texas swing on her radio.

Detail of Four Tulips Quilt block with feed-sack material in center.

Yo-Yo Quilt, c. 1935, 82 1/2" x 96 1/4", made by Etta Nelson Back, owned by Ann Lucas.

Yo-Yo Quilt

c. 1935

Etta Mae Nelson Back

Mansfield, Tarrant County, Johnson County

Shared by Ann Lucas

Just by looking at quilts, we often see hints about the women who made them. From the selection of fabrics and colors, from the choice of patterns and borders, from the use of appliqué or piecework, those decisions reveal personalities or lifestyles. Why did the quilter choose this pattern or this layout? Why did she select that fabric? Was her choice from her heart or from necessity? In this way, Etta Mae Nelson Back's Yo-Yo Quilt, just from its unusual orderly layout, reveals something about the quilter herself.

Etta Nelson Back, 1900. Courtesy Ann Lucas, with permission.

Etta Mae Nelson was born on September 15, 1884, in Mansfield, Texas, during the rural phase of that town's growth. A few miles southeast of Fort Worth, Mansfield is located in parts of three counties: Tarrant, Johnson, and Ellis. Founded by Ralph Man and Julian Field, when they sold their interests in Fort Worth and moved to southeastern Tarrant County, the settlement was named jointly for the two men. Mansfield prospered as the Dallas–Fort Worth area prospered, changing from a rural area into a suburb of the metroplex.

But, as mentioned, Mansfield was still rural when Etta was born. When she was only fifteen, Etta married Charles Jacob Back on September 1, 1900. Their marriage produced two sons, Harvey and Dudley, but Dudley died when he was only a baby. The marriage lasted just seven years, and Etta and Charles divorced in 1907, not a common occurrence for that day and age. Etta never remarried, raising Harvey by herself. Perhaps being a single mother and divorced were factors that brought out Etta's strength and allowed her disciplined personality to emerge, those assets that served her in every facet of her life. Etta was a fastidious homemaker, and she also loved to garden and quilt. Great-granddaughter Nancy White recalls that her great-grandmother "was a very ordered person, with a stern personality and disciplined in her manner. Even her

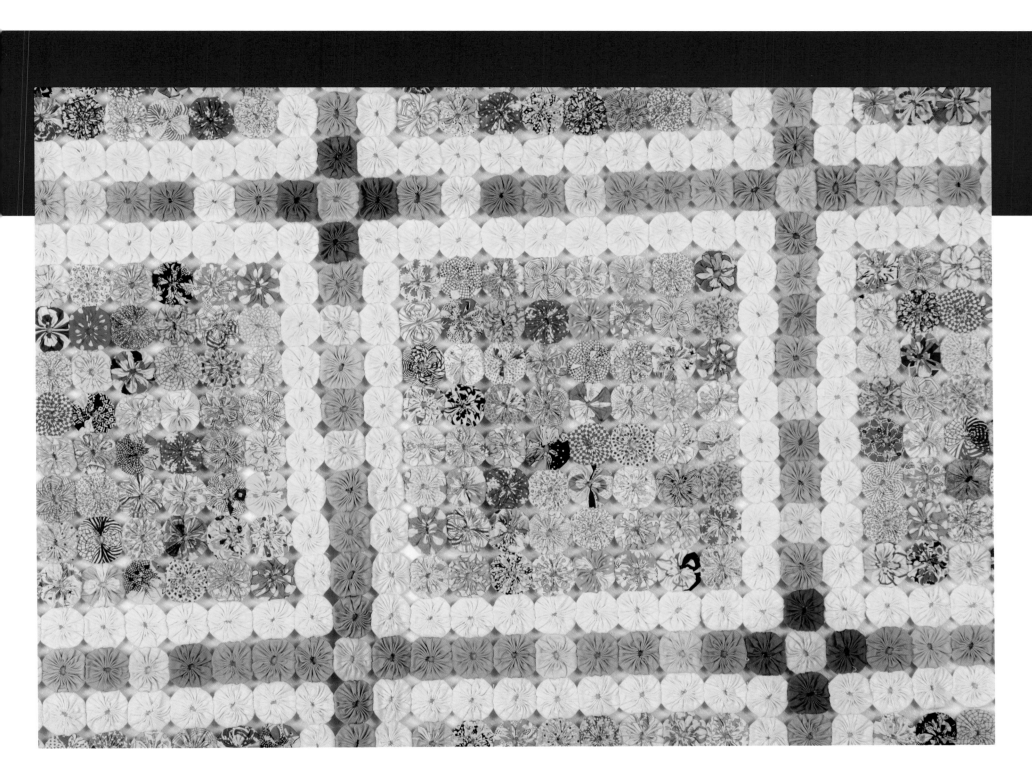

Detail of yo-yos in Yo-Yo Quilt, each measuring one and a quarter inches in diameter.

Yo-Yo Quilt, c. 1935

gardens were straight and orderly." Thus in every part of her life, Etta demanded order. Her great-granddaughter Ann Lucas agrees. "She had a formidable manner about her even in her later years. You did not want to make Granny Back angry!"

The Yo-Yo Quilt featured here also reflects her sense of order and rigid discipline. Rather than sew yo-yos together in a random fashion, Etta pieced her quilt with 5,082 one-and-a-quarter-inch yo-yos, creating a traditional quilt pattern with sashings. The quilt, measuring 82 1/2" x 96 1/4", has thirty blocks, each measuring 12 1/2" x 12 1/2", and is triple

sashed in solid yellow yo-yos with cornerstones and three outer borders in blue, pink, and peach yo-yos. Although the strong lines and well-defined pattern of this quilt lack spontaneity, they highlight Etta's knack for bringing order and beauty to her surroundings.

"One had a sense that her house, her gardens, and her quilting fabrics were all there just to do her bidding," says Ann. And this quilt reflects how her garden, her house, and her quilting fabrics must have obeyed her commands. In her garden zinnias and snapdragons must have grown in perfectly straight rows, and perhaps roses bloomed in pastel shades, such

as the Peace Rose, Tiffany, or Helen Hayes. Ann also remembers seeing a stunning fan quilt with a lilac backing mounted in the quilting frame at her great-grandmother's house. "She was very proud of it and liked to show it to visitors, but failing eyesight and poor health kept her from completing it before she died." Ann inherited Etta's unfinished quilt as well as the Yo-Yo Quilt, and for her they remain a tangible remembrance of the well-ordered life of her great-grandmother.

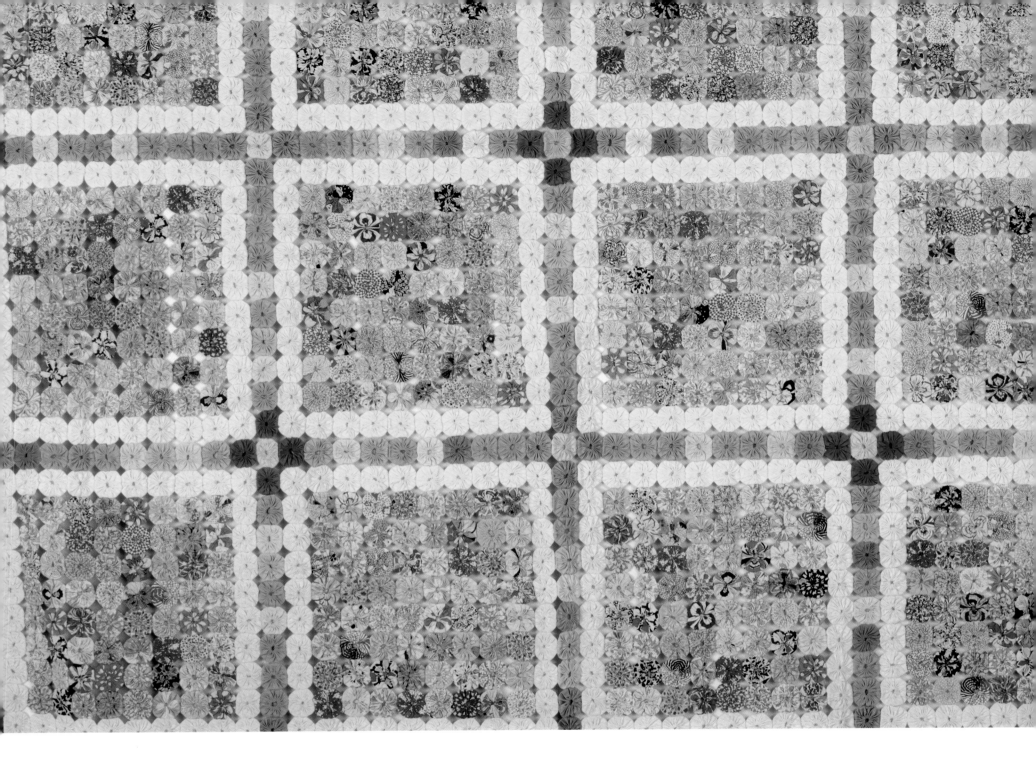

Detail of how blocks are set for the Yo-Yo Quilt with yo-yos to create triple sashing.

Y o - Y o Q u i l t , c . 1 9 3 5

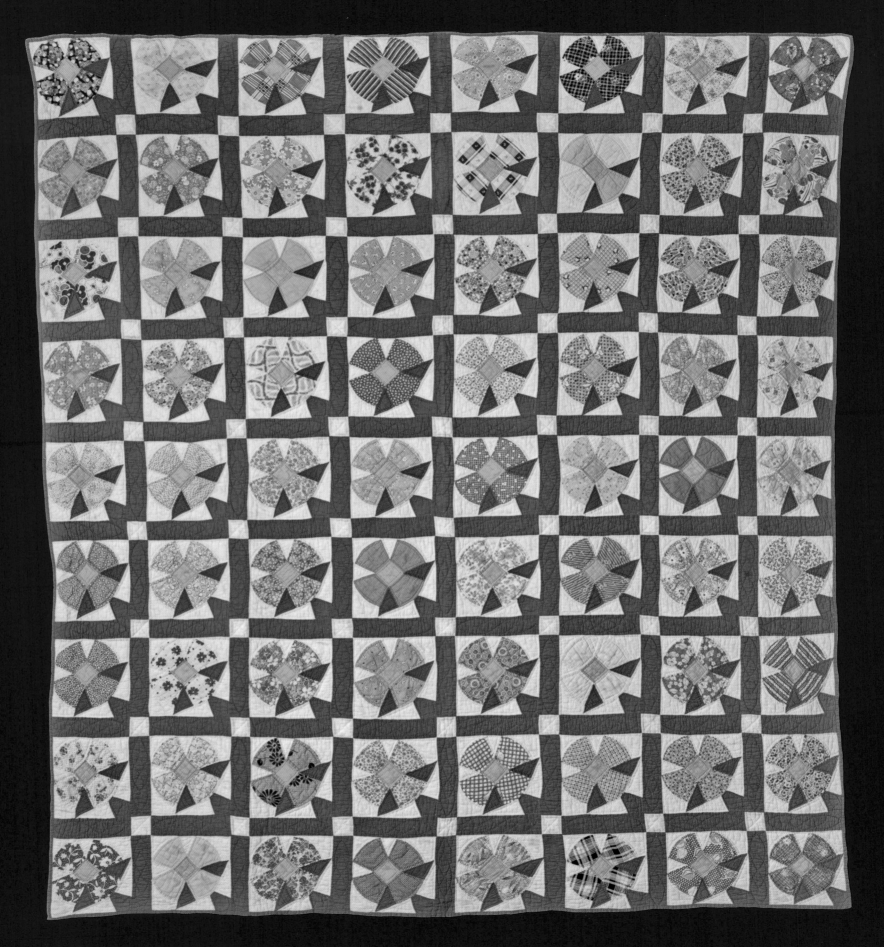

High School Graduation Friendship Quilt, 1936, 72 1/2" x 82", made by Bertha Richardson York, owned by Sybil York Harrell.

High School Graduation
Friendship Quilt
1936

Bertha Richardson York

Panhandle, Carson County

Shared by Sybil York Harrell

Some of us have been taught to quilt by a mother or grandmother; a few recall playing under a quilt frame as a mother, grandmother, or a group of women chatted and stitched. Others have memories of quilting bees where they, themselves, made friendship or wedding quilts, commemorating a special day. In this quilt, a mother stitched an entire bouquet for her daughter's graduation day.

I met that daughter during my visit to the Squarehouse Museum in Panhandle in August 2004. I was there, searching for

Bertha Richardson York, 1908. Courtesy Sybil York Harrell, with permission.

Texas-made quilts and speaking to a group of museum quilters about quilt care and conservation methods. During my day at the museum, Sybil York Harrell and her daughter, Beverly Harrell Ingram, arrived with this quilt made in 1936 by Sybil's mother, Bertha Richardson York, as a surprise graduation gift for Sybil.

Bertha Viella Richardson was born January 1, 1881, in Alco, Arkansas. She married Dr. Henry Andrew O. York on August 31, 1901. Bertha York was a homemaker, but she also raised chickens and cows, gardened, churned her own butter, sewed for her family of eleven children, and made her own soap. However, her health suffered in the humid climate of Arkansas, so the family moved, in March 1906, to the drier climate of West Texas, settling in the town of Panhandle. Dr. York chose Panhandle after encountering some of the town's men on a train traveling west. Their enthusiasm for the town, as well as the town's need for a doctor, convinced him to settle his family there. Panhandle, Texas, located in Carson County, was the terminus for the railroad in the late 1880s, and as such, it prospered, surrounded by cattle ranches, eventually building churches, mercantiles, and law offices. By the turn of the century, Panhandle had become a mecca for those seeking restored health at its sanatorium.

With her health restored, Bertha York and her family thrived in Panhandle. When her daughter Sybil's last year in high school arrived, Bertha

Senior Class of 1936, Panhandle High School, Panhandle, Texas. Sybil is pictured at lower right in photo. Courtesy Sybil York Harrell, with permission.

Detail of High School Graduation Friendship Quilt block showing green sashing, a characteristic color used during the 1930s.

Detail of High School Graduation Friendship Quilt showing a block with fabrics from a classmate's dress.

wanted to do something special; she decided to make a quilt. Because it was a friendship quilt, Mrs. York asked each of the girls in Sybil's class to bring a piece of fabric to make the flowers in the blocks. The pattern is called Friendship Flowers, designed by Brooks/Wheeler, readily available in newspapers during the 1930s. The friendship quilt measures 72 1/2" x 82" and is made of seventy-two blocks, each measuring 8" x 7 1/2", with colorful fabrics for the flower petals and solid green cotton for the leaves, stems, and sashings that measure two inches in width with muslin cornerstones. The

borderless quilt has no signatures, making it somewhat unusual for a friendship quilt. Looking at the fabrics of the flowers, I can imagine the swirling dresses of Sybil's classmates at a tea party or their white gloves folded over their laps at Sunday school. Sybil, too, must have been able to recall her friends, even without a signature, each time she touched the petals of every square.

Bertha York made quilts for her children—Lone Star quilts for each of her sons, knowing that's what suited them; doll quilts for her daughters and granddaughters, making sure the quilts she

gave were keepsakes. According to her daughter, Bertha often quilted with another woman but would sometimes pick out her stitches at night if they weren't good enough.

This High School Graduation Friendship Quilt exemplifies how heritage and quilting are bound together. Sybil's mother had made the quilt, and Sybil's daughter had come to the Panhandle Museum to learn about quilts with her; generation by generation, the art of quilting continues.

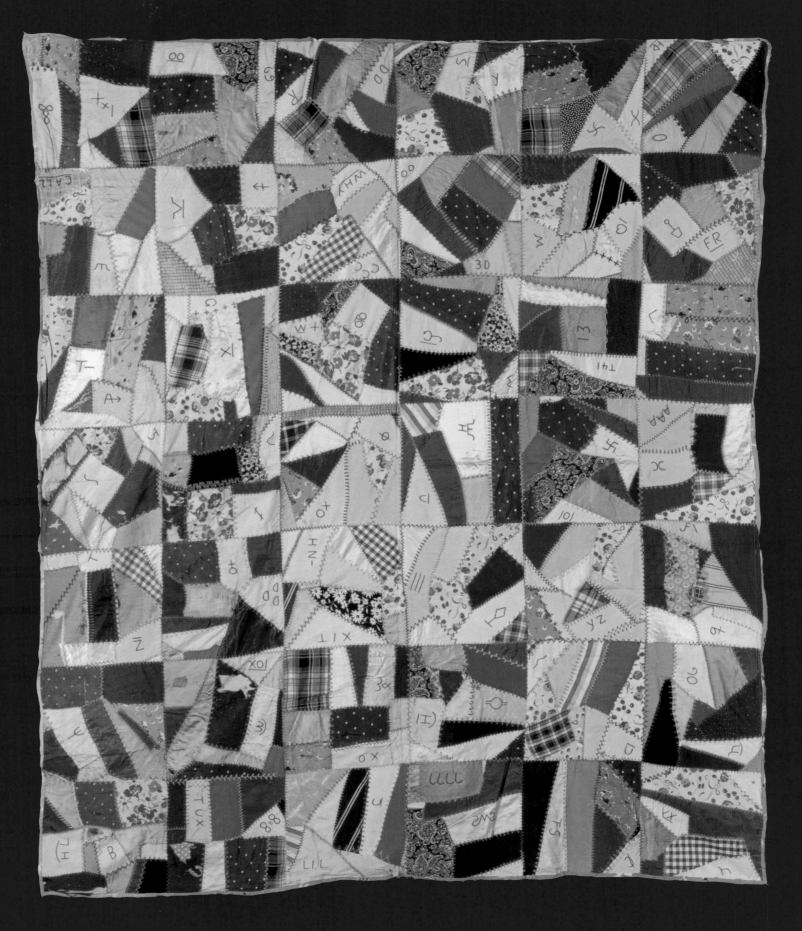

Crazy Quilt with Cattle Brands, 1935, 60" x 70", made by Willie Ann Tackitt Young, owned by Kay Prestridge.

Crazy Quilt with Cattle Brands

1935

Willie Ann Tackitt Young

Guthrie, King County

Shared by Kay Prestridge

Cattle brands and crazy quilts—an odd mixture, but in Willie Ann Tackitt Young's hands, this quilt turns out to be better than a telephone directory, for Willie's quilt tells which ranches were in King County and what brands were registered at the time. This Crazy Quilt with Cattle Brands, which has brands as its sole style of embellishment, was created by Willie Ann Tackitt Young in 1935 as a record of the cattle brands of her husband and sons' ranches and those of their neighbors.

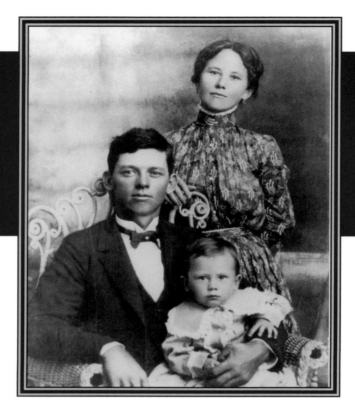

Harper and Willie Ann Tackitt Young with their son, Hubert, 1899. Courtesy Kay Prestridge, with permission.

118
★

Willie Ann Tackitt was born on May 7, 1878, in Graham, Texas, to a Texas pioneer family. Her mother, Louisa, had married Andrew Tackitt at the age of twelve. Andrew, Willie Ann's father, later became a Texas Ranger, surveyor, sheriff, and King County judge, and in 1891, her family built the first house in Guthrie, the seat of King County. Willie Ann's grandfather, William P. Tackitt, was known as the Fighting Parson of Young County because he preached with a Bible in one hand and a gun in the other, prepared for the Indian raids. Needless to say, Willie Ann came from a Texas heritage that prepared her for the difficulties of life on a ranch.

Willie Ann married Harper Young, known as H.P., on August 20, 1897. When he was fourteen, H.P. had come alone to King County, Texas; he was breaking horses at the "Old 8" Ranch when he and Willie married. After the wedding, they lived at the "Old 8" Ranch, which Burk Burnett later bought and made part of the 6666 Ranch. In 1909 the Youngs moved to a 160-acre farm north of Guthrie. In 1926, Harper bought nine sections of ranch land, mostly in King County. With that responsibility, he and his sons Hubert and Mann concentrated on running the ranches and lived there most of the time.

Detail of Crazy Quilt with Cattle Brands showing Harper Young's brand.

Crazy Quilt with Cattle Brands, 1935

Detail of Crazy Quilt with Cattle Brands showing the XIT brand.

Willie Ann stayed at the farm, being more of a homebody, preferring sewing, rearing her children, and tending to the farm animals. Particularly fond of a flock of wild turkeys that roosted in the trees by the house each evening, she made them batches of cottage cheese for food. She raised chickens and saved money from the sale of the eggs to buy a Victrola. Although Willie enjoyed church music, she was unable to attend church regularly, so she also bought a

pump organ with her egg money and learned to play it. Even though living on a farm, Willie Ann valued education, and each of her children attended college. Continuing to stay on the farm, Willie kept up with her work and sewing and ran the farm until her death in 1945.

The Crazy Quilt with Cattle Brands was made in 1935, when the popularity of crazy quilts was waning. Backed in teal floral rayon, it measures 60" x 70"and is made of forty-two blocks, each meas-

uring 10" x 10". It is foundation pieced and has no borders. The quilt, made for Willie's son Mann, is embellished with embroidery stitching at the edges of pieces, within the blocks, and also where the blocks are pieced together. The only embellishment consists of cattle brands, drawn by pencil and embroidered over with perle cotton. The quilt looks like rangeland scattered with cattle, and the brands include Harper's own brand embroidered on pink solid. Other brands

Detail of Crazy Quilt with Cattle Brands showing pencil markings under embroidery. Note that silk fabric in lower left corner shows a state of disintegration.

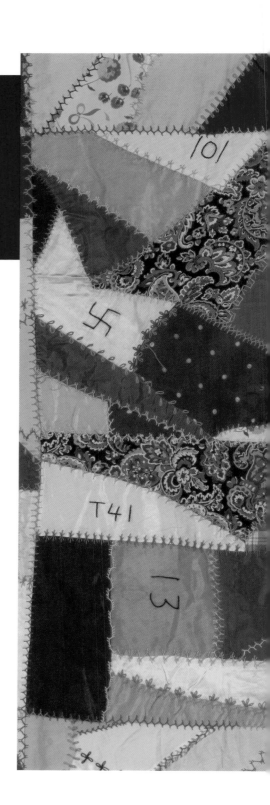

fill in the open spaces, with some brands, like the XIT, more famous than others. Even though Willie embroidered over her pencil markings, some of those markings are still visible on the quilt.

Crazy quilts from the Victorian era were usually heavily embroidered with flowers, motifs, symbols, initials, and dates, but it is more common to see crazy quilts from the early twentieth century, like Willie Ann's, with less decorative stitching. She has taken an example of

ornate Victoriana and transformed it to fit her lifestyle with the choice of western motifs and simplicity of ornamentation. Willie approached challenges head on, whether facing difficulties of a ranching life, bringing music into her life, or changing the style of a quilt to suit her.

Detail of Crazy Quilt with Cattle Brands showing many brands from neighboring ranches.

Crazy Quilt with Cattle Brands, 1935

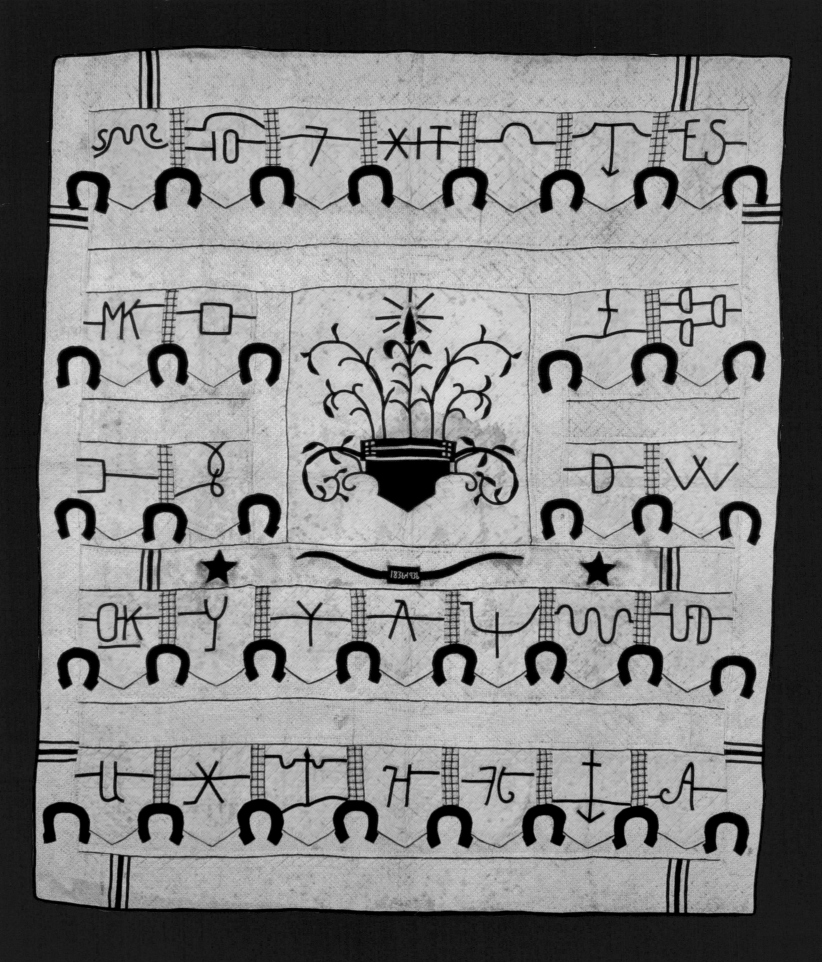

Cattle Brand Quilt 1936, 67" x 82" made by Frances Punchard McCulloch, owned by private collector.

Cattle Brand Quilt

1936

Texas A&M Quilt

1938

Frances Punchard McCulloch

San Saba, San Saba County

Shared by Paula Mitchell

When I first examined the Cattle Brand Quilt made by Frances Punchard McCulloch, its new owner showed me a newspaper clipping that had arrived with it. Pictured there was a second quilt made by the same woman. These two quilts, so Texan and yet so very different, piqued my interest in the quilter who made them and in her story. That newspaper photograph started my long search for the second quilt, and Frances's Texas A&M Quilt was not going to be another quilt that I let slip away.

Texas A&M Quilt, 1938, 65" x 82", made by Frances Punchard McCulloch; in the collection of Texas A&M University.

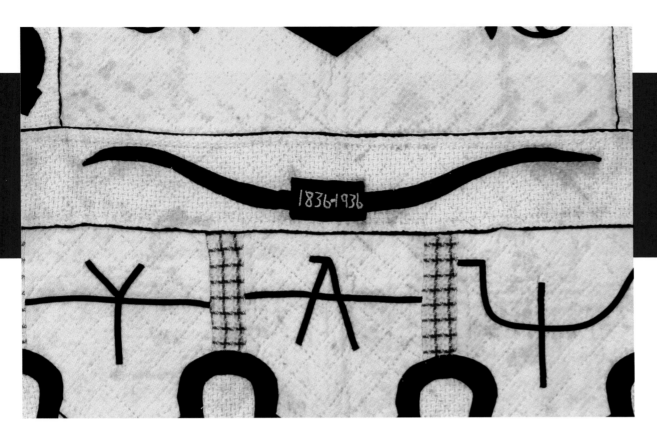

Detail of McCulloch Cattle Brand Quilt showing centennial dates inside longhorns.

Frances Punchard was born in 1911 in Rogers, Texas, a town in Bell County. Little is known about Frances's early years, but she did graduate from Rogers High School in 1928, and her younger sister, Johnnie, graduated in 1930. Both young women attended Baylor Women's College in Temple, known today as the University of Mary Hardin Baylor. When Frances graduated in 1932 with a degree in home economics and a minor in art, she was hired by the Texas Agricultural Extension Series as a home-demonstration agent and worked as one of the county home-demonstration agents for San Saba County from 1936 to 1938.

San Saba is a small town located on the banks of the San Saba River. First settled in the 1850s and well established by the 1880s, the town's economy always had an agricultural base even though crops changed throughout the years. In the 1930s and '40s, the government sent county extension agents and home-demonstration agents like Frances to help the local townspeople. These agents demonstrated ways for farm families to improve home life as well as how to start marketing co-operatives and home demonstration clubs. One monthly activity of the clubs was quilt making. Frances worked as a home-demonstration agent in San Saba County in the 1930s and in Tarrant County in the 1940s.

Frances created her Cattle Brand

Detail of McCulloch Cattle Brand Quilt showing XIT brand and horseshoes worked in black wool crepe.

128 ★

Quilt in 1936 as Texas celebrated its Centennial and quilters found ways to commemorate the event, incorporating the dates 1836–1936 into their quilts in some way. In her quilt, Frances placed the Centennial dates in the center of the longhorns. The quilt, which measures 67" x 82", has twenty-nine brands from various ranches on it, many of them famous. Frances made the quilt from nontraditional woven cotton fabrics, using black wool crepe for the horseshoes

and center motif and woven checked fabric between the brands to represent roads or fences. The quilt has five-and-a-quarter-inch top and bottom borders as well as three-and-three-quarters-inch side borders, and black flanging throughout. In color, pattern, and visual presentation, the quilt is complex in design and distinctly Texan in feel.

I started my search for the Texas A&M Quilt with the information in the article accompanying the Cattle Brand

Quilt. According to the article, Frances had made that quilt as a Christmas gift in 1938 for John Shows, who had been the agricultural adjustment agent for San Saba County and had worked with her. Shows had been extremely proud of his Texas A&M Quilt and often took it to alumni meetings and Aggie Musters.

I knew my next step: to continue my search at the Texas A&M Alumni Association. There I found Shows's last known address. After writing to him and

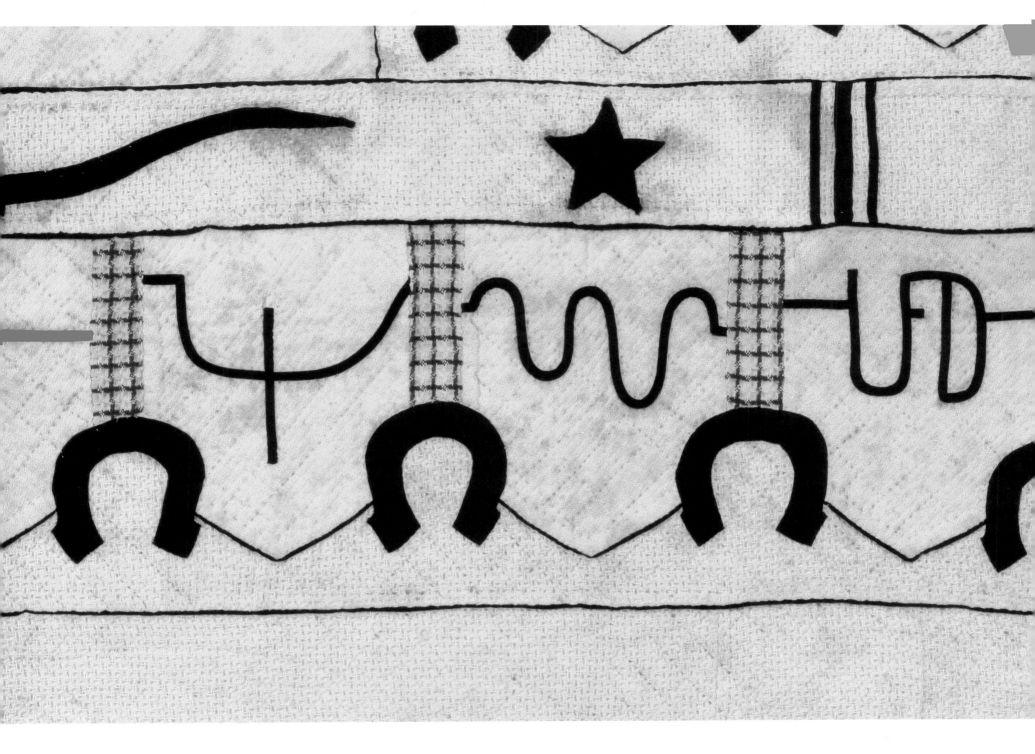

Detail of McCulloch Cattle Brand Quilt showing other brands and woven checked fabric to represent roads and fences.

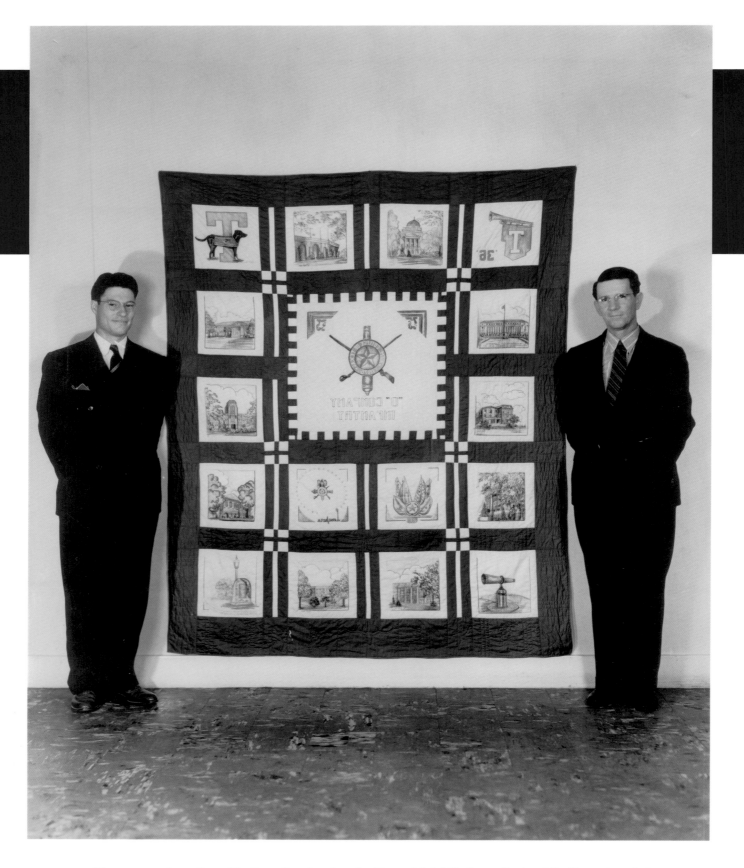

Newspaper photo from *The Battalion* showing the Texas A&M Quilt on display. Mr. Shows is at left.

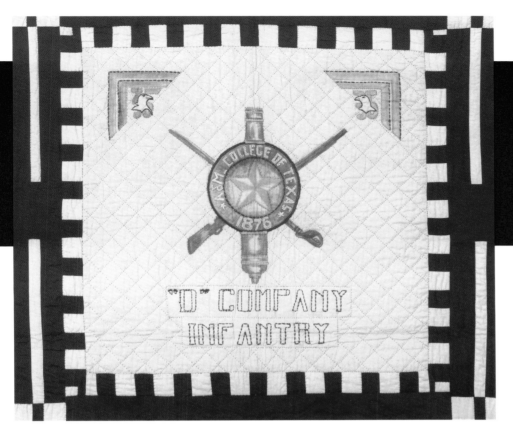

receiving no reply for months, I believed my search for the quilt had ended. Then I received a telephone voice message from Shows's son. My letter had been forwarded to him; his father had died in 2001. He left no telephone number but did add that he had contacted his sister. Stumped again and about to give up on the location of the Texas A&M quilt, I received a phone call from Shows's daughter, Paula Mitchell, who told me her father had bequeathed the quilt to

Texas A&M. The quilt was back in Texas after traveling to Mississippi with Shows and then to Tennessee with his daughter. Finally, in December 2003 at College Station, I examined the quilt.

Made in 1938, the quilt is a visual tour of Texas A&M University. It measures 65" x 82" and is made of sixteen blocks with scenes and symbols of the university rendered in crayon and colored pencil. The center medallion bears the Coat of Arms and the Texas Seal, the

two symbols that are pictured on the sides of the senior class ring. In the upper right corner of the quilt is a block with Reveille, the first university mascot, a black dog with white paws, rather than the familiar collie that is the present Reveille. The background fabrics are maroon and white, the school colors, and each block is individually quilted to enhance the designs. The borders of the quilt are quilted with cacti, Texas stars, and longhorn designs.

John and Frances lost touch during World War II when Shows served in the military. After the war he settled in Mississippi, married, and had two children. Frances continued with her work, met and married Brady McCulloch, and settled in Huntsville, Texas. They had no children, but Frances continued working on her many projects. She was a woman of many talents, building a lake cabin and refinishing furniture. She continued quilting but later gave it up in favor of her greater passion, genealogy.

John never forgot Frances and visited her in Huntsville in 1987. The story of the quilt and their friendship appeared in the *Huntsville Item* newspaper along with the photo of John Shows and the Texas A&M quilt—the same photo I saw attached to the Cattle Brand Quilt that started my search.

Reveille

Detail showing first Texas A&M mascot.

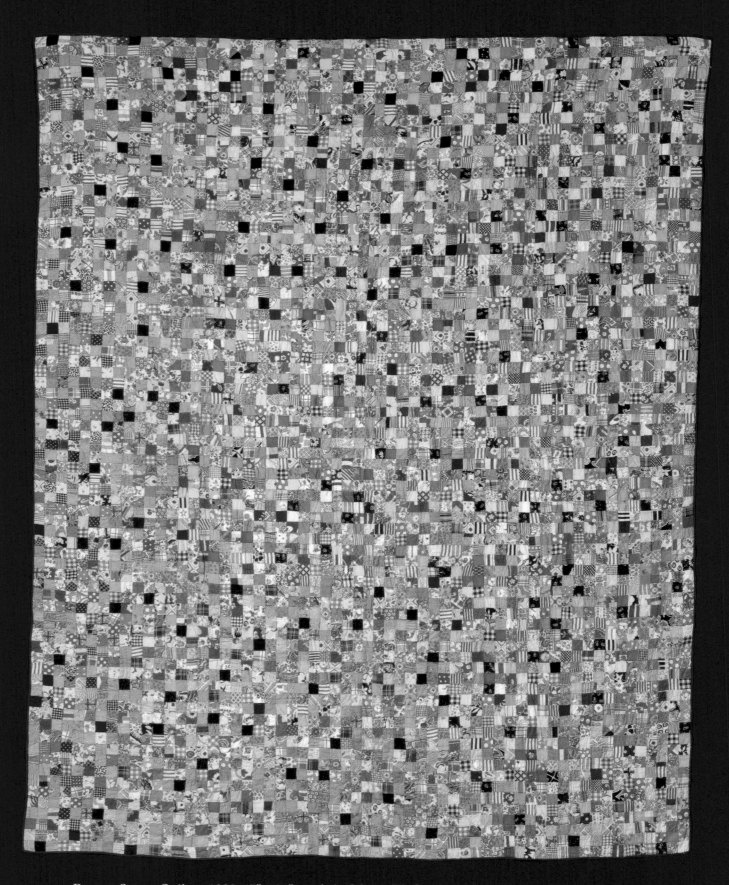

Postage Stamp Quilt, c. 1938, 67" x 84", made by Mattie McCutcheon Adams, owned by Rossie Gideon.

Postage Stamp Quilt

c. 1938

Mattie McCutcheon Adams

Brownfield, Terry County

Shared by Rossie Gideon

October 1929 began the Great Depression with the stock market crash, which brought even harder times for farmers. In the drought years that followed, farmers learned that every little bit counted, whether money, water, or food. Quilters saved their scraps, even the tiniest, and cut them into squares resembling stamps; often those squares were less than one inch in size. This Postage Stamp Quilt, made c. 1938 by Mattie Adams, is an example of how quilters found a practical and colorful way to

Mattie McCutcheon, at left, and her sisters with their father, 1903. Courtesy Rossie Gideon, with permission.

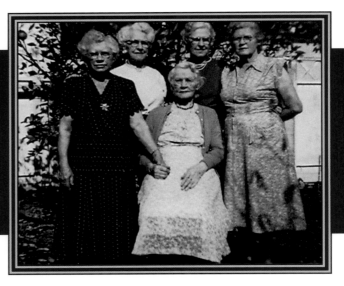

Mattie McCutcheon Adams, at left, and her sisters, taken before 1956. Courtesy Rossie Gideon, with permission.

136

★

continue their art even during the most difficult times.

Mattie Bee McCutcheon was born on September 22, 1883, in Marysville, Missouri, the ninth of twelve children. On Christmas Day in 1907, she married Charley Ross Adams in Tipton, Oklahoma, and they moved to Brownfield, Texas, in Terry County. Brownfield had become a town in 1903, the county seat in 1904, and the railroad arrived in 1917, enabling the growth of farming and the cattle market.

Ross was a farmer, and Mattie had a busy life rearing the children, keeping house, and raising chickens to make down pillows. She quilted prolifically with a quilt always in the frame and scraps in her basket, ready for piecing.

Mattie's Postage Stamp Quilt measures 67" x 84" and has 4,560 one-inch squares in it. The backing is solid pink cotton, and the colorful cotton fabrics in the quilt top are a sampler of the fabrics available during the 1930s and 1940s. Mattie has taken a variety of fabrics:

solids of every shade; calicoes, some feminine, others more masculine in colors such as brown and navy; paisleys; polka dots, both white and colored; florals, varying in size from small flowers to large ones that fill the entire square; plaids, set straight or on a bias; checks and vibrant stripes in every color, with some set horizontally, some vertically, varying even in the same fabric. Although practical, Mattie has shown a playful spirit in the way she combined and cut her tiny squares.

Detail of Postage Stamp Quilt.

Mattie also passed on her love of quilting to her daughter, Pauline Adams Lyles, who passed on the same to her daughter, Rossie Gideon. Rossie recalls that "in 1956, when my son was four months old, Grandma came by to see us. My mother had a quilt up in the frame. For the first time in my life, I got to quilt with Grandma." It was also the one and only time that mother, daughter, and granddaughter sat together at the quilting frame, a never-to-be-forgotten memory.

Mattie's Postage Stamp Quilt represents a pattern that was one of the fads in quilt making that persisted for many decades. She did not have the luxury of buying a variety of fabrics or "fat quarters" as quilters do today. She had feed sacks, friends, and clothing scraps. From these, she cut squares, and cut squares, and cut squares. The result was a bright, colorful bedcover to keep her family comforted during the hard years of the Great Depression.

Detail of Postage Stamp Quilt showing variety of fabrics used in quilt.

Postage Stamp Quilt, c. 1938

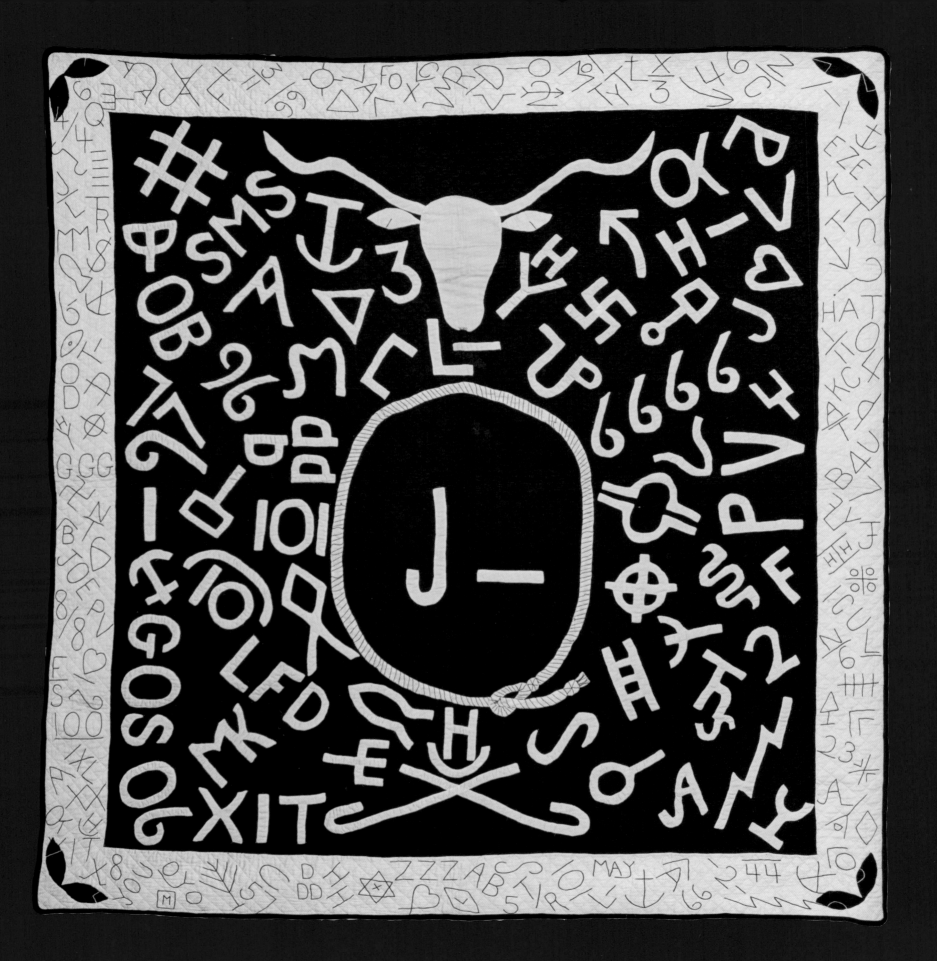

Jack's Brand Quilt, 1945, 72" x 87", made by Gertrude Robertson Roberts, owned by Jack Roberts.

Jack's Brand Quilt

1945

Rainbow Quilt

1946

Gertrude Alnora Robertson Roberts

Sierra Blanca, Hudspeth County

Shared by Jack and Mary Roberts

To one extent or another, people seem to be shaped by place. Consequently, so are their stories. And sometimes a quilter's story is so enriched by the region that her quilts themselves become narratives of place. These two quilts by Gertrude Alnora Robertson Roberts tell her story and, at the same time, tell how she discovered that stark beauty in a place called Sierra Blanca, Texas.

Sierra Blanca, at the base of a mountain with the same name, some eighty miles southeast of El Paso, is the seat of

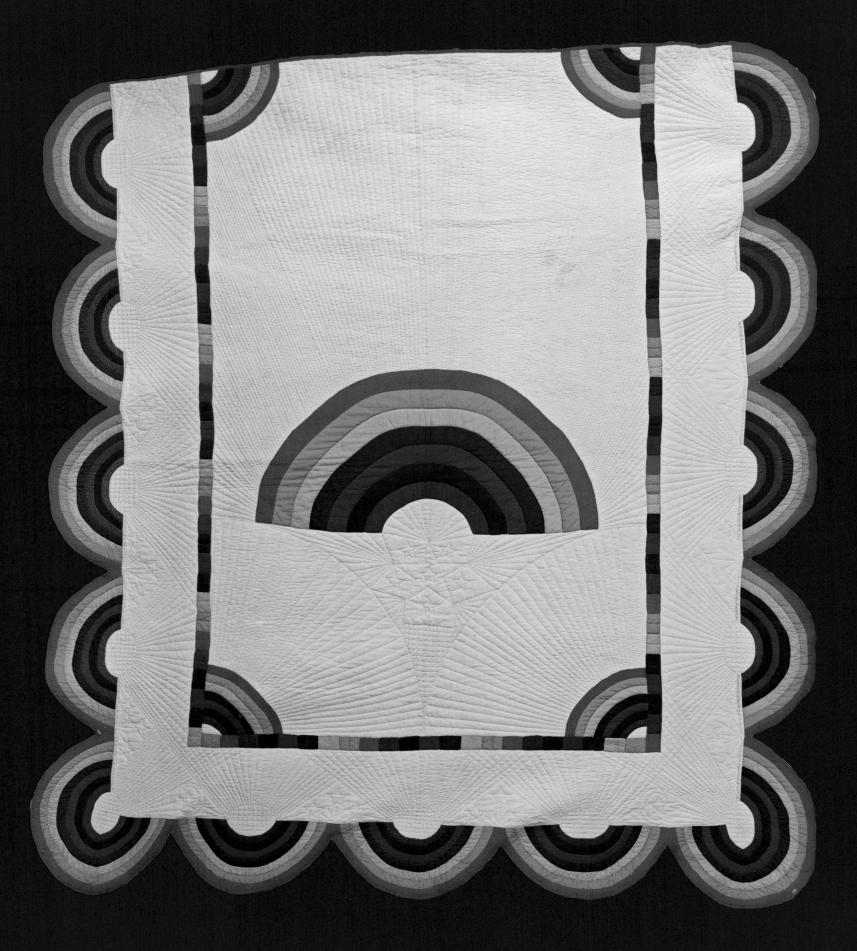

Rainbow Quilt, 1946, 72" x 90", made by Gertrude Robertson Roberts, owned by Mary Roberts.

Detail of Jack's Brand Quilt with hand-made cardboard templates.

Hudspeth County. Historically famous as the site where Jay Gould drove a silver spike to join the nation's second inter-continental rail in 1881, Sierra Blanca grew into an important shipping center with local ranchers using the town as a railhead for shipping cattle.

Although Gertrude Robertson was born in Michigan on April 8, 1903, a far cry from Texas, she and her family moved to El Paso when she was fourteen years old. There she met Lafayette Wilmuth "Bill" Roberts, a man who had a ranch near Sierra Blanca where he raised horses for the United States Cav-alry. In 1920, Gertrude and Bill married and had their first son, Jack. Gertrude, known to her friends as "Missy," kept busy with ranch work when her children were young, often carrying them on horseback with her. According to Jack, "There was no entertainment on a ranch other than hard work." Later, after the boys were older and able to help with ranching chores, Gertrude began quilting and crocheting to keep busy. In the evenings she quilted at first by the light of a brass-bottomed coal oil lamp and later by gaslight, which provided better illumination. Jack built her first quilting frame, suspending it from the master bedroom ceiling by ropes that could be raised and lowered for use. "We were all glad when she went to using hoops instead," he said in an interview in his home on April 15, 2005. Later, she used

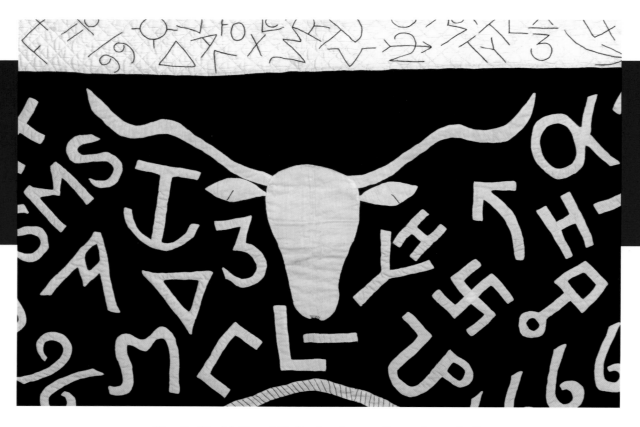

Detail of Jack's Brand Quilt showing appliqué of cow skull.

Detail of Jack's Brand Quilt showing various brands from Hudspeth and other counties.
Note embroidery details on lasso at bottom center.

Detail of Jack's Brand Quilt showing ear tag appliqués in corner of quilt.

hoops, and Jack said she "kept those hoops right by her chair wrapped up in a sheet and every time she sat down, she picked up the hoops and began quilting."

Gertrude quilted despite eye problems that eventually caused her vision to fail. She began to design Jack's Brand Quilt in 1932, using cardboard to make the templates for the cattle brands. The quilt, which measures 72" x 87", is an original design and has as its centerpiece a longhorn cow skull and Jack's brand, the J — (J Bar), encircled by a lasso.

Most of the brands appliquéd on this quilt belonged to Jack's uncles and relatives, but some of the brands were from famous ranches like the 6666 and the XIT. Gertrude even designed special appliqué patterns for the corners of the quilt, using ear tags from the cattle on the ranch, and she embroidered additional brands around the outer border of the quilt. Gertrude finished the quilt when Jack was serving as a Marine in the South Pacific during World War II and gave it to him when he returned home in

1945. When Jack's cousins came to stay at the ranch during the summers after the war, they persuaded Gertrude to make quilts with their own cattle brands, but none were as ornate as Jack's quilt.

But for Gertrude, the ranch at Sierra Blanca was more than just sand and cattle; around her was the color of the Guadalupe Mountains to the north, the nearby yuccas in bloom, and much more. That beauty is reflected in the second quilt. When Jack and Mary married in 1946, Gertrude surprised her new

Jack's Brand Quilt displayed on wall of the historic
Gage Hotel in Marathon, Texas.

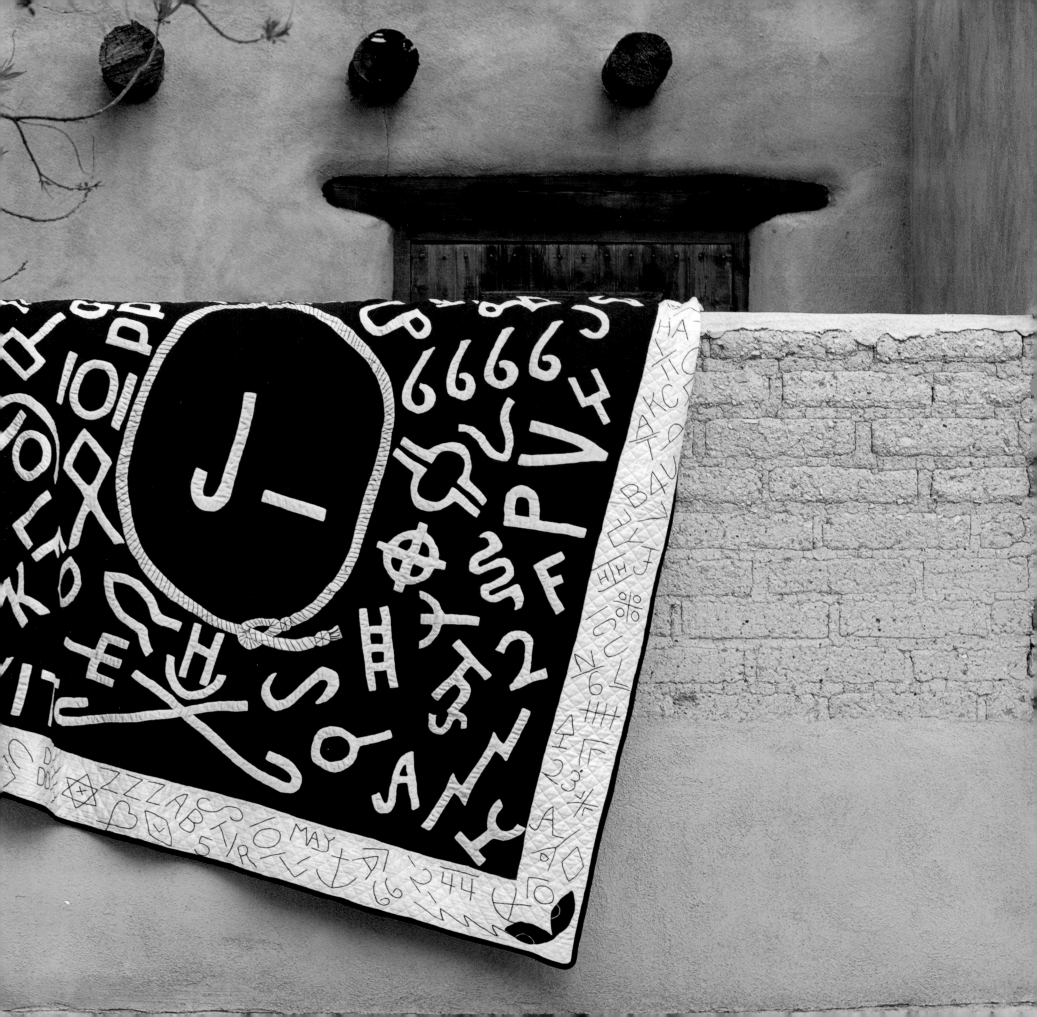

Gertrude Roberts, age ninety, wearing her original wedding dress, for her seventieth wedding anniversary. Courtesy Janie Roberts, with permission.

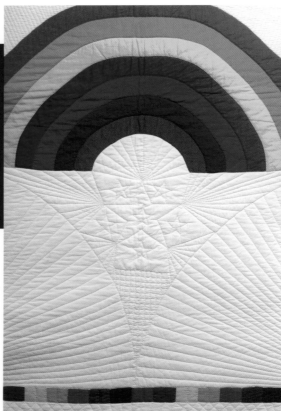

Detail of Rainbow Quilt showing original quilting designs.

daughter-in-law with this Rainbow Quilt as a wedding gift. The quilt is another original design by Gertrude, measuring 72" x 90" with a border of small rainbows on three sides. The rainbow, a symbol of beginnings, seems appropriate for a wedding quilt and also imitates the colors of sunrises and sunsets on that high desert where Gertrude had spent so many years. In her quilting stitches, Gertrude echoed her surroundings with an original design of stars that

recall West Texas skies and radiating lines like meteors streaking through space. Additionally, the lines of quilting and piecing connect—stars, lines, curves, rainbow arcs.

In 1951, even though nearly blind, Gertrude created one last Cattle Brand Quilt for Jack's brother, Bob. She made the quilt in cream and brown solid cottons and buttonhole-stitched around the brands because it was easier to see than appliqué stitching.

Gertrude's quilts show her appreciation for the ranch where she lived, the place that became a part of her. She reflected the contrast of shadow and sun in the Cattle Brand Quilt and later splashed a West Texas rainbow across muslin to celebrate a beginning for her son and his new wife. Gertrude's artisanship celebrates both the ranch and cattle around her and the startling beauty of the high desert of Sierra Blanca.

Detail of Rainbow Quilt showing corner quilting designs.

149 ✳

Rainbow Quilt shown on wall of Los Portales
courtyard at the Gage Hotel, Marathon, Texas.

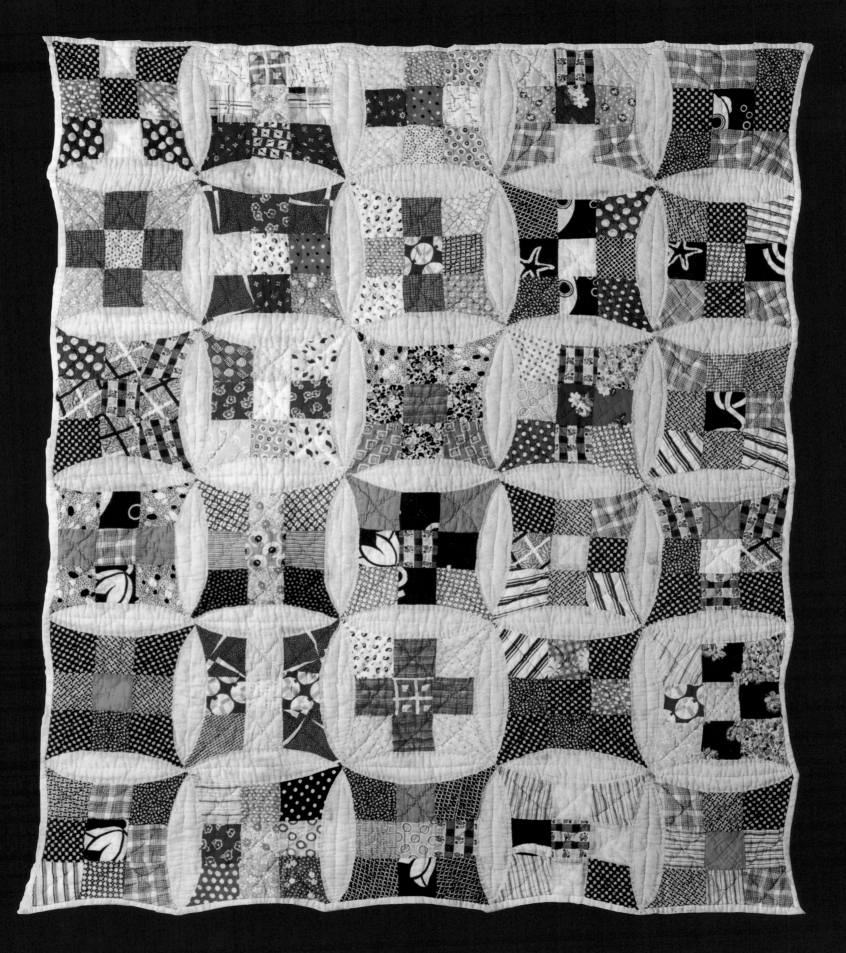

Improved Nine-Patch Quilt, c. 1940, 40"x 48", made by Elizabeth Priddy Fields, owned by Zanna Bickham.

Improved Nine-Patch Quilt

c. 1940

Elizabeth Priddy Fields

Groom, Carson County

Shared by Zanna Bickham

Children often lie in their beds and let their imaginations go. Sometimes, if quilters find just the right pattern or color to create the magic, a quilt can become Robert Louis Stevenson's "land of counterpane." Elizabeth Fields did just that when she made a special quilt for her little granddaughter, Zanna, by taking a full-size pattern and adapting it to make this Improved Nine-Patch Quilt.

Elizabeth Minerva Priddy was born on July 19, 1874, at Pilot Point, Texas. Eventually, Elizabeth moved to Nocona

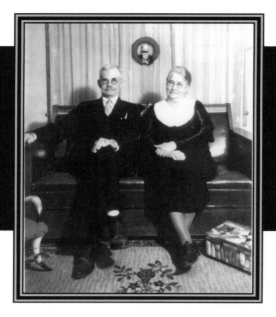

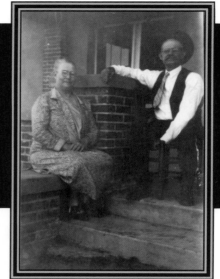

154

and became a schoolteacher. There she met Dr. Charles Lewis Fields, a traveling dentist, and they married on May 19, 1895. After her marriage, Elizabeth retired from teaching; Dr. Fields was a widower with two small children, so Elizabeth immediately began taking over the household duties. Eventually, Elizabeth and Charles had twelve children of their own, and Elizabeth was a busy woman, cooking, canning, and caring for all fourteen children.

While Elizabeth's life was primarily that of a farm wife, she also endured long absences from her husband, who was West Texas's first and possibly only traveling dentist. Loading his self-made folding dental chair and dental instruments into a horse-drawn buggy, Dr. Fields traveled the roads of West Texas, serving towns with no dentist of their own. Eventually, Dr. Fields gave up his practice, only extracting aching teeth for local cowboys and hands at nearby ranches. Having moved twice to start new farms while their family grew, in

1916 Dr. and Mrs. Fields bought a large farm property near Groom and started their new farm life in a dugout and a two-room house until a large adobe-covered stucco house was completed in 1927.

Elizabeth made this child-sized quilt for her granddaughter Zanna. The quilt measures 40" x 48" and contains thirty blocks, each measuring 8" x 8" in the Improved Nine-Patch pattern. Elizabeth made each block from clothing scraps, using a solid yellow cotton fabric for the

Detail of Improved Nine-Patch Quilt block showing variety of clothing scraps.

Improved Nine-Patch Quilt, c. 1940

Zanna Bickham in front of her Improved Nine-Patch Quilt, holding photos of her grandparents, Dr. and Mrs. Fields.

inset melon portions of the blocks. With her choice of this yellow, a soft pastel, Elizabeth brought sun into her granddaughter's quilt and onto her bed, awakening her each morning, regardless of the weather, with a touch of spring. The squares themselves seem to stretch into the sun, arms up, legs standing out wide, ready to face the day. Additionally, the quilt has a muslin backing and is self-bound with the backing turned to the front of the quilt. Interestingly, the shape of the quilt blocks at the edges of the

quilt creates a reverse scallop effect. On Zanna's "land of counterpane," Elizabeth created a maze of flowers, both large and small, where her imaginative little granddaughter could walk her fingers through gardens. With this quilt Zanna could play hand hopscotch on the nine-patch blocks or count the purples and browns across her bed. Through colors and pattern, Elizabeth pieced together a world of imagination.

In the evening, Elizabeth quilted between other chores, using whatever

materials she had on hand. Her grandchildren recall how she pieced blocks as they sat in her lap, her basket of fabric scraps nearby, and they remember the delight later in discovering bits of their own clothing pieced into her quilts. From her scraps of time and fabric, Elizabeth stitched this small quilt, perhaps a child's magic carpet, just the right size for her granddaughter Zanna.

Detail of Improved Nine-Patch Quilt block showing variety of clothing scraps.

Improved Nine-Patch Quilt, c. 1940

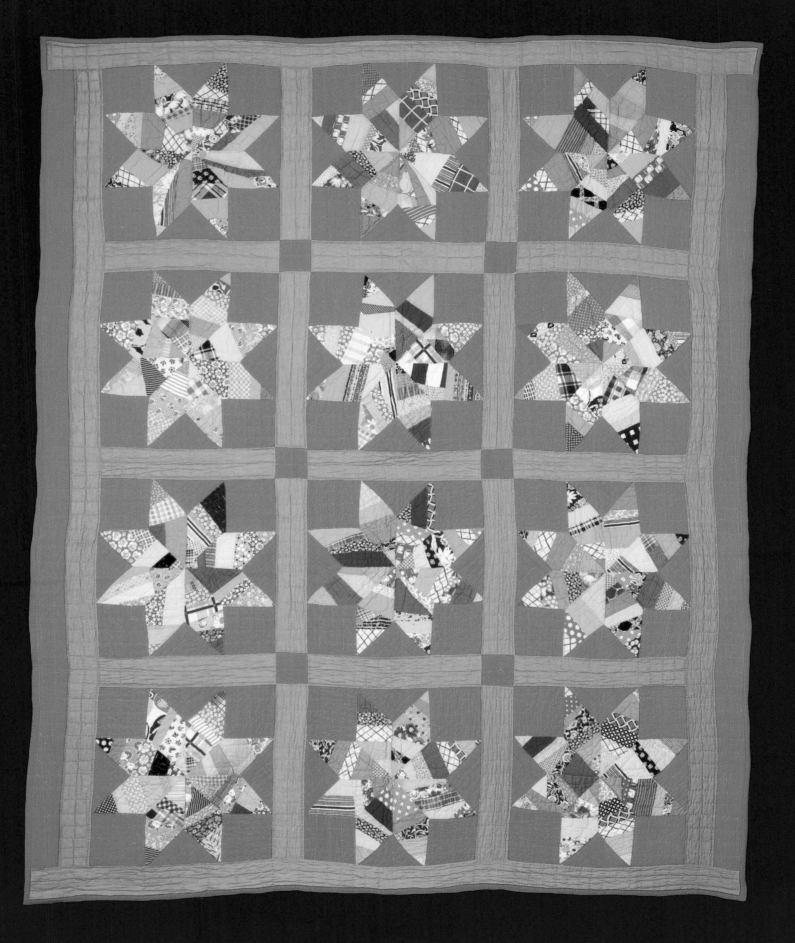

String Pieced Star Quilt, c. 1945, 66" x 81", made by Ollie Rigdon Wilson, owned by Mr. and Mrs. Johnnie L. Wilson.

String Pieced
Star Quilt

c. 1945

Ollie Rigdon Wilson

Floyd County

Shared by Johnnie and Sue Wilson

When I heard about a woman who covered her brand-new 1936 Chevrolet with worn-out quilts and blankets, even when it was in the garage, I knew this quilter lived the adage, "Waste not, want not." And so it did not surprise me that Ollie Rigdon Wilson made this String Pieced Star Quilt.

Ollie Loraine Rigdon was born March 7, 1878, in Holland, located in Bell County, Texas, and grew up in a farming family. She married Charles A. Wilson on September 25, 1898, in

Ollie Rigdon Wilson, c. 1945. Photo by Melton's, Clovis, New Mexico. Courtesy Johnnie L. Wilson, with permission.

Silverton, and during the early 1900s they moved to Curlew, in Floyd County. They had seven children, one of whom died in infancy. As they began working their fertile farmland, the Wilsons' farm grew prosperous while yielding wild plums, apples, peaches, and grapes for Ollie's canning. Besides rearing her children, Ollie also was a hardworking farm wife who raised chickens for the eggs and meat, milked cows, and tended the livestock. During harvest time, Ollie cooked for more than fifteen extra field hands and her family. But Ollie also

enjoyed the beauty flowers could bring and planted a large flower garden near the house, tilling the soil with an iron plow she pushed herself and sharing her flowers for weddings and funerals.

With her quilting projects, Ollie had a more frugal attitude. She enjoyed making pinafore aprons from feed sacks as gifts for family and friends at Christmastime, but she kept all the feed-sack scraps from those projects and accepted fabric scraps from women in the church and community for her pieced quilt tops. Ollie also used feed sacks to back her

quilts, and her youngest son would take her to town so she could examine the fabrics on sacks of chicken and cow feed and choose the ones she wanted. She took her time making the selection and bought five sacks at a time, all of the same color and design if possible.

When she quilted, Ollie used the time-honored method of foundation-paper piecing on bits of newspaper or other scrap paper from her household to make her quilts. She was particularly fond of the eight-pointed star pattern shown in this quilt even though she

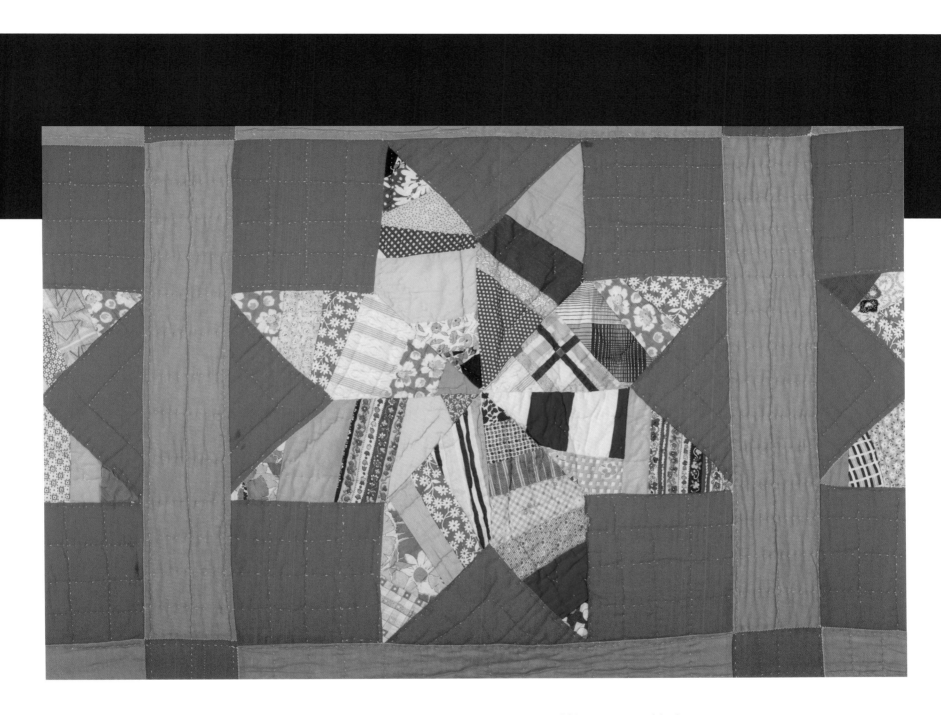

Detail of String Pieced Star Quilt showing variety of fabric scraps in block.

String Pieced Star Quilt, c. 1945

For the backing to her String Pieced Quilt, Ollie Wilson chose two types of feed sacks.

pieced many other patterns as well. Ollie had a quilting frame suspended from the bedroom ceiling in her house. When she hosted quilting parties, ladies brought a covered dish for lunch and stayed all day to quilt. Ollie did not like to use all-over quilting patterns like the fan or clamshell design, which would have allowed her to quilt faster in the frame; instead she adapted multiple quilting designs for each particular quilt.

This String Pieced Star Quilt made in the 1940s represents the beauty that can be made from recycled scraps, feed sacks, and a quilter's imagination. The quilt measures 66" x 81", with twelve blocks of foundation-pieced string stars set on a red cotton background. The blocks measure 16" x 16", and there are three-inch-wide Nile-green sashings, red cornerstones, and additional two-and-a-half-inch green borders on the top and bottom of the quilt. Ollie machine stitched the red commercially produced binding. Although Ollie liked to hand quilt all of her quilts, she felt that machine-applied bindings lasted longer.

This quilt was a wedding present from Ollie to her grandson Johnnie Loraine Wilson and his wife, Sue. Ollie unfolded her new quilts, spread them out, and invited the young couple to choose. The bright red background of the stars and the Nile-green sashings give a bright sense of gaiety to the quilt and yet somehow reflect the directness of a woman who would say to her grandson and his new wife when they first selected another quilt as their choice, "No, you can't have this one. I'm not ready to give it away." Perhaps this quilt, their second selection, with all its bright color, feed-sack pieces, and sharp points, does indeed portray the personality of Ollie Wilson, tell her story, and end up being the quilt she really wanted them to have.

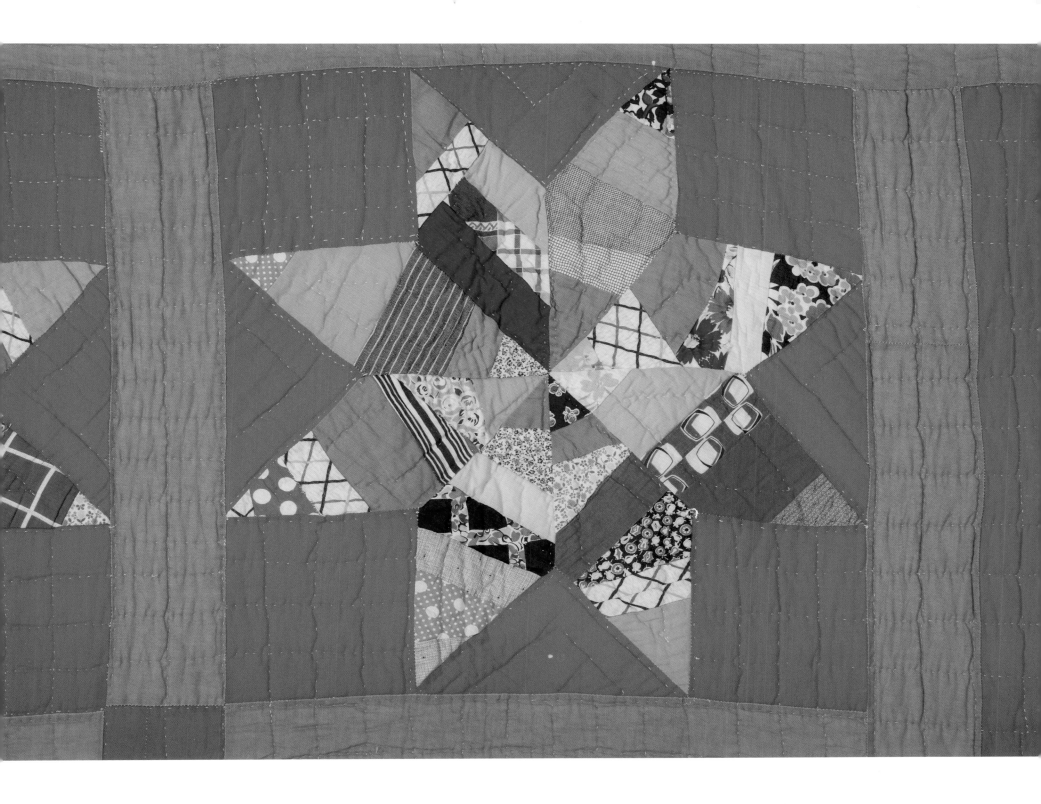

Detail of String Pieced Star Quilt. Note unusual diagonal piecing in upper left arm of star and
pieced scraps in lower right arm. Nothing was wasted.

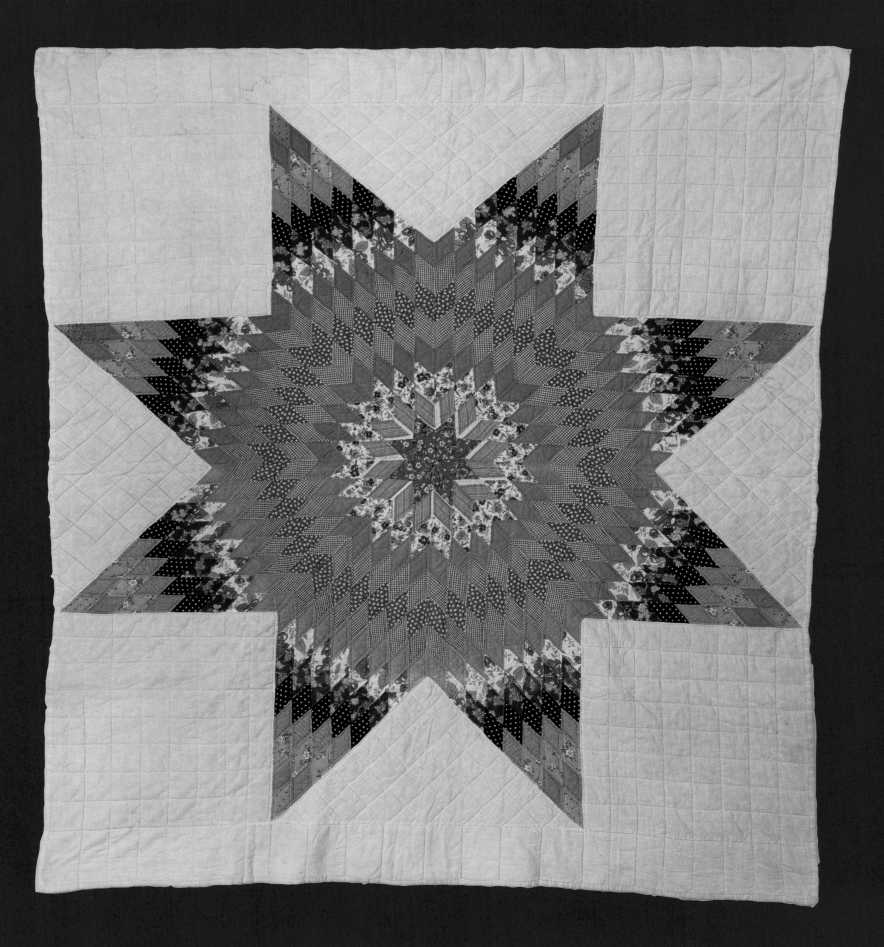

Blue Lone Star Quilt, 1947, 75 1/2" x 80 1/4", made by Allie May Close Burkett, owned by Frank Lowell Avent.

Blue Lone Star Quilt

1947

Allie May Close Burkett

Collin County

Shared by Frank L. Avent

In today's world, families often have been called blended if they are, in some way, not what everyone assumes is the traditional idea of family. However, those new labels are simply that—new labels for old concepts. Family is family, and Allie May Close Burkett's family knew they were loved by the way she treated them and by the memories she left them. One tangible example is this Blue Lone Star Quilt belonging to her grandnephew Frank Avent.

Allie May Close was born on May 8, 1888, in Chambersville, Texas, which no

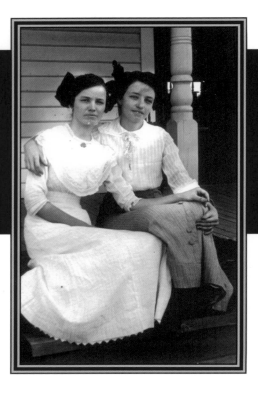

166

longer appears on Texas maps but was located near Melissa, a town located on State Highway 75 northeast of McKinney in Collin County. As with so many towns in Texas, Melissa began as a railroad town in 1872 along the Houston and Texas Central Railway route. The town prospered again in 1908 when connected to the Texas Electric Railway, and it became a commercial center for local farmers. Although the town of Melissa had electricity and telephones before 1920, these modern conveniences did

not extend to the farms surrounding the town, and one of those farms belonged to John and Allie Burkett.

Allie and John Cornelius Burkett had married in June of 1923. Little is known of Allie's childhood, but she had at least one brother, Neal, who had died in the Galveston hurricane of 1900. On that farm outside of Melissa, John farmed cotton and Allie was a homemaker, raising chickens and sometimes selling those chickens to passing housewares salesmen for money to buy fabrics and notions to

make her quilts. John and Allie had no children of their own; however, in 1924, they began rearing Allie's sister's child, Rudell, who was twelve at the time. In an unusual arrangement of their family, Rudell's brother, Dudley, was raised on the same farm by John's parents, who were known as Grandma and Grandpa Burkett. The whys and hows of the situation did not matter; what mattered was that the family was together.

The farm had an outdoor water pump and an outhouse rather than

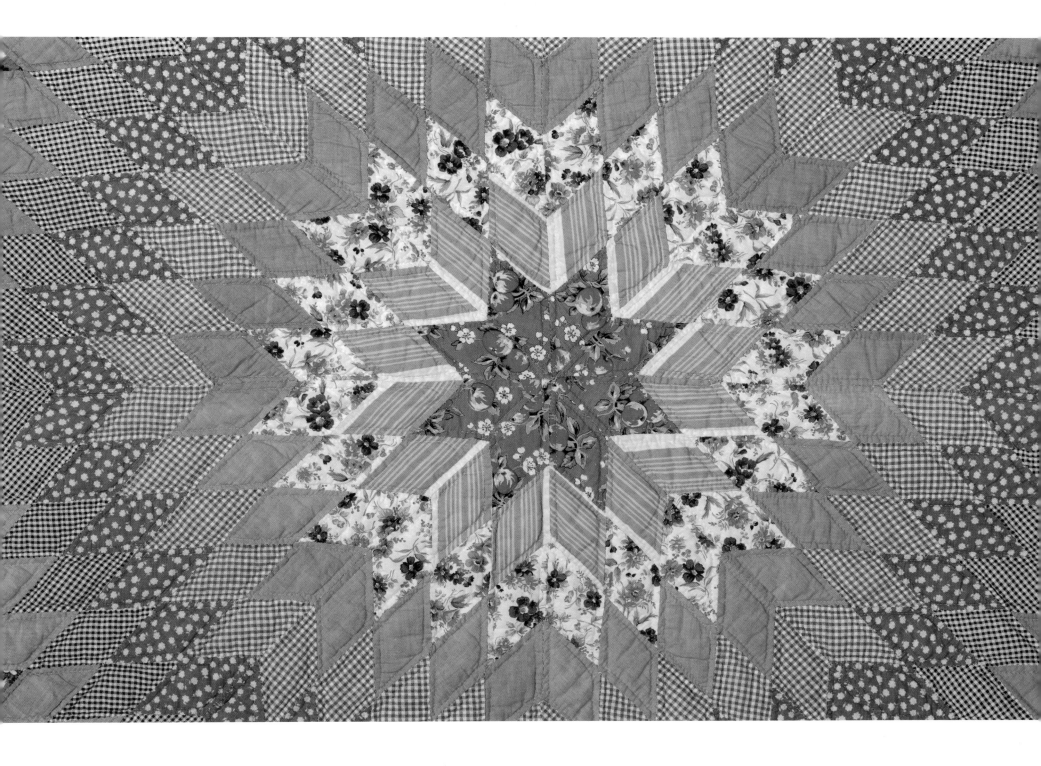

Detail of Blue Lone Star Quilt center showing array of fabrics and feed-sack materials.

indoor plumbing. For years Allie used a wood-burning, pot-bellied stove with a corncob handle, and later a coal oil cook stove. Even after electricity arrived at the farm, Allie refused to give up her coal oil stove. She took it with her when she moved to Melissa in the late 1950s, using the stove until her death several years later.

Eventually, Rudell grew up, married, and had three children, Frank, Rowena, and Jan. As Allie's family enlarged, she decided to make quilts for her grand-nephew and grandnieces. She thought Frank was old enough to select his own pattern from among the ones that Allie

showed him. He chose the Lone Star with blue for his quilt color. Since the Burkett farm had no electricity until the late 1940s, the Blue Lone Star Quilt that Allie made for Frank was hand pieced by lamplight. Rowena, who was about five years old at the time, perhaps chose the Lone Star because she wanted to be like her big brother, but, of course, she wanted pink. Then in 1959, Jan, the youngest child, received Allie's last quilt, a Trip Around the World.

This quilt measures 75 1/2" x 80 1/4" and is hand pieced and hand quilted in a classic Lone Star pattern. The quilt is made from several different cotton prints

and feed-sack fabrics as well as muslin. The blue fabrics in various shades create the illusion of whirling movement in the quilt and radiate from the center to the points of the star. Now a grown man, Frank considers this quilt one of his most prized possessions. The Lone Star seems similar to Allie Burkett's family—made of various individual pieces that when together blend and create a unified whole.

Blue Lone Star Quilt on ranch
fence, Fort Davis, Texas, with
Blue Mountain in background.

Part Three

1950–2005

This section traces the eventual resurgence of quilting in Texas. As new generations across America rediscovered older arts and crafts, the invention of new tools and techniques broadened the possibilities of quilting as an art form.

Immediately after the end of World War II, the general population continued to do without, until factories used in war production could be refitted to produce consumer goods. Once that transformation was complete, women were able to buy merchandise for the home and for

sewing. Fabric and sewing notions such as needles and thread were again plentiful. Government leaflets and programs encouraged women to create a beautiful home environment for their families and to enjoy the new appliances and inventions made possible by wartime technology.

Quilting declined at this time in many suburban areas, perhaps because it reminded women of the hard times of the Great Depression and the war, perhaps because women wanted a fresh start with new items, not the old. The national quilting fever had abated, and quilts were simply out of fashion. Women's magazines encouraged modern looks, and city women wanted that look. They had their domestic duties, but new social activities took them away from the home.

However, in the more traditional and rural areas of the country, quilt making continued much as it had from previous decades. Women made quilts both with commercial patterns and with the tradi-

tional patterns passed down from previous generations. Leonor Gonzalez's Whole Cloth Baby Quilt reflects a desire to try a traditional art form in a new way. Mountain Mist, a division of Stearns and Foster, still created and published patterns with their batting. Many women took traditional patterns, such as Turkey Tracks, Carpenter's Wheel, and Broken Star, and made their own variations. Elvira Smith Green's Church Signature Quilt is an example of this kind. Lillian Richman, in her Nine-Patch Tied Utility Quilt, shows how thrift continued during this period as rural women clung to old habits, letting nothing go to waste.

During the decade of the 1960s, the mood of the nation shifted and once again influenced quilt making. Many people were disillusioned with national and international politics and felt an uncertainty with the present, including Vietnam and the assassinations of John F. Kennedy and Martin Luther King, Jr. In such a chaotic decade, people started to

look backward for times in our nation when they perceived that life was more tranquil, even pastoral. As a result, interest in traditional crafts revived, and many Americans rediscovered quilting. Once again, people used what fabrics were at hand. During the 1960s, polyester knit was popular, but polyester did not handle like traditional cotton. It was practically impossible to quilt, and many such quilts were abandoned halfway finished. Some were completed, survived, and are now indestructible.

During this time, creativity flourished, and in Ethel Hargrove's *Gone with the Wind* Pictorial Quilt, she uses an old technique of coloring in the blocks with crayons, a practice first used in the 1920s that resurfaced in the 1960s. In fact, crayoning came back again in the 1990s, showing how quilters can modernize and reinvent an old technique.

Because of so many people now interested in quilting, quilt kits found a new audience, especially embroidered quilts

on prestamped background fabric. *Quilter's Newsletter Magazine,* the first national magazine devoted to quilt making, was begun by Bonnie Leman in 1969, and other magazines and newsletters followed, such as *Aunt Kate's Quilting Bee,* published by Glenna Boyd from Fort Worth, Texas. With such magazines available, quilters started to connect with one another at a national level and create a network of quilt enthusiasts.

In the decade of the 1970s, people started recognizing quilts as a legitimate textile art form, and books on quilting offered bold, new ideas and patterns. Museums began to view quilts as textile art rather than traditional craft when the Whitney Museum of American Art made history with its exhibit *Abstract Design in American Quilts,* choosing to view quilt design in its purest art form, looking at the overall design instead of the technical aspects of making quilts. Scholars began to study quilts, and books were published offering pictorial surveys of quilts as a means of identifying and valuing the work.

The approach of the United States Bicentennial fostered interest in traditional crafts, with quilting foremost among them. Many quilts were designed and made to commemorate this event in American history. *Good Housekeeping* magazine sponsored a national quilt contest that drew tens of thousands of entries, and a quilt revival swept the nation.

There is one difference, however, from past quilt revivals, and that was the advent of the art quilt, where studio artists began using the quilt as a medium for expression. Some artists continued to work in a more traditional shape and form, but others worked without the constraints formerly limiting size and shape. These quilts were never meant to be used and were created solely as art to be hung on walls. Often art quilts are designed to express their makers' feelings about a topic of interest or an event. Dana DeBeauvoir's Nannie's Quilt honoring her grandmother is a classic art quilt in the traditional sense with the wave image and colors symbolically expressing her love of her grandmother.

Quilting has long been a way to commemorate a special event, express feelings or thoughts, or comfort a loved one. Several quilts in this section fit into that category, regardless of their date. Zella Woodruff made her Precious Memories Quilt as a way to honor her mother, Osceola Dyer, whose Dutch Dolls Quilt was one that comforted Zella's children when they were ill; Amelia Perry made her Lone Star Quilt as a special surprise for her son's inauguration as governor of Texas. Quilts have always been created as objects that tie people together with memories and caring, and regardless of the modern age, that fact has not changed.

Quilters also have always taken their own vision and put it on the canvas of the quilt. Kathleen McCrady, who has

shared her quilting knowledge with others, created her Traveling Stars Quilt as a combination of both contemporary vision and traditional piecework. Reverend Eugene Tomlin brought his eye for nature and his exquisite embroidered squares to his Butterfly Quilt. Once again, the scope of possibilities broadens as each individual quilter adds his or her talents to the art of quilting.

Another influence of modern times now appearing in quilting is the use of computer-aided design and the computer-driven sewing machine to create quilts of traditional, contemporary, and highly original work. With the computer has come the Internet, and for the first time quilters have become a truly worldwide commun-ity, sharing patterns, designs, and ideas instantly with others they have never met face-to-face but with whom they are bound by a love of quilts and quilt making. The possibilities are endless, and the story is never-ending.

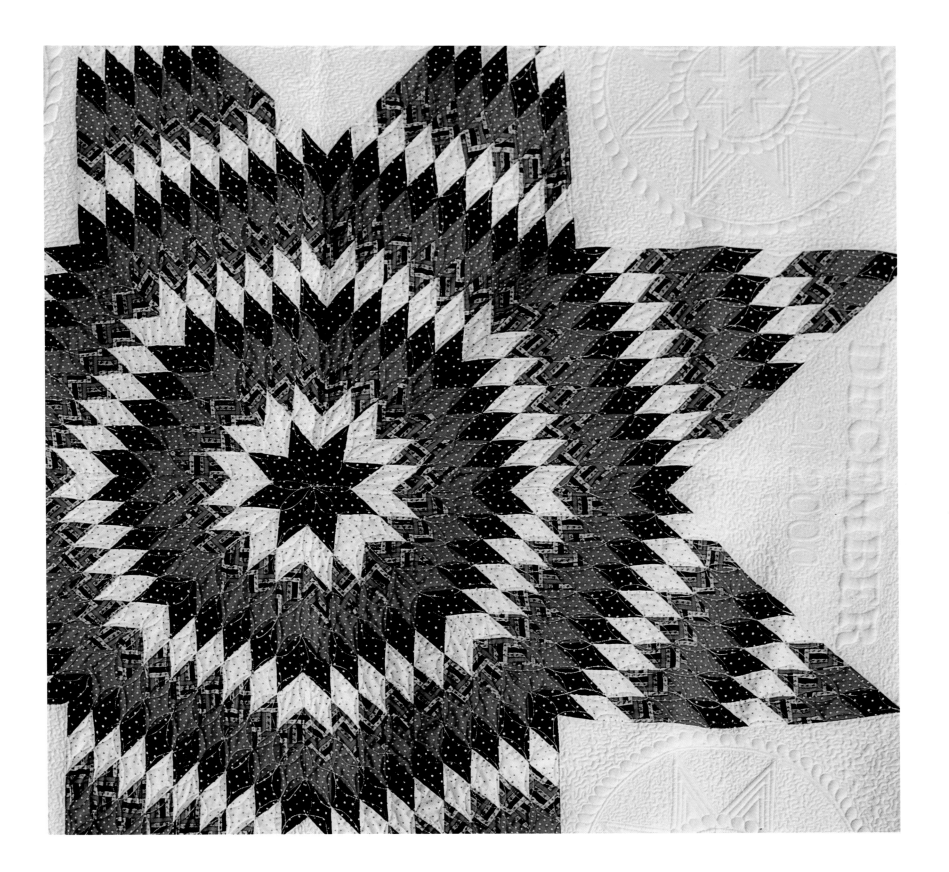

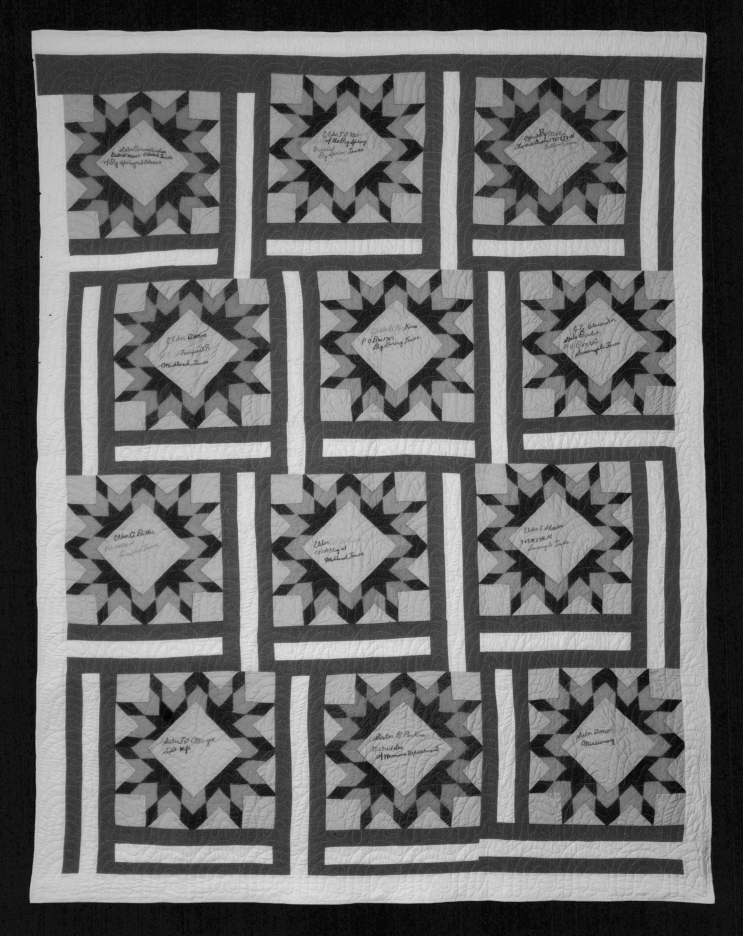

Church Signature Quilt, 1950–2005, 76" x 102", made by Elvira Smith Green, owned by Teresa Colvin.

Church Signature Quilt

1950–2005

Elvira Smith Green

Midland, Midland County

Shared by Teresa Colvin

Some women have a calling, a mission in life to care for others in a spiritual way. Elvira Smith Green extended her arms to her church community and widened her idea of family beyond her own home, and as a result people came to call her Mother Green. As a representation of her church family, she made her Church Signature Quilt while continuing her ministry in a far West Texas town called Midland.

Early in its history Midland was called the Queen City of the South

Elvira "Mother" Green, late 1940s. Courtesy Teresa Colvin, with permission.

Plains and then the Windmill Town. Since the discovery of oil in the Permian Basin, that resource has defined Midland's growth. And like most Texas towns, as it grew, Midland became home to churches of many denominations. Among these was the Church of God in Christ in Texas Northwest, where Elvira taught for fifty-two years.

Born Elvira Smith on September 6, 1890, in Yoakum County, Elvira married Ed Green, and together they had eleven children. Elvira and her husband homesteaded in Brownwood but traveled during cotton-picking season to work in Anson, Brady, Lubbock, Tahoka, and Big Spring. Affectionately known as Mother Green in the churches where she ministered and taught and called Grandma Shane by her family, Elvira found the center of her life to be among her family and her church. Elvira often made quilts as gifts because money was scarce.

This Church Signature Quilt was the last she worked on but was not completed by her. It is a document in fabric of many pastors and elders with whom she associated during the final years of her church ministry. The quilt measures 76" x 102" and has twelve blocks, each measuring approximately 17 1/2" x 17 1/2". In each block Elvira has embroidered the name, title, and address of a member of the Church of God in Christ. Elvira's block pattern, a variation of the Broken Star pattern, is made from solid cotton fabrics in vibrant shades of green, orange, and purple with the embroidery worked in green, yellow, and red embroidery floss. The quilt has a two-inch triple sashing of red and yellow solid cotton fabric in an unusual off-line setting. By her choice of the block pattern reminiscent of the Broken Star, Elvira seemed to emphasize how each of the names she

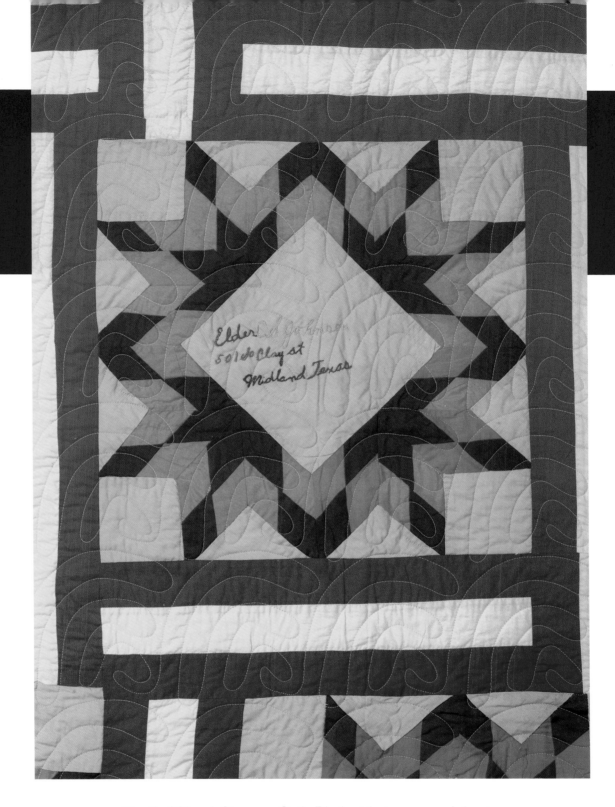

Detail of Church Signature Quilt. Block with signature and showing
multicolored embroidery thread.

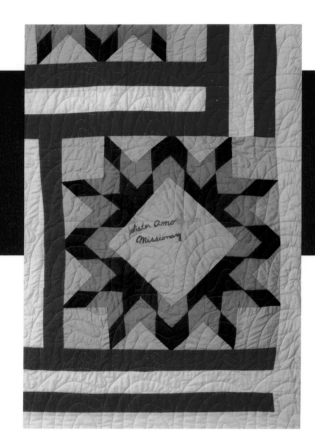

Detail of Church Signature Quilt. Block of Sister Amos Taylor, missionary.

embroidered on the quilt was important, deserving a star in heaven because of his or her ministry in the church. And the rich color palette of Elvira's quilt formed the background for her careful rendering of those names as she even changed the color of her threads while stitching them. This was a woman who wanted to celebrate, through her choice of both pattern and color, the people she admired.

Elvira died on March 22, 1968, with the quilt top left incomplete. Her great-granddaughter, Teresa Colvin, had the top finished and quilted for the family reunion in July 2005 by Suzanne Garman of the Needle Nook Quilt Shop in Midland, Texas. Teresa sent a note after the reunion with this message: "We had a wonderful family reunion. I had them all in tears when I displayed the quilt. My Great-grandma Shane has one son still living, and he was able to attend the reunion. When he arrived, neither of us knew the intention of each other's actions, but he brought additional photos of both my great-grandparents. So we were able to make a display of the items. It was truly a memorable experience."

Elvira "Mother" Green's quilt, with exuberant colors, careful stitches, and a thoughtful pattern, reminds her children and the church members of one woman's dedication to her family and her ministry.

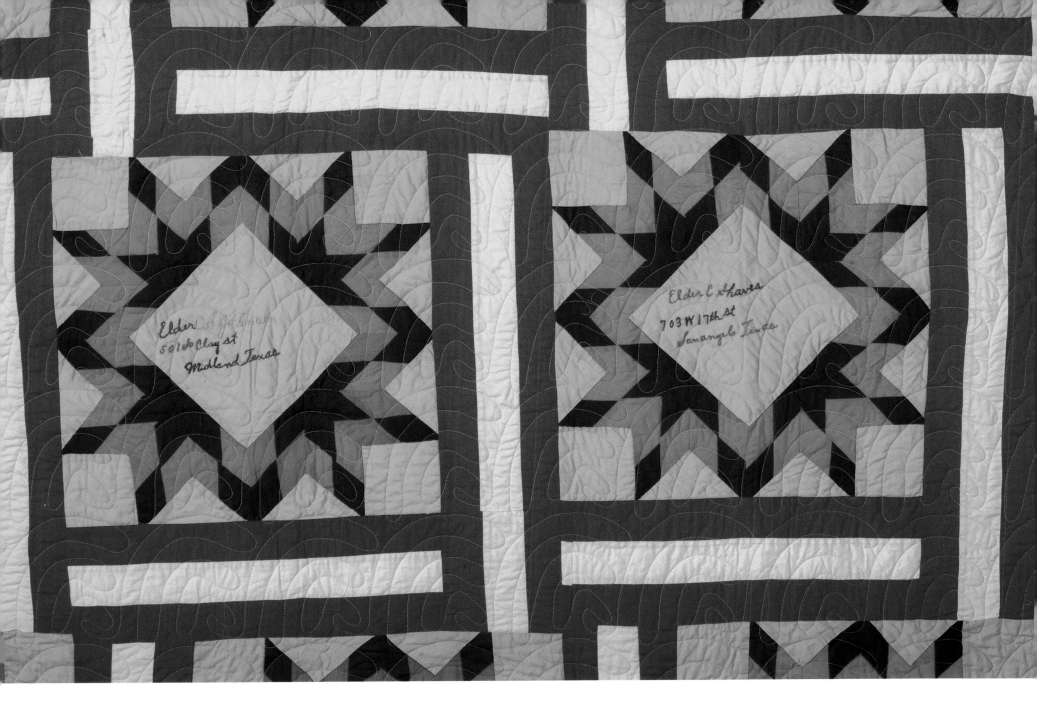

Detail of Church Signature Quilt. Note unique sashing.

Church Signature Quilt, 1950-2005

Whole Cloth Baby Quilt, 1952, 36" x 46", made by Leonor Hernandez Gonzalez, owned by Alma Brewer.

Whole Cloth
Baby Quilt
1952

Leonor Hernandez Gonzalez

Mercedes, Hidalgo County

Shared by Alma Brewer

Not all quilts are pieced, and the concept of the whole cloth quilt has been around for centuries. In this way someone could make a quilt without the time element of piecework by adding batting, a backing, and then quilting. Although Leonor Gonzalez had never made a quilt before, she tried her hand now, deciding to use a whole piece of cloth rather than patchwork for her new baby's coverlet. The result was this Whole Cloth Baby Quilt.

Leonor Hernandez was born on May 6, 1927, in Mercedes, Texas, a town that

Photo of Leonor Gonzalez, age nineteen, 1946. Courtesy Alma Brewer, with permission.

lies in the heart of the Rio Grande Valley in Hidalgo County. The town of Mercedes was established in 1904, although previously called Lonsboro, and became a central point for the railroad. In fact, the town developers used the railroad to bring potential northern settlers to tour the area. These new settlers developed a large agricultural industry of citrus fruits and truck farming in the early part of the twentieth century. Other businesses developed as settlers came from Mexico to find opportunities for better lives.

One of the businesses that thrived in Mercedes was La Nacional Bakery, run by Leonor's parents, Mr. and Mrs. Hernandez, who came to Mercedes from Mexico to start a *panadería* (Mexican bakery) and raise a family. Leonor was one of nine children, and she grew up helping her family at the bakery. Her father died young, so when Leonor was in ninth grade, she had to drop out of school to help her mother run the bakery. Her brothers, who also worked in the bakery, served in the military during World War II, then came home, went to

college, and earned their degrees. Leonor, very intelligent and determined to complete her own education, persisted with her studies through the years until she finally earned her general equivalency diploma at the age of forty-three, long after her children were grown.

As a young woman, Leonor had met her future husband, Manuel Gonzalez, at a local carnival. They married on December 26, 1949. Although they moved to Austin to pursue jobs, Leonor chose to stay home and work as a full-time mother to their three children until

Detail of Whole Cloth Quilt showing pink ruffle and close-up of kitten print fabric.

1966. For the birth of each child, Leonor returned to Mercedes to have her mother nearby, coming back to Austin a few weeks after the baby's delivery. Alma, Leonor's daughter, was born in Mercedes on December 15, 1952, and Leonor brought her back to Austin six weeks later.

Although Leonor was a seamstress, she was not a quilter, but after Alma was born, Leonor made her new daughter a baby quilt. This Whole Cloth Baby Quilt measures 36" x 46" and is made of a pink cotton fabric printed with little kittens celebrating a birthday. The fabric itself is covered with 1950s-style popular animated creatures, from the dressed kittens holding the birthday cake—a little girl kitten in a pink dress and a little boy kitten in a blue plaid shirt—to the twittering bluebirds scattered around in the background. There are also some single figures throughout the quilt, again in the cartoonlike images appropriate for the decade. The sweet faces and the pink background seem the perfect cloth for Leonor to select for her new daughter. The quilt is machine stitched with a three-inch light pink ruffle around the outer edge of the quilt, but it is hand quilted in a heart-shaped pattern. The batting is unusually heavy for a baby quilt and may indicate that Leonor used kapok, a cotton grown in Mexico, rather than traditional, lighter-weight cotton batting.

As evidenced by the photographs, the quilt was well loved and heavily used, not only by Alma but also by her children. Leonor's choice of the cloth, with its celebrating kittens, chirping bluebirds, and sprigs of grass on a pink background, bring to mind the nursery and a sleeping Alma tucked in as her mother turned out the light. Leonor's quilt with the heart quilting covered her little daughter and throughout the years became, for Alma, a link to her mother's heart.

Whole Cloth Baby Quilt, 1952

Nine-Patch Tied Utility Quilt, c. 1955, 71" x 83", made by Lillian Mae Phillips Richman, owned by Priscilla Owen.

Nine-Patch Tied Utility Quilt

c. 1955

Lillian Mae Phillips Richman

Matagorda County

Shared by Priscilla Owen

I found this utility quilt fascinating because of the contrast between the fabrics and the place where the quilt was made. Lillian Richman, a woman who lived in Matagorda County along the Gulf Coast of Texas, where the heat and humidity are both high, made her quilt out of wools and flannels. That disparity made me curious about Lillian and her story.

Lillian Mae Phillips was born on March 19, 1903, in Sipe Springs, a town in Comanche County, located almost in

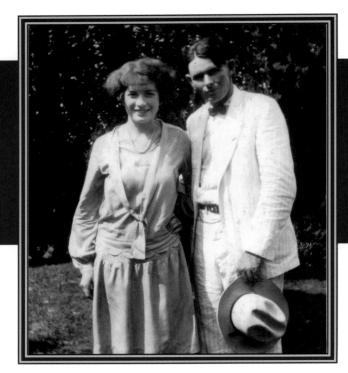

Lillian and Patrick Richman, taken shortly before their marriage, 1927. Courtesy Priscilla Owen, with permission.

190

the center of Texas. Sipe Springs was established in 1873, the railroad was built nearby in 1911, and the town became a bustling tent town in 1918 with the discovery of oil, a short-lived boom. Somewhere along the way, Lillian met and married Patrick Alfred Richman.

For whatever their reasons, Lillian and Patrick moved to Matagorda County along the Gulf Coast, and Patrick became a rice farmer and cattle rancher. They had two sons, and Lillian's life was that of a farm wife. She raised chickens and other domestic animals, planted a garden, and canned whatever vegetables she grew. Lillian also knew where the local wild mustang grapes grew and made a little mustang grape wine "for medicinal purposes"—a fact she was reluctant to tell, for she was a devout Baptist. Lillian also pursued many forms of artistic expression, including quilting, china painting, and oil painting.

During planting and harvesting seasons, Lillian had to feed the extra crews hired to help, and she found as many as forty extra mouths at the table a commonplace occurrence. There were also those times she had to manage the farm by herself when her husband was away, sometimes a week or more at a time, selling the harvested crop at market.

In the 1950s Lillian took tailoring lessons, and those projects must have been the source of wool fabric for this Nine-Patch Tied Utility Quilt. Like most women of her era, Lillian allowed nothing to go to waste, and this quilt reflects the true nature of a utility quilt made

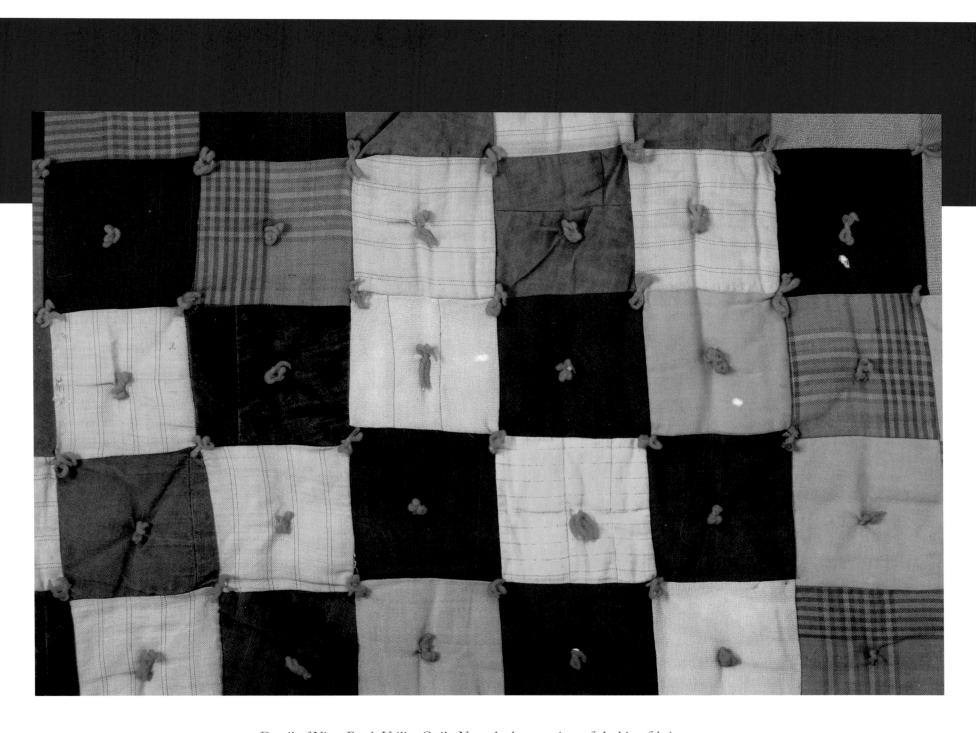

Detail of Nine-Patch Utility Quilt. Note the large variety of clothing fabric scraps.

Nine-Patch Tied Utility Quilt, c. 1955

with scraps from clothing and tailoring projects. The quilt measures 71" x 83" and contains forty-two, nine-patch blocks. The fabrics are mainly wools, flannels, and mixed-fiber blends. The backing is flannel, and the batting is heavy cotton. Lillian tied the quilt with red wool in the center of each square and at the corners of the blocks. She finished the quilt with a back-to-front self-binding on the sides and a knife-edge finish on the top and bottom. While the quilt shows disintegration from fifty years of heavy use, its beauty is not diminished.

Lillian's house in those low coastal lands was made of ground oyster shells and concrete, and she had palm trees in the yard. In that land of heat and humidity, she made this heavy, mostly wool and flannel quilt. Somehow, I wonder if the cold mornings of her central Texas childhood stayed with her and combined with her practical side for reusing tailoring scraps. Or maybe the Gulf breezes chilled the air on stormy winter days, and she and Patrick saved their money on heating by using heavy quilts. Whatever the reason, the contrast of the hot Gulf Coast and a heavy wool quilt piques my interest.

But perhaps there is a simpler explanation. Maybe Lillian knew a secret about keeping little children settled at night. Lillian's granddaughter Priscilla Owen said that all of her grandmother's quilts were very heavy. "They were so heavy that it was difficult to turn over under them. You had to be sure that you were going to stay in bed all night!"

Detail of Nine-Patch Utility Quilt showing red wool ties.

Nine-Patch Tied Utility Quilt, c. 1955

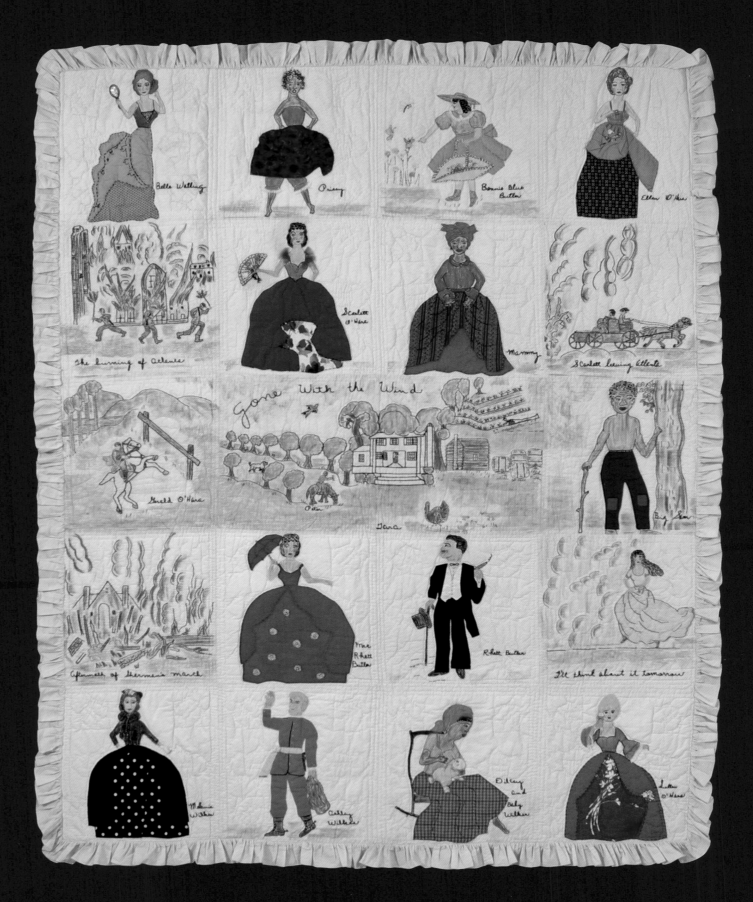

Gone with the Wind Pictorial Quilt, 1963, 65" x 83", made by Ethel Hargrove and owned by Virginia Lucas.

Gone with the Wind
Pictorial Quilt
1963

Ethel Cox Hargrove

Rosebud, Falls County

Shared by Virginia Lucas

Americans have long been enthralled by certain movies so memorable we call them classics. We can all name them: *The Wizard of Oz, Casablanca*, and, of course, *Gone with the Wind.* Regardless of when viewers first watch the film—first release date or a newly restored version on DVD—the moment the music begins and the title words start moving across the screen, the audience knows something breathtaking is happening. After seeing a rerelease of *Gone with the Wind* in the 1960s, Ethel Hargrove was so

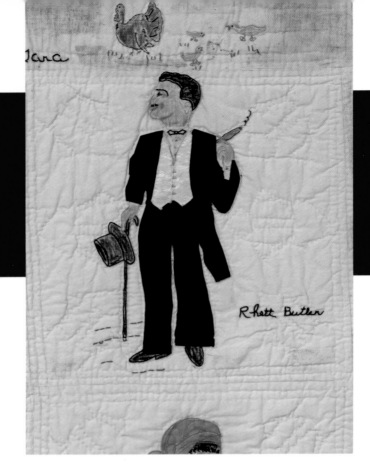

Detail of *Gone with the Wind* quilt showing Rhett Butler and how sparkles used at the tip of his cigar "glow." Also note crayon work in face and hand.

taken with the film that she created this quilt.

Ethel Cox, the second oldest of ten children, was born on April 1, 1908, in Westphalia in Falls County, Texas. Her father, who was half Native American, was a farmer; however, the family lived a nomadic existence picking cotton on various farms. The family eventually settled near Rosebud, a small town originally settled in 1884 that had grown rapidly after the San Antonio and Aransas Pass

Railway decided to build through it in 1892.

After moving to the Rosebud area, Ethel met Walter Hargrove. Not long afterward, they married and later had one daughter. With the coming of World War II, Ethel and Walter relocated to Corpus Christi. Walter worked with the war effort while Ethel monitored the study hall in the local high school. After the war they returned home to Rosebud.

Ethel's quilt is pictorial in nature, and

her original drawings are done entirely by hand with her renditions of the characters' faces strongly resembling the actors from the film, including that of Scarlett O'Hara. Throughout the quilt, Ethel used different mediums, including fabric, notions, and crayons, to depict various characters and scenes from the movie. She incorporated a variety of fabrics to re-create Prissy's red pantaloons and added sparkles to light the tip of Rhett's cigar. Other fabrics and notions such as

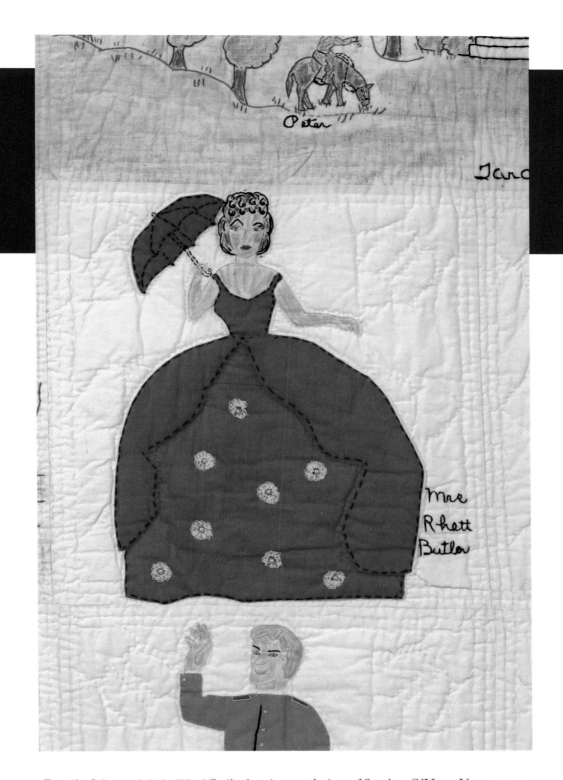

Detail of *Gone with the Wind* Quilt showing rendering of Scarlett O'Hara. Note strong
resemblance to actress Vivien Leigh, who played the role of Scarlett in the movie.

lace, buttons, tulle, small pearls, and silk became elements Ethel added to create the characters' elaborate costumes. The faces of the characters, most of the central panel scene, and the burning of Atlanta scene were created with crayons and fabric, and Ethel even used miniature cotton balls to depict the cotton fields. The quilt measures 65" x 83" and has blocks with thirteen characters from the movie. A large center panel depicts Tara, the O'Hara family mansion. Three smaller blocks portray the burning of Atlanta, the aftermath of Sherman's March, and Scarlett fleeing in the wagon. Each block, whether of a character or

a scene, has names or descriptions embroidered in black embroidery floss. The quilt is machine pieced, hand appliquéd, and hand quilted with a variety of original designs in each block. Ethel finished the quilt with a two-and-a-half-inch ruffle inserted into the binding.

Original in its design and execution, Ethel's *Gone with the Wind* Pictorial Quilt pays homage to that connection between Americans and classic films. In her work, Ethel has created her own unique piece of American folk art.

Detail of *Gone with the Wind* Quilt showing cotton pellets to represent cotton in the field.

Dutch Dolls Quilt, c. 1935, 65"x 84", made by Osceola Douglas Dyer , owned by Zella Woodruff.

Dutch Dolls Quilt

c. 1935

Osceola Douglas Dyer

Bogota, Red River County

Shared by Zella Woodruff

Precious Memories Quilt

1999

Zella Woodruff

Abilene, Taylor County

Shared by Zella Woodruff

I often hear stories about people who love to make a cup of tea and curl up under an old family quilt. There is something soothing, even healing, about the inner warmth from the hot tea and outer warmth from those soft, frayed layers. But the Dutch Dolls Quilt made by Osceola Douglas Dyer and the Precious Memories Quilt by Zella Woodruff, although very different and separated by many decades, spoke to something much deeper than comfort. The stories of this mother and daughter were so entwined

Precious Memories Quilt, 1999, 81"x 98", made by Zella Woodruff and members of the Prairie Star Quilters;
in the collection of the quilt maker.

Osceola Douglas Dyer, c. 1940.
Courtesy Zella Woodruff,
with permission.

Zella Dyer Woodruff, 1999.
Courtesy Zella Woodruff,
with permission.

that it did not seem fair to separate either their quilts or their stories.

Osceola Douglas Dyer was born in Waskom, a small East Texas town on the Louisiana border, in 1904, but would spend most of her life in Bogota, another small town in Red River County. Bogota, established in 1881 and named by its first postmaster for the Colombian capital, flourished as a railroad town from 1919 to 1956.

Osceola, a hardworking member of this thriving community, sewed for the public. As part of her work, she did "quilting on the halves," which meant that a person supplied Zella with fabric for one quilt, and as payment she received enough fabric to piece a quilt top for herself. These quilts were also called barter quilts. As Osceola worked, her daughter Zella helped her wash the family's quilts in a large black pot in the backyard and hang them on the line. Although Zella herself did not quilt, she had at age six collected enough leftover scraps from her mother's sewing fabric to make herself an apron.

Osceola had made the Dutch Dolls Quilt in the 1930s, and in 1958 she gave it to Zella. The quilt measures 65" x 84" with twenty blocks of Dutch Dolls and has triple sashing in pink and white. Twelve nine-patch cornerstones set the interior of the quilt with pink and white triple borders. The quilt is backed in solid pink cotton. The dresses of the Dutch Dolls represent clothing from the family and other sources, and the quilt holds a special place in the Woodruff family.

Because Zella used the quilt on her children's bed when they were ill, the children and Zella started calling it "the sick quilt." When they were sick, Zella would sit beside them, making up stories about the little Dutch Dolls, entertaining

Dutch Dolls Quilt, c. 1935

Precious Memories Quilt, 1999

Detail of Dutch Dolls Quilt showing black edge-stitching and detail typical of the 1930s style of quilting.

her children and keeping them quiet. Those Dutch Dolls went on great adventures while little fevered children listened to their mother's soft voice soothing them, her cool hand testing their foreheads, settling them into the sheets so they could rest and be well. And the children knew the Dutch Dolls were smiling behind their big bonnets, telling their mother secrets. This quilt made by a loving grandmother became a mother's book of stories told during her children's illnesses.

But Zella's encounters with illness became more difficult when she took care of her mother throughout Osceola's terminal illness. As close as they were, however, it was only after Osceola's death in 1982 that Zella became aware of the scope of her mother's work, finding dozens of quilt tops she'd never known about. "I was so surprised," she said. "I didn't know they existed until after I opened up the trunks and closets. I just laid them around for a while to get used to seeing them and knowing that my mother had made them."

Years later, while caring for a friend with breast cancer, Zella was reminded of her mother and decided to have some of the tops quilted. She went to the Prairie Star Quilt Shop in Abilene, where she now lived. There, the staff urged her to learn to quilt them herself. Zella found that quilting her mother's quilt tops helped fill a void she'd felt since her mother's death and also created lasting bonds with other quilters. She explained, "It soothed me to work on the quilts and helped to give me comfort and ease my grief." The healing that Zella felt as she learned to quilt and worked on her

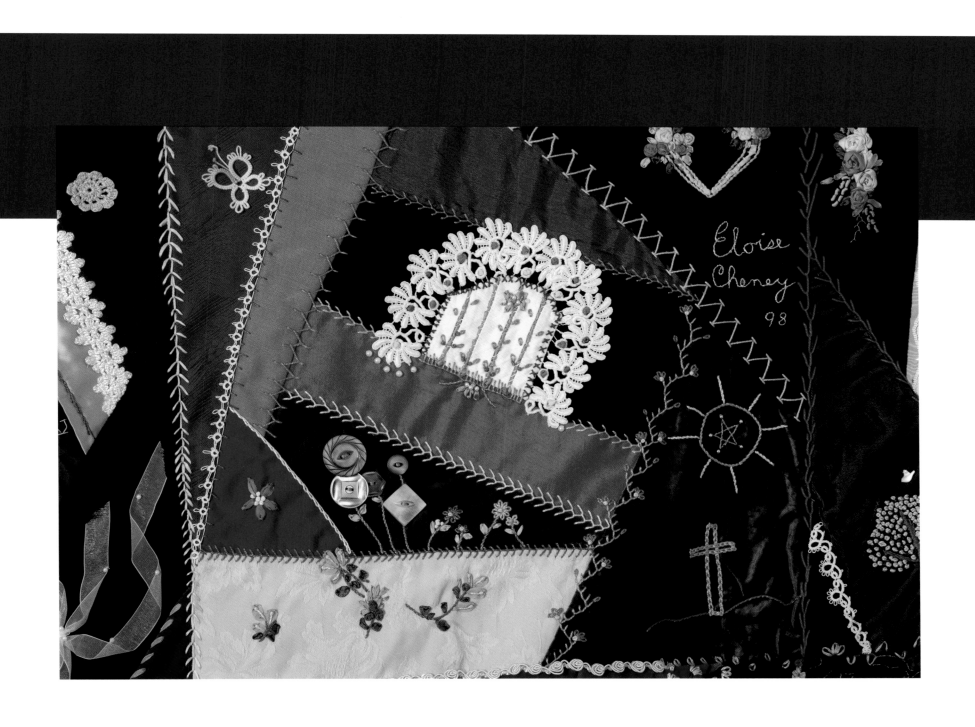

Detail of Precious Memories Quilt showing buttons and Osceola's tatting.

Dutch Dolls Quilt, c. 1935
Precious Memories Quilt, 1999

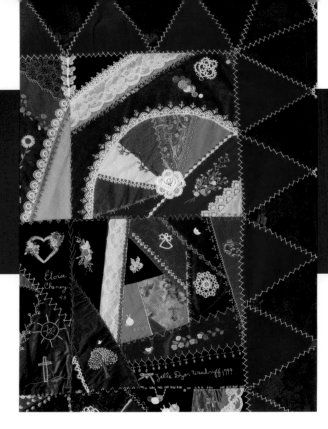

Detail of Precious Memories Quilt showing several blocks with embroidery, lace, and embellishments.

mother's quilt tops led her to a decision: she would make a quilt that would have special meaning. Zella joined a quilt block exchange group, the Prairie Star Quilters, with fourteen other women, and each woman contributed a block to the quilt.

The Precious Memories Quilt has Zella's fabrics and her mother's pieces of tatting that were discovered along with the quilt tops and other needlework in 1982. It measures 81" x 98" and has twenty blocks constructed of silks, satins, and velvets with heavy embellishments of lace, tatting, buttons, embroidery, silk ribbons, and beads. The quilt has a nine-inch ice-cream-cone-shaped border of velvet and satin. The staff at her local quilt shop encouraged Zella to enter the quilt into the International Quilt Festival in Houston, Texas, in 1999, where it was juried into the show and displayed as a finalist.

Zella keeps a journal about each of her quilts. "You can keep anything in the journal," she says. "Entire projects, people you meet, even what television shows you watch while making the quilt." With her journals and her quilts, Zella is sharing her skills and creating a legacy for her children and future generations. And by teaching her granddaughters to quilt, she is also strengthening family bonds that sustain through both joy and sorrow, and reminding them of that first story: of their great-grandmother Osceola and her barter quilts, her big kettle, and her quilting legacy.

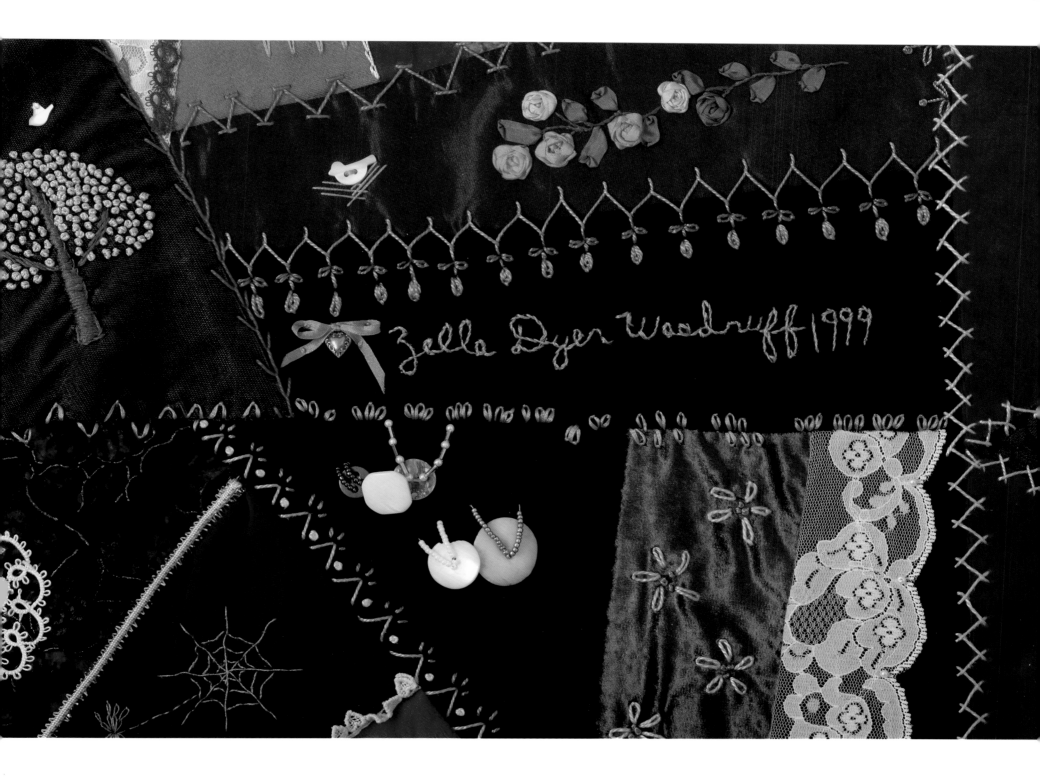

Detail of Precious Memories Quilt with Zella's signature. Note spiderweb embroidery at bottom left, symbolizing good luck.

Dutch Dolls Quilt, c. 1935
Precious Memories Quilt, 1999

Traveling Stars Quilt, 2001, 69" x 69", made by Kathleen McCrady, in the collection of the quilt maker.

Traveling Stars Quilt

2001

Kathleen Holland McCrady

Austin, Travis County

Shared by Kathleen Holland McCrady

Sometimes a quilt's title gives a clue to a quilter's life, and the title of Kathleen McCrady's quilt suggests various layers about her story. The star is an appropriate symbol for both Texas and Kathleen herself, who has become a star in the world of quilting. As for traveling, Kathleen traveled much of her life, especially after marrying, until she finally settled in Austin, the state capital of Texas.

A third-generation quilt maker, Kathleen McCrady calls Austin home now, but she was born Kathleen Holland

Kathleen McCrady, 2005. Courtesy Kathleen McCrady, with permission.

210

in Marysville, Cooke County, Texas, in 1925. Her family relocated to farm some family property in Oklahoma, where she grew up, the fourth of five children. Kathleen married her high school sweetheart, Jack McCrady, during the Christmas holidays of their senior year, 1942. Jack had enlisted in the Army Air Corps rather than being drafted into the regular army. In June 1943, Jack left to train as an aviation cadet, and after graduation, Kathleen joined him, the two of them living at various military bases, a

nomadic life that continued after World War II while Jack served in the Texas National Guard.

As a teenager, Kathleen learned to quilt from her mother and her mother-in-law and made her first quilt top, a Lone Star, while living in San Antonio when she was twenty-six. In 1955, Kathleen moved to Austin, eventually joining the Austin Stitchery Guild. In 1979, she began taking classes and joined the guild's quilting group. She explained, "I thought everyone hand pieced by esti-

mating the seam allowance, and marking around templates was new to me. Sometimes the new way was better; sometimes my estimating way was better for me. For the first few years of organized quilt making, I took every workshop I could because I could always learn something from it. Sometimes I learned that I did not care for the method, but at least I tried it. It also helped me to develop my own teaching methods."

Kathleen has since become an important force in the quilting world, creating

contemporary quilts and yet recycling fabrics into old-fashioned scrap quilts. A quilt historian, teacher, and appraiser, Kathleen received her certification from the American Quilter's Society in 1980 and has served as mentor for other appraisers. In 1996, deciding that physically she could no longer travel and teach workshops but not wanting to give up her association with other quilt makers, Kathleen created a "quilt study hall" at her home. There, quilt history students could learn about dating quilts, types of fabrics used in quilts, and quilt-making styles in U.S. history. Taking only eight students at a time and using her own collection of quilts and memorabilia, Kathleen has already taught 317 students, charging no fee, feeling rewarded that her students "have taken the knowledge and passed it on, especially to their own families, and they are helping the public to understand that quilt making is a legitimate art that has a place in history."

In her Traveling Stars Quilt, created in 2001, Kathleen combined a traditional quilt pattern with her knowledge of quilting. The quilt measures 69" x 69" and features nine blazing star blocks, each measuring 18" x 18". Half sunbursts and three-quarter sunbursts are set in a six-and-a-half-inch-deep border. As the eye moves around the border with its partial stars, those stars create movement, reflecting Kathleen's own once-nomadic life. And yet, inside the border the nine blazing star blocks exude a steadiness, even as their centers rotate. The quilt in

its totality becomes a reflection of a woman's ability to be resilient yet flexible, ready to compromise and yet stand her ground. Thus, Kathleen has honored traditional women and modern women in her work. The quilt is hand pieced and hand quilted reminiscent of the traditional style of quilt making. It was exhibited at the International Quilt Festival in Houston, Texas, in 2001 and appeared on the cover of *Quilter's Newsletter Magazine* in October 2002.

Although Kathleen's quilts have won many awards both nationally and internationally, one quilt that hung in exhibit at the International Quilt Festival brought a sense of family home to Kathleen. "My grandmother had made a quilt that contained the names of all twelve of her children. When I was invited to exhibit my family's quilts at the International Quilt Festival, it was one of the quilts exhibited there. At that show a cousin of mine whom I had not seen in about twenty years saw my exhibit and found me during the show. I did not know she had taken up quilting. She had never seen the quilt, and I showed her parents' names to her. It was a very emotional moment for both of us. Her mother and my mother were half sisters."

Kathleen continues to mentor many new quilt makers in the Austin area and plans to leave a legacy of her work to regional quilt centers in the United States. In this way, her work will educate and inspire future generations of American quilters.

Detail of stars in border of Traveling Stars Quilt. Note precision cutting of fabric in stars.

Traveling Stars Quilt, 2001

213

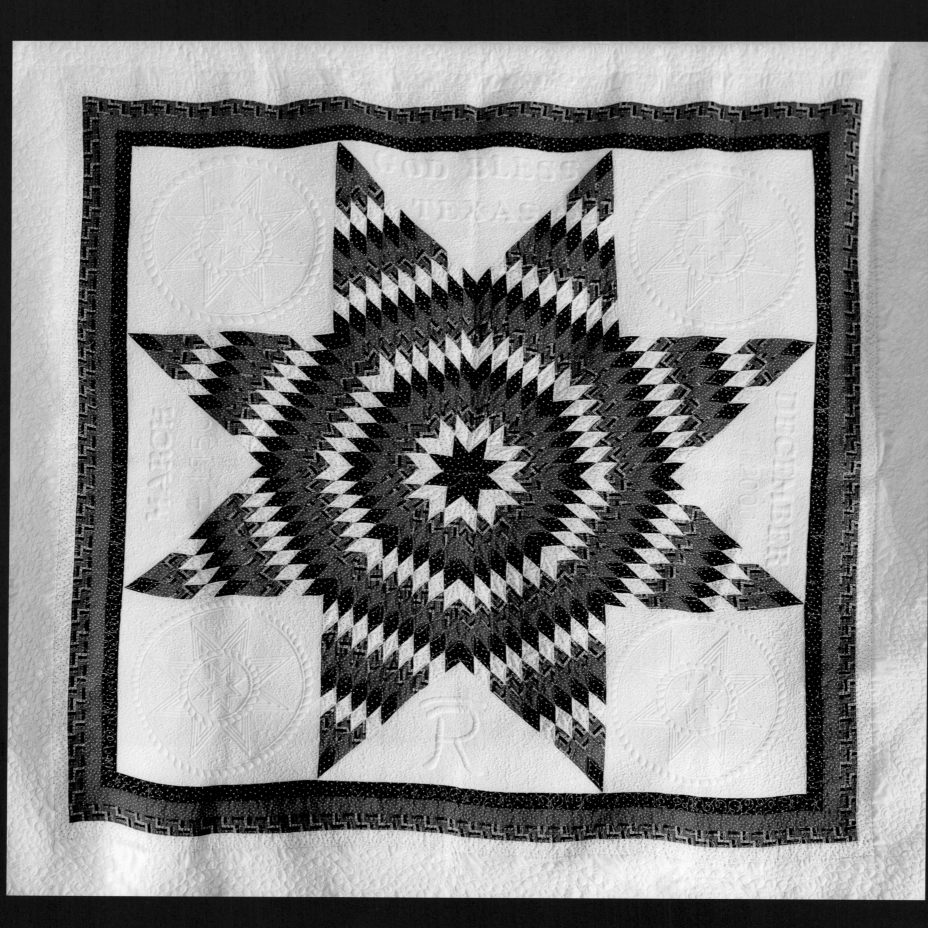

Lone Star Quilt, 2001, 65" x 65", made by Amelia Holt Perry, owned by Governor Rick Perry.
Photograph by Jim Bonar; with permission.

Lone Star Quilt

2001

Amelia Holt Perry

Paint Creek, Haskell County

Shared by Amelia Holt Perry

According to Amelia Perry, "One of my earliest memories is watching my grandmother carding cotton for a quilt batt. She would go over to the gin and get the raw cotton with the seeds still in it, bring it home, and card it by hand. I used to sit by her chair and watch."

As a child, Amelia played under the quilt frame while her mother, aunts, and friends quilted. "We would have to be careful not to bump the frame. This is how the women visited with one another. They'd take their thimble and go spend

Amelia Perry, 2004. Photograph by Olan Mills; courtesy Olan Mills and Amelia Perry, with permission.

216
★

an afternoon helping to quilt on a quilt, and then on another afternoon, everyone would come to your house and help." Amelia herself learned to sew at age six, began her first full quilt just a few years later, and has never stopped.

Amelia Holt was born in Paint Creek, Texas, in Haskell County in 1929. After meeting Ray Perry on a blind date, she married him in 1947. Ray was a rancher, coming from a family that had

been ranching for six generations in Haskell County. Ray and Amelia had two children, Rick and Milla. While Amelia was busy raising her children, over the years she also taught quilt making at three different local quilt shops. Amelia and her students developed close friendships and have continued to help each other through difficult times in their lives. During one difficult episode in Amelia's life, she made the Lone Star

Quilt that now hangs in the office of her son, Texas Governor Rick Perry.

Although Amelia is now a proud cancer survivor, she did not reveal her diagnosis to anyone until after Governor Perry's inauguration. "I had my surgery four days after the inauguration," she says, "and then went into chemotherapy. It was then that I decided that Rick needed something special to commemorate his time in office." During her

chemotherapy, Amelia designed, pieced, and created the Lone Star Quilt for her son from the "fabric stash in my quilting closet." At times the weakness caused by the treatment made the work difficult, and she pieced much of the work while sitting in her chair. When Amelia surprised her son with the quilt, presenting it to him on April 19, 2001, he grinned, shook his finger at his mother, and said, "You're fifty-one years late!" It was the first quilt she had quilted just for her son.

The quilt measures 65" x 65" and is a classic Lone Star design pieced by Amelia in navy, burgundies, and ecru cotton fabrics, and quilted by Marjory Lake of Anson, Texas. The quilting commemorates several very special dates in Governor Perry's life. His birth date, March 14, 1950, is on the left side of the quilt; his inauguration date, December 21, 2000, on the right side. At the top of the quilt are the words, "God Bless Texas"; a trapunto-work quilting of his own brand—an R with an arch over the top—is on the bottom of the quilt; and the Texas State Seal is quilted into the four corners.

Although this quilt pattern is truly Texan, Amelia told me that the Log Cabin is her favorite pattern, and she made a Log Cabin quilt from the leftover scraps of the governor's quilt. She also

made her husband, Ray, a Log Cabin quilt to commemorate his twenty-eight years of service as Haskell County commissioner. His quilt, which covers her dining room table, has a black border appliquéd with birds, flowers, and vines.

Not an idle woman, this petite dynamo has made over 150 quilts, some of which have been sold at charity auctions, and several were exhibited in Anson, Texas, in 2000. Inspiration for quilts comes from everywhere, according to Amelia. "You can see designs in car-pets, walls, borders, even in doctors' offices. I saw many designs in waiting rooms." She also takes design ideas from the world outside. "Sometimes you can see a design in ivy on a fence or in a flower garden; even the clouds in the sky offer great possibilities." Amelia Perry's life is full of family, quilting, and friends. She believes that "it's who you surround yourself with that makes your quality of life."

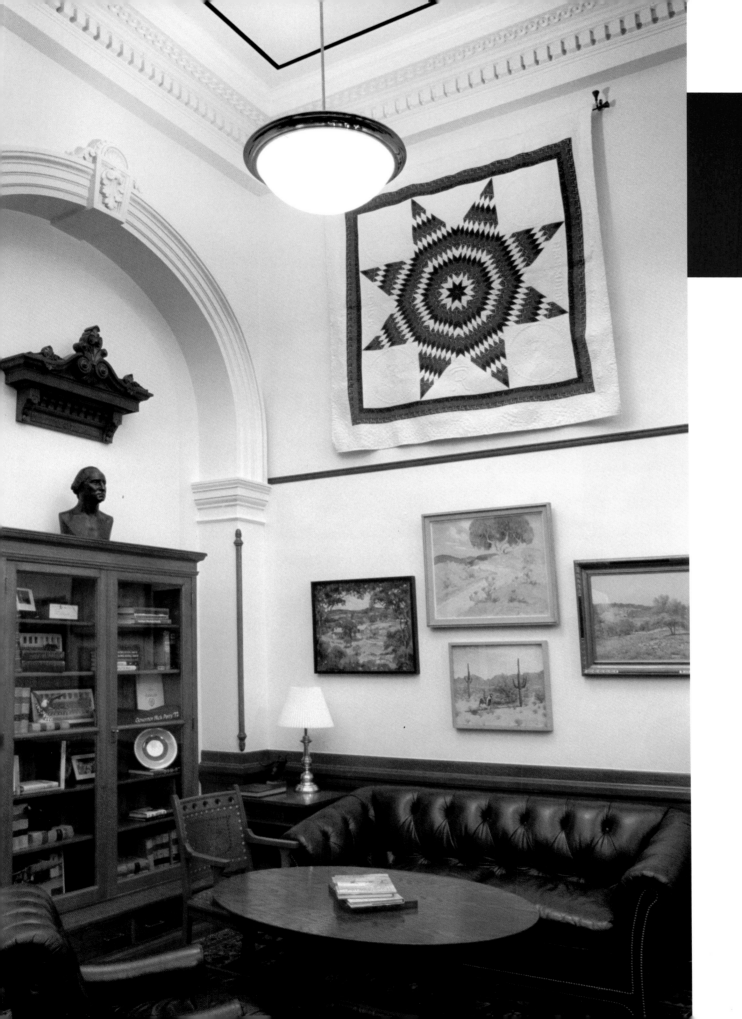

Lone Star Quilt, hanging in Governor Perry's office at the state capitol in Austin. Photograph by Jim Bonar; with permission.

219 ✫

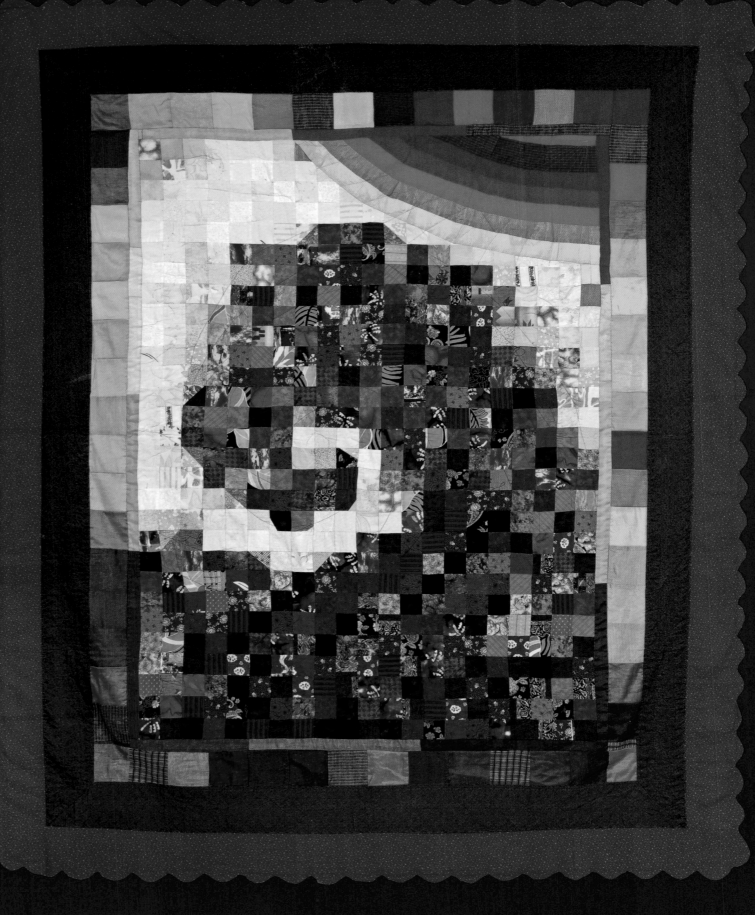

Nannie's Quilt, 2003, 77"x 96", made by Dana DeBeauvoir, owned by Mr. and Mrs. Sheldon Fields.

Nannie's Quilt

2003

Dana DeBeauvoir

Austin, Travis County

Shared by Dana DeBeauvoir

In Victorian times, people often kept a loved one's lock of hair as a memento. Pictures, whether the old daguerreotypes, tintypes, or modern photographs, have always been reminders of those we hold dear. And since the early nineteenth century, when women wanted to keep someone's memory alive, they have created remembrance quilts, sewing pieces of the person's clothing in as part of a quilt. Even today, quilt makers keep this time-honored tradition alive as a way of having a physical reminder of someone dear

Cleadith Marie "Bobbie" McCarty, 1970. Courtesy Dana DeBeauvoir, with permission.

to them. Although modern in its appearance, this quilt by Dana DeBeauvoir was made in just such a tradition to honor and remember her grandmother, Cleadith Stephens McCarty.

Dana's grandmother, Cleadith Marie Stephens, was born on March 15, 1918, in Stephens County, Oklahoma. After her birth, the family moved back to Fort Worth, Texas, to farm and raise horses. Cleadith's father had always wanted a son and called her "Robert" until she was six. When it was time for "Robert" to go to school, her nickname changed to "Bobbie," a name she kept for the rest of her life.

Bobbie grew up in Fort Worth, married C. L. McCarty in 1934, and became a homemaker. After her children were grown, Bobbie then took care of her granddaughter Dana while Dana's mother worked. Dana remembers Nannie, as she called her grandmother, as a stabilizing force in her life, teaching her skills like sewing and even helping Dana make an Indian costume for her third-grade play. Until her death on June 25, 2001, Bobbie remained a constant presence in Dana's life.

After Bobbie's death, Dana felt the need to keep her grandmother's memory alive and thought of making a quilt from her grandmother's clothing, but Dana was not a quilter. However, that fact did not stop Dana from her goal. She explained, "After Nannie passed away, I wanted to do something with her clothing that would be a reminder of her and also to honor her life." Dana had tried quilting while in her twenties, but her first attempt was not too successful. On her first quilt, she didn't piece correctly. "I remember vividly, throwing that quilt in the wastebasket," she says. "I don't remember the quilt at all, but I remember that wastebasket!" About ten years later, Dana tried her hand at quilting again, making one quilt and giving it away. Ten

years after that, Dana finally took a class on quilt making and began making three quilts from her grandmother's clothing.

Nannie's Quilt is Dana's first totally original design. She says the design came to her in a dream. "The blues and greens in the fabrics represent waves, and the reds and yellows represent sunset, or passing away. The spiral curl of the wave signifies the circle of life," she explains. Dana used lighter-colored silk fabrics to give the illusion of water and air. The quilt measures 77" x 96" and contains silk, cotton, and synthetic fabrics. Dana created the design by using two-inch squares of fabric cut from her grand-

mother's clothing. Dana chose to make this very special quilt for Bobbie's youngest grandchild, Sheldon Fields, and his wife, Julie, as a wedding present in May 2003.

As Dana has created this memory quilt, she has honored her grandmother and given a gift that connects the family with a tangible bond. The spiral curve, that circle of life in the quilt, has been continued in the circle of family that Bobbie nurtured in Dana, who has now passed it on to others.

Detail of Nannie's Quilt showing fabric squares cut from Dana's grandmother's clothing.

Butterfly Quilt, 2003, 81 1/2" x 87 1/2", made by Reverend Eugene Tomlin, quilted and owned by Sara Cooper.

Butterfly Quilt

2003

Reverend Eugene Tomlin

Tyler, Smith County

Shared by Sara H. Cooper

What did a mother do when her active little boy was bedridden with a childhood illness in 1931? How did she keep him quiet during his recuperation? Eugene Tomlin's mother taught him to embroider.

Born in Rusk, Texas, in 1926, Eugene recovered from his illness, continuing to embroider and learning other types of artistic pursuits as he grew older. He graduated from Howard Payne University in 1950 and married schoolteacher Elna Pauline Cox in 1951 while working as a youth ministry pastor in Galena Park, Texas.

Reverend Eugene Tomlin, 1998. Photograph by Sara Cooper, with permission.

Shortly after, Reverend Tomlin began making embroidery blocks of the churches where he had pastored or had a ministry. He wanted to turn the blocks into quilts as a way of memorializing this aspect of his ministry. Although Reverend Tomlin made the quilt blocks, the quilts were assembled and quilted by others, usually women in the churches where he preached. In his first attempts at making quilt blocks, he used Liquid Embroidery, but later returned to more conventional thread embroidery techniques. Reverend Tomlin always said he enjoyed quilt making as much as he enjoyed his ministry in the church.

He visited his churches on a rotating schedule, preaching in one church in the morning, another in the afternoon, and another once every two weeks. Truly a modern circuit rider in every sense of the word, Reverend Tomlin felt that he could best meet the needs of his churches with this alternating schedule. Eventually, however, Reverend Tomlin was assigned to just one church and became the pastor of the Old North Baptist Church in Nacogdoches, Texas. He remained there for twenty-five years until he retired from pastoral duties, eventually moving to Tyler, Texas. His favorite hymn was "How Great Thou Art," and he created a quilt embroidered with this hymn and other favorites. He often brought the quilt with him when he spoke to church groups, quilt guilds, and AARP groups about his work. Another of Reverend Tomlin's quilts, Our Field of Service, is pictured in *Texas Quilts: Texas Treasures,* produced by the Texas Heritage Quilts Society, 1986. Reverend Tomlin embroidered quilt blocks all of

Detail of Butterfly Quilt showing additional butterflies and border fabric.

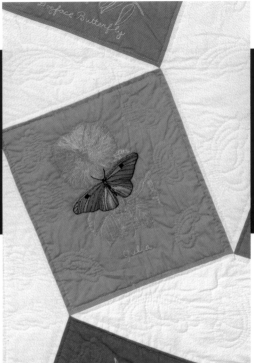

Detail of Reverend Tomlin's Butterfly Quilt showing embroidery work on Julia butterfly.

his adult life, creating enough for seven quilts during his last eleven years, and several of these quilts won awards. Reverend Tomlin died in August 2003 before the Butterfly Quilt was finished.

Although this is Reverend Tomlin's last quilt, the Butterfly Quilt shows how carefully he observed nature. The quilt measures 81 1/2" x 87 1/2" and has sixteen blocks of embroidered butterflies, each measuring 11 1/4" x 13". When Reverend Tomlin finished the blocks, he gave them to his cousin, Sara Cooper, to make into a quilt, and Sara chose to set the blocks in a playful style reminiscent of butterflies fluttering in his garden. Sara also continued Reverend Tomlin's motif as she quilted extra butterflies into the white background. Additionally, she bordered the quilt in a fabric reminiscent of a pea gravel walkway in a garden. Truly, she recalled and was faithful to her cousin's comments that many of his quilts were from natural scenes that he saw outside his home. In this quilt, Sara has a tangible connection to her cousin and his work.

Male quilters are rare in the world of quilt making, generally making up about 1 percent of the quilting population. Reverend Tomlin brought his own style to the craft with his unique eye for nature and detail. That skill a mother taught to keep her little bedridden boy quiet sparked his artistic interest and inspired him to make quilts that captured bits of nature with a needle and embroidery thread.

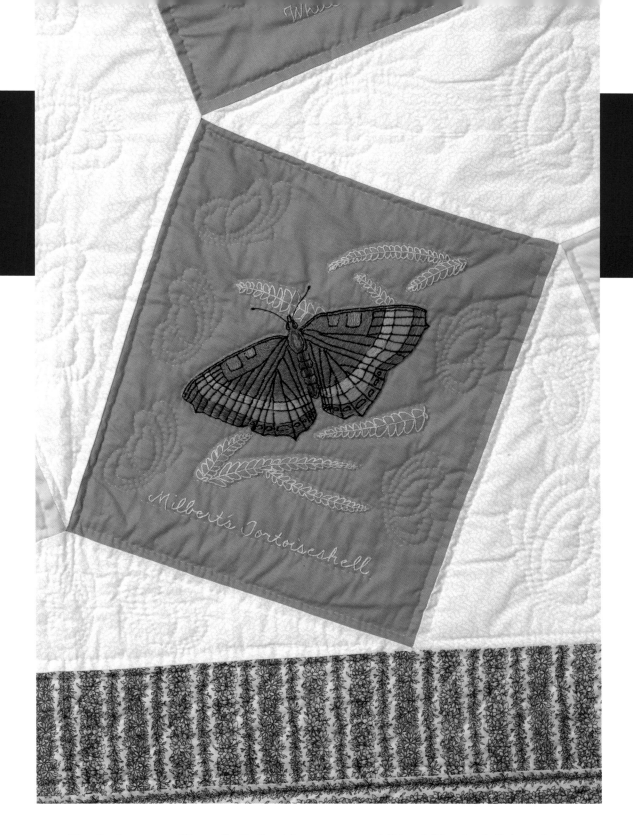

Detail of a square of Butterfly Quilt with proper name, Milbert's Tortoiseshell, included.

Author's Source Note

These stories are based on personal communication between the
quilters and their families and Marcia Kaylakie and have been supplemented
with letters, e-mails, questionnaires, audio tapes, and other documents
provided to Kaylakie. That information has been donated to the
Southwest Collection/Special Collections Library at Texas Tech University.
In supplementing the stories for other minor geographic and historical details,
she relied on information in the public domain, primarily
found in the *Handbook of Texas On-line*.

Suggested Reading

Many good books have been written about quilts and quilt making and are available to those interested in learning more about quilts, quilt history, and the quilt-making process. It would not be possible to list them all here, so I have selected a few that will help readers find answers and begin their journey to learn about quilts. I also highly recommend individual state quilt-search and documentation books.

Texas Quilts

Abernathy, Francis Edward. *Folk Art in Texas.* Dallas: Southern Methodist University Press, 1985.

Bresenhan, Karoline Patterson, and Nancy O'Bryant Puentes. *Lone Stars, Volume I: A Legacy of Texas Quilts, 1836–1936.* Austin: University of Texas Press, 1986.

———. *Lone Stars, Volume II: A Legacy of Texas Quilts, 1936–1986.* Austin: University of Texas Press, 1990.

Cooper, Patricia, and Norma Bradley Allen. *The Quilters: Women and Domestic Art, An Oral History.* Lubbock: Texas Tech University Press, 1999.

Orbelo, Beverly Ann. *A Texas Quilting Primer.* San Antonio: Corona Publishing, 1980.

Texas Heritage Quilt Society, eds. *Texas Quilts, Texas Treasures.* Paducah, TX: American Quilter's Society, 1986.

Yabsley, Suzanne. *Texas Quilts, Texas Women.* College Station: Texas A&M University Press, 1984.

History of Quilts and Quilting

Bacon, Lenice Ingram. *American Patchwork Quilts.* Bonanza ed. New York: Crown Publishers and William Morrow & Co., 1980.

Basset, Lynne Z. *Northern Comfort, New England's Early Quilts: 1780–1850.* Nashville: Rutledge Hill Press, 1998.

Bishop, Robert, and Carter Houck. *All Flags Flying: American Patriotic Quilts as Expressions of Liberty.* New York: E. P. Dutton, 1986.

Colby, Averil. *Patchwork.* New York: Charles Scribner's Sons, 1958.

Finley, Ruth E. *Old Patchwork Quilts and the Women Who Made Them.* Philadelphia: Lippincott, 1929.

Fox, Sandi. *Wrapped in Glory: Figurative Quilts & Bedcovers 1700–1900.* London: Thames and Hudson, Ltd., 1990.

Fry, Gladys-Marie. *Stitched from the Soul: Slave Quilts from the Antebellum South.* New York: Penguin Books, 1990.

Granick, Eve Wheatcroft. *The Amish Quilt.* Intercourse, PA: Good Books, 1994.

Hall, Carrie A., and Rose G. Kretsinger. *The Romance of the Patchwork Quilt in America.* New York: Bonanza, 1935.

Ickis, Marguerite. *The Standard Book of Quilt Making and Collecting.* New York: Dover Publications, 1949.

Lasanky, Jeannette. *In the Heart of Pennsylvania: Nineteenth & Twentieth Century Quiltmaking Traditions.* Lewisburg, PA: Oral Traditions Project of the Union County Historical Society, 1985.

———. *Pieced by Mother: Over 100 Years of Quiltmaking Tradition.* Lewisburg, PA: Oral Traditions Project of the Union County Historical Society, 1987.

Lipsett, Linda Otto. *Remember Me: Women & Their Friendship Quilts.* San Francisco: Quilt Digest Press, 1985.

Martin, Nancy J. Pieces of the Past. Bothell, WA: That Patchwork Place, 1986.

McMorris, Penny. Crazy Quilts. New York: E. P. Dutton, 1984.

Orlofsky, Patsy, and Myron Orlofsky. *Quilts in America.* New York: McGraw-Hill Book Co., 1974.

Peto, Florence. *American Quilts and Coverlets.* New York: Chanticleer Press, 1949.

———. *Historic Quilts.* New York: American Historical Co., 1939.

Safford, Carleton L., and Robert Bishop. *America's Quilts and Coverlets.* New York: E. P. Dutton, 1980.

Shaw, Robert. *Quilts: A Living Tradition.* Beaux Arts Editions. Westport, CT: Hugh Lauter Levin Associates, Inc., 1995.

Sienkiewicz, Elly. *Spoken without a Word.* Washington, DC: Turtle Hill Press, 1983.

Smith, Patricia S. *Calico & Chintz: Antique Quilts from the Collection of Patricia S. Smith.* Washington, DC: Renwick Gallery, National Museum of American Art:

Smithsonian Institution, 1997.

Waldvogel, Merikay. *Soft Covers for Hard Times: Quiltmaking & the Great Depression.* Nashville: Rutledge Hill Press, 1990.

Waldvogel, Merikay, and Barbara Brackman. *Patchwork Souvenirs of the 1933 World's Fair.* Nashville: Rutledge Hill Press, 1993.

Woodard, Thomas K., and Blanche Greenstein. *Twentieth-Century Quilts, 1900–1950.* New York: E. P. Dutton, 1988.

———. *Crib Quilts and Other Small Wonders.* New York: Bonanza Books, 1988.

Zegart, Terri. *Quilts: An American Heritage.* New York: Smithmark Publishers, 1994.

Index

Janice Whittington

Marcia Kaylakie

Jim Lincoln

Marian Ann J. Montgomery